THE MASTERWORKS OF VAN GOGH

The Masterworks of
VAN GOGH

Nathaniel Harris

SMITHMARK

This edition published in 1996
by SMITHMARK Publishers,
a division of U.S. Media Holdings, Inc.,
16 East 32nd Street, New York, NY 10016

SMITHMARK books are available for bulk purchase
for sales promotion and premium use.
For details write or call the manager of special sales,
SMITHMARK Publishers,
16 East 32nd Street, New York, NY 100016; (212) 532-6600

This edition first published in Great Britain in 1996
by Parragon Book Service Limited
Copyright © Parragon Book Service Limited 1996

ISBN 0-7651-9694-8

Editor: Linda Doeser
Design Direction: Robert Mathias, Publishing Workshop
Designer: Helen Mathias
Picture research: Charlotte Deane
Special thanks go to Joanna Hartley of the Bridgeman Art Library, London
for her invaluable help

Contents

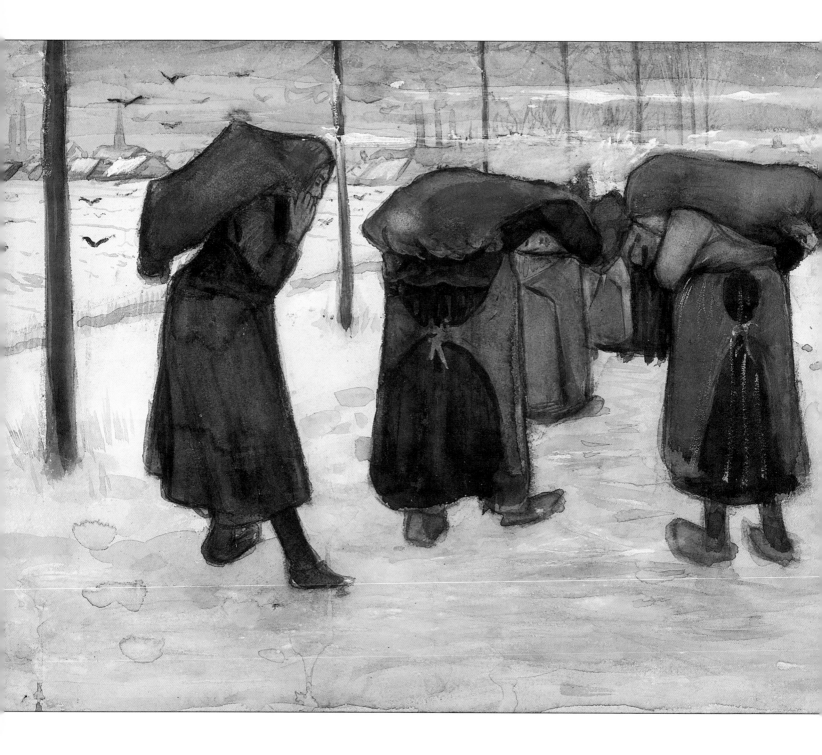

ABOVE: **Miners'
Wives Carrying
Sacks of Coal**
1882
RIJKSMUSEUM
KRÖLLER-MÜLLER,
OTTERLO

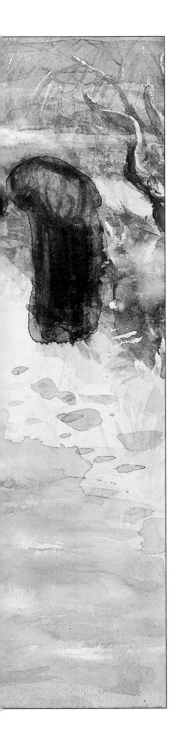

The Pastor's Son

Many artists have led humdrum lives, interesting mainly as chronicles of work done and accounts of its reception. Even poverty and struggle are not necessarily exciting. This is not the case with Vincent van Gogh, whose tormented vagabond existence, documented in a wealth of letters written by the artist himself, has inspired novels, films and even a pop song. If anything, the difficulty in his case is to disentangle the legend from the life, and to be cautious about relating the life and the work too directly. Recent writers on Van Gogh have tended to lean in the opposite direction, denying that his canvases can be read as reflections of his personal crises and afflictions; to put it crudely, they prefer not to see his late paintings, in particular, as expressing his alienation and threatened sanity.

Obviously they are more than that, but it would be strange indeed if there were no connection between a canvas such as *Starry Night* (pages 170-1) and Van Gogh's tragic fate. Van Gogh himself told his brother that 'There is certainly an affinity between

a person and his work, but it is not easy to define what that affinity is, and on that question many judge quite wrongly'. Fair warning to writer and reader.

Vincent Willem van Gogh was born on 30 March, 1853, at the parsonage in the village of Groot Zundert. His father, Theodorus van Gogh, was a 31-year-old pastor of the Dutch Reformed Church. His mother, Anna Cornelia van Gogh, née Carbentus, was already 34 but would, nevertheless, bear five more children. As a young man Theodorus was good-looking – he was nicknamed 'the handsome pastor' – but his abilities seem to have been no more than adequate. At any rate, his superiors moved him every few years from one small parish to another in the province of North Brabant, which is, despite the name, in the far south of the Netherlands. All the parental homes that Van Gogh stayed in or visited during his life – Groot Zundert, Helvoirt, Etten, Nuenen – were within a few kilometres of one another in this peaceful agricultural region, untouched by the excitements of the city and the industrial nineteenth century.

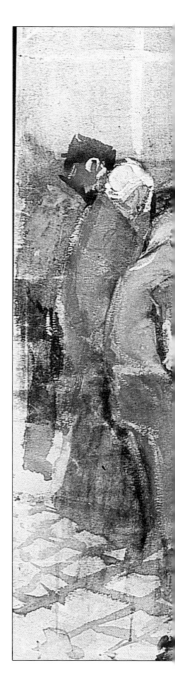

Vincent van Gogh was the pastor's eldest surviving child. But Anna Cornelia had given birth to a stillborn son on 30 March, 1852, exactly a year before his arrival, and this child too had been called Vincent Willem. The coincidence of names and dates has inevitably given rise to speculation about the possible psychological effects although there is no evidence to suggest that Van Gogh's parents regarded him as a mere substitute for the dead child, or that the artist ever thought of himself as a 'usurper'. People grieved at the death of an infant, but in those days it was too common to be surprising. Vincent was a family name – among others, the name of Van Gogh's uncle and godfather – so there need have been no special significance in it being chosen a second time as the name of the eldest boy. Interestingly, a later artist, the Spaniard Salvador Dalí (1904-89), was born in similar circumstances and did think of the earlier Salvador as a haunting presence in his life; but then Dali was a child of the age of psychoanalysis and surrealism, all too eager to develop a carefully controlled neurosis.

Vincent's childhood seems to have been uneventful. He learned to read and write at the village school, but was then put in the charge of a governess. At the age of 11 he was sent to the first of two North Brabant boarding schools, Jan Provily's at Zevenbergen; then, two years later, he moved on to a state-run establishment at Tilburg. It is difficult to imagine Van Gogh being happy at a

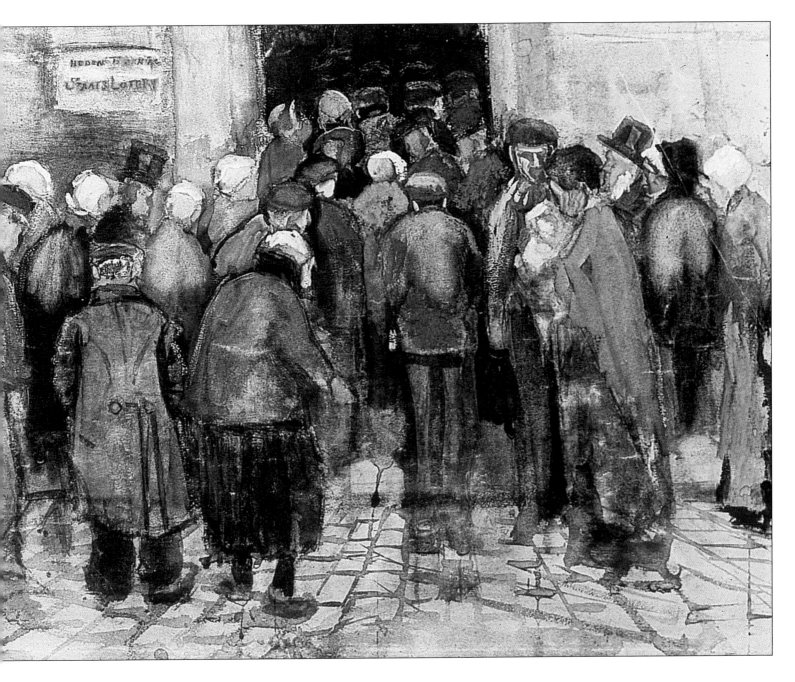

boarding school (something thousands of children failed to achieve in the nineteenth century and later) and when he was older he compared his painful departures from home in adult life with the earlier leave-takings he endured as he went off to school. But while he was there he learned French, English and German – and learned well, if we can judge by his later proficiency. Nevertheless he left Tilburg in March 1868, before he had even reached his fifteenth birthday. This may have been because he was a scholastic failure, or may simply have reflected the state of the family finances, strained by the need to support the three sisters and two brothers who had followed Vincent into the world.

ABOVE: **Outside the State Lottery Office**
1882
RIJKSMUSEUM VINCENT VAN GOGH, AMSTERDAM

A Model Employee

RIGHT: **Sorrow**
1882
RIJKSMUSEUM
KRÖLLER-
MÜLLER,
OTTERLO

A year passed before he found a job, or rather had a job found for him. Although there had been Van Gogh pastors for generations, Theodorus's brothers had made very different careers: one had risen to the top in the Dutch navy as a rear-admiral, while no less than three of Vincent's uncles were art dealers. His godfather-uncle, also named Vincent van Gogh, had incorporated his own establishment at The Hague in a leading international firm, Goupil's, which had a headquarters in Paris and other branches in Brussels, London and Berlin. Thanks to this 'Uncle Cent', Vincent was taken on at The Hague branch in July 1869, beginning his apprenticeship to art in surprisingly prosaic fashion, as a salesman rather than a creator.

The young Van Gogh stayed at the Hague for almost four years, winning golden opinions from his employers. A hard worker and regular churchgoer, lodging with a respectable family, he must have seemed a solid citizen in the making. Like most branches of Goupil's, The Hague dealt in high-quality copies rather than original paintings. Copies in the form of prints – engravings, etchings and lithographs, made by highly skilled artists – took the place nowadays occupied by photographic reproductions in poster shops and art books; and since most nineteenth-century people had few opportunities to travel and view masterpieces at first hand, such copies were immensely influential in spreading an interest in art. They must also have encouraged people to value works for their subjects rather than their painterly qualities, which were not visible in prints. This was in any case a tendency of the Victorian age, so preoccupied with great causes and moral issues. Van Gogh himself always retained a partiality for 'message' paintings and illustrations, many of which have lost their appeal for us.

Van Gogh had made drawings since childhood, acquiring considerable skill in the art. This was not necessarily evidence of a vocation, since drawing was widely studied and practised by educated people during the nineteenth century. Among other things, it enabled an individual to make a personal record of places and people (another function taken over by photography), whether as a souvenir or as a 'snapshot' for the benefit of distant relatives or friends. Once he had left home Van Gogh made a habit of drawing each new house where he lodged, sending these and other record-sketches along with his letters to his family.

When he went home for the holidays in 1872, 'home' meant

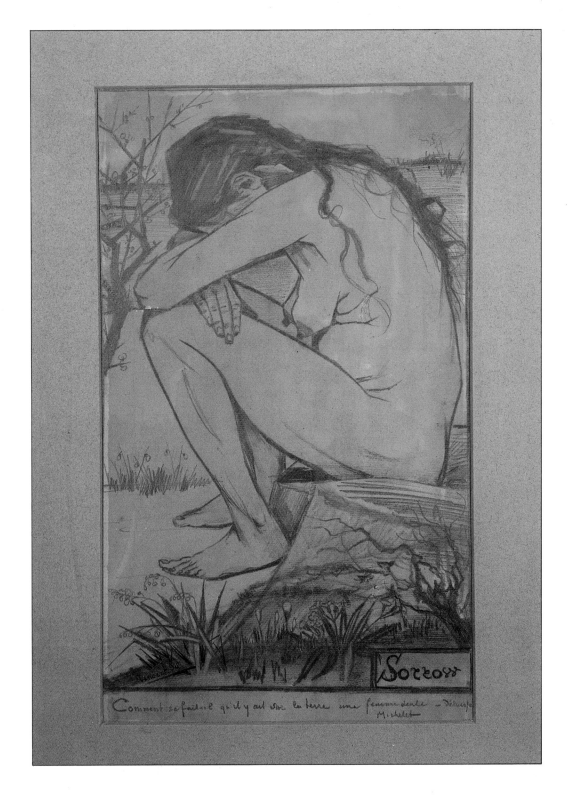

Helvoirt, to which his father had been transferred the previous year. He spent a good deal of time with his brother Theo, who later strengthened the bond between them by visiting Vincent at The Hague; the brothers walked out to a nearby village and solemnly swore that they would always stand by each other. Vincent began writing at length to Theo, and the correspondence

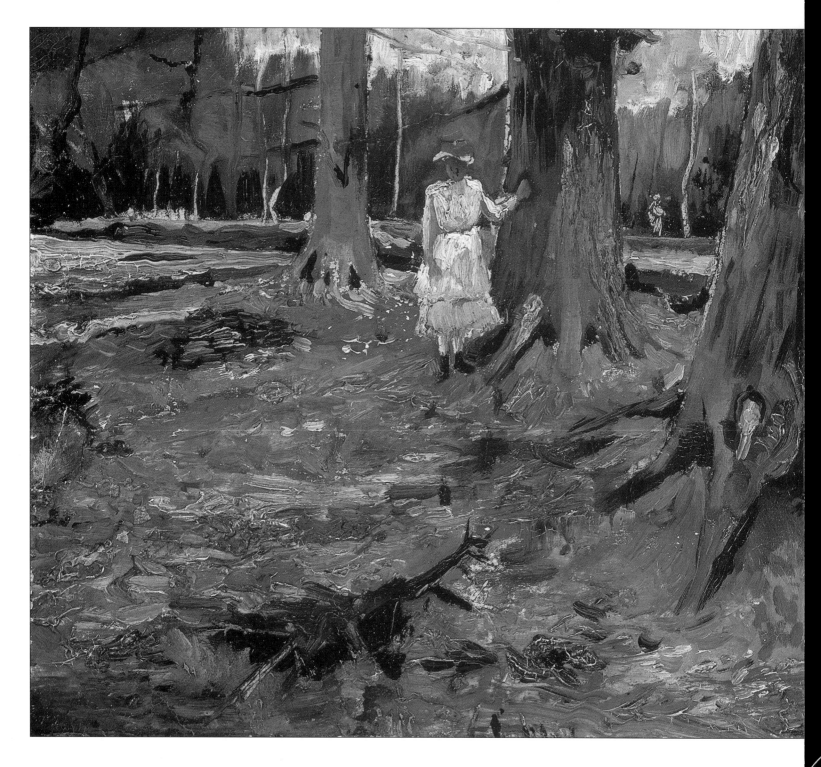

eventually comprised over 600 letters on his side alone. Written with a self-searching candour that would make them of literary value even if Van Gogh had failed to achieve greatness, they provide a unique record of the artist's thoughts and actions.

Four years younger than Vincent, Theo became his brother's confidant, and in time his main support. The relationship was to have a strong symbiotic element, in which Theo achieved all the

ABOVE: **Girl in White in the Woods** 1882 Kröller-Müller Stichtung, Otterlo

everyday goals that Vincent's waywardness – and genius – put out of his reach. At this point in their lives, however, they seemed to be taking the same direction, for in January 1873 Theo, too, joined Goupil's, beginning his career at the firm's Brussels branch. And when Vincent was promoted and left The Hague, Theo took his place there a few months later.

Van Gogh's promotion took him to the expanding London branch of Goupil's. On his departure, Hermanus Tersteeg, the manager of the Hague branch, gave him a glowing testimonial. Perhaps, in view of Van Gogh's family connections, this was to be expected, but there is no reason to believe that Tersteeg exaggerated when he pictured his assistant as not only conscientious but able to get on with people – a quality in which he was later to be sorely lacking. Still only 20, Van Gogh remained a conventional and biddable young man when he made his first foray into the wider world. After visiting his family he had a few days in Paris (a sign of his prosperous, assured position), where he saw the masterpieces in France's principal museum, the Louvre, for the first time. Then in May 1873 he left for London.

England and Eugénie

Goupil's was in Southampton Street, between Bloomsbury and Holborn. The management was trying to widen its operations by selling original paintings as well as reproductions, so Van Gogh's prospects for promotion seemed excellent. He was still an assistant, but the £90 a year that he earned was not at all bad for a young bachelor. Among his earliest purchases was a top hat, which at that time was standard wear, roughly equivalent to the bowler hats that were sported somewhat later by Britons who were 'something in the City'.

Van Gogh's first London address is not known, but by the end of August 1873 he had moved to Brixton, one of the south London suburbs from which thousands of employees commuted daily to the centre of the city. At 87 Hackford Road, Mrs Ursula Loyer and her daughter Eugénie ran a small school; Van Gogh lodged with them, renting the front top-floor room of the three-storey house. The Loyers made him very comfortable, and when he wrote to his sister Anna inviting her to write to Eugénie, Anna divined that a little romance was in the air.

Unfortunately the romance was all on one side. By the spring of 1874 Van Gogh knew that Eugénie was engaged to another

man, but he evidently continued to cherish hopes. In June he took a short summer holiday with his family at Helvoirt, returning to Hackford Road in mid-July with Anna, who intended to look for a teaching post in England; only a few months earlier the Loyers had intimated that, if she decided to come, she would be very welcome to stay at their house. But within a couple of weeks Vincent had made some kind of declaration to Eugénie and had been decisively rejected. In view of his later behaviour-patterns, it seems likely that he had kept his passion to himself for a year, conducting a love affair with Eugénie that took place entirely in his own mind, until something triggered an outpouring of frightening intensity. Given his reluctance on a number of subsequent occasions to accept that reality would not fall in with his imaginings, he probably pressed his suit with an unreasonable violence that, failing, made any further contact with the Loyers impossible. At any rate, Vincent and Anna left Hackford Road at once and took new lodgings in Kennington Road.

This first rebuff was an important event in Van Gogh's life and it is a great pity that we know so little about it. There are certain mysterious elements in it that will probably never be cleared up. Both of Van Gogh's parents felt that the Loyer household had turned out to be an unhealthy one and referred to its 'secrets' as having harmed their son; it is unclear whether they knew more about it than we do or were merely expressing a puritanical aversion to Eugénie's supposedly secret engagement. They were certainly worried about Vincent's frame of mind, realizing that he was solitary and miserable, and too withdrawn into himself to do anything about it. To make matters worse, Anna had to leave him almost immediately to take a teaching post at Welwyn, some 40 kilometres north of London.

Van Gogh's failure in love may have been a piece of sheer bad luck that might have happened to anyone. But it seems more likely that the apparently prosaic assistant, he had already developed into a strange, combustible mixture of shy fantasist and demanding idealist, and that consequently some setback of the kind – something that would begin to unravel his conventional way of life – was bound to occur. Although he continued to work at Goupil's, his parents were sufficiently concerned to take up Uncle Cent's remark that Vincent should widen his experience by getting to know the business in Paris. Telling themselves that the gloomy London fogs were probably keeping their son in a melancholy mood, they arranged for him to leave for the

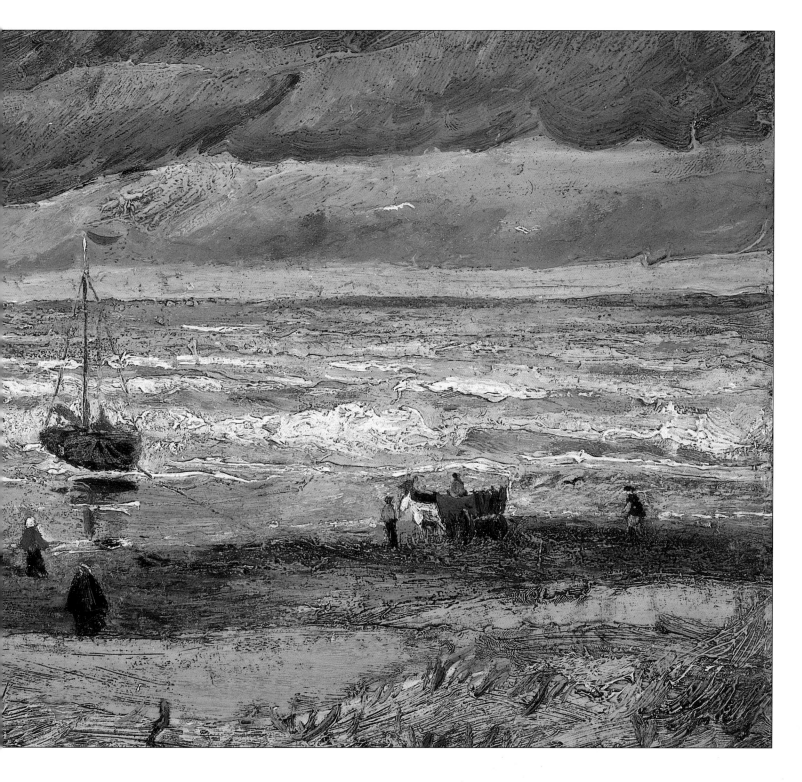

French capital at the end of October 1874.

Van Gogh's first extended stay in Paris was not a success. He resented his parents' interference, even though the transfer was only a temporary one, and for a time he could not bring himself to write home. But he spent Christmas at Helvoirt and then returned to England. He still harboured ambitions of doing well at Goupil's, which had moved to grander premises in Bedford Street and had begun dealing in paintings, many of them by Jozef Israëls and other members of the Dutch school whom Van Gogh

ABOVE: **The Beach at Scheveningen** 1882 VAN GOGH MUSEUM, AMSTERDAM

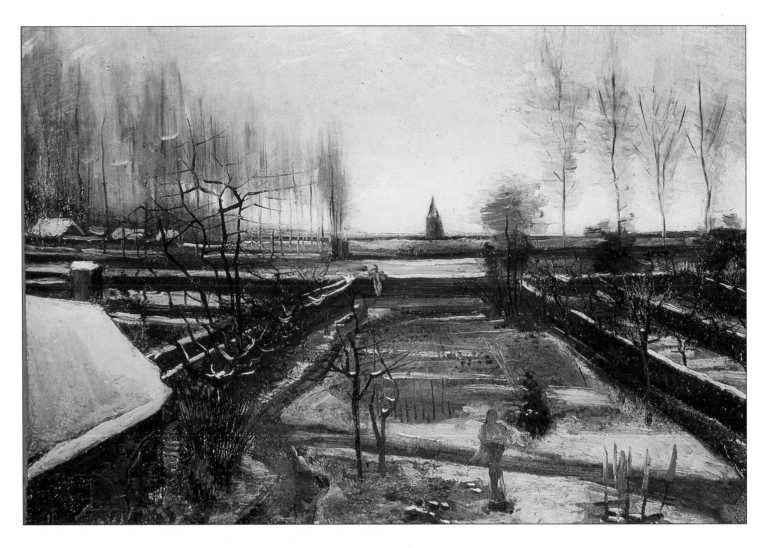

ABOVE: **The Parsonage Garden at Nuenen in the Snow** 1885
ARMAND HAMMER MUSEUM OF ART, LOS ANGELES

admired. Some of his letters suggest that he was not entirely happy in his work, feeling that he was under scrutiny and mistrusted, but it is not at all clear whether this was fact or fantasy.

In May 1875 he was again summoned to Paris on a temporary basis. Irritated at first, he grew to like the city and took calmly the news that he would not, after all, be returning to London in the near future. Unconsciously anticipating his later life in Paris, he rented a room in Montmartre, which was not yet a centre of Parisian nightlife but had already begun to interest some painters. However, despite his intermittent residence in Paris during 1874–5, Van Gogh apparently remained unaware of the first Impressionist exhibition of 1874. The works of Monet, Renoir and other Impressionist painters are now universally popular, but in the 1870s they scandalized the art world. Impressionist paintings were done in shockingly bright colours and with 'rough', visible brushwork that seemed crude beside the smooth, dark-toned, dignified style promoted by the schools, the academies and the

official show (the Salon) held every year at the Palais d'Industrie. A decade later, Impressionism would help to form Van Gogh's mature style; in 1875, if he had known of its existence, he would almost certainly have disapproved of it, if only for its lack of social and moral content.

Parisian Piety

Van Gogh had always been pious – he was, after all, a pastor's son – but at some point after his rejection by Eugénie Loyer he had become obsessed with religion. It is tempting to backdate this development to his departure from Hackford Street, but the evidence of a qualitative change only becomes clear from what we know of his life in Paris. Van Gogh's religious feelings were always closely linked with his compassion for the poor and outcast; this was the basis for his admiration for socially minded British artist-illustrators such as Luke Fildes, whose *Applicants for Admission to a Casual Ward* he had seen at the 1874 Royal Academy show, and for British novelists such as Charles Dickens, whose works exposed social evils.

In Paris, Van Gogh lived a retired life, but not a solitary one. He had made a friend of an Englishman named Harry Gladwell, who was a fellow employee at Goupil's and lived at the same lodgings. Still rather homesick, Gladwell was pleased to make friends with someone who spoke excellent English and shared his interests. The two young men pored over the Bible, read Dickens and George Eliot, and went to church together. Van Gogh remained interested in art outside working hours, mourning the death of Jean-François Millet (1814–75) and visiting an auction of his work in June 1875. Millet's paintings of peasants, though touched with sentimentality, are still popular. To Van Gogh, images such as *The Sower* (1850) and *The Angelus* (1859) spoke loudly of the hard life of the common man and the dignity of labour. He never lost his regard for Millet and, as with most of his admirations, learned from him by making direct copies of his works.

Vincent spent Christmas 1875 with his family at Etten, Theodorus van Gogh's latest parish. His parents could see that he was in a state of nervous strain, and worried about him; but they blamed big-city life and were unaware that anything was wrong at work. By his own account, Van Gogh was expecting trouble. When he returned to Paris he was summoned by Goupil's son-in-law and successor, Léon Boussod (the firm would soon become Boussod

RIGHT: **Weaver:
the Whole
Loom, Facing
Right** 1884
PRIVATE
COLLECTION

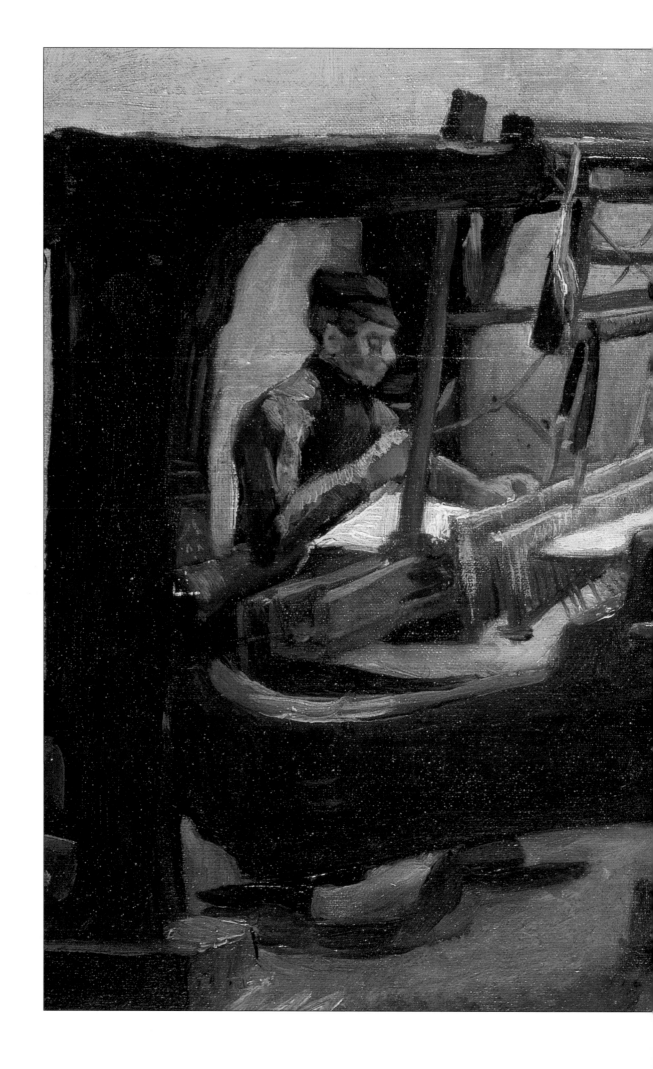

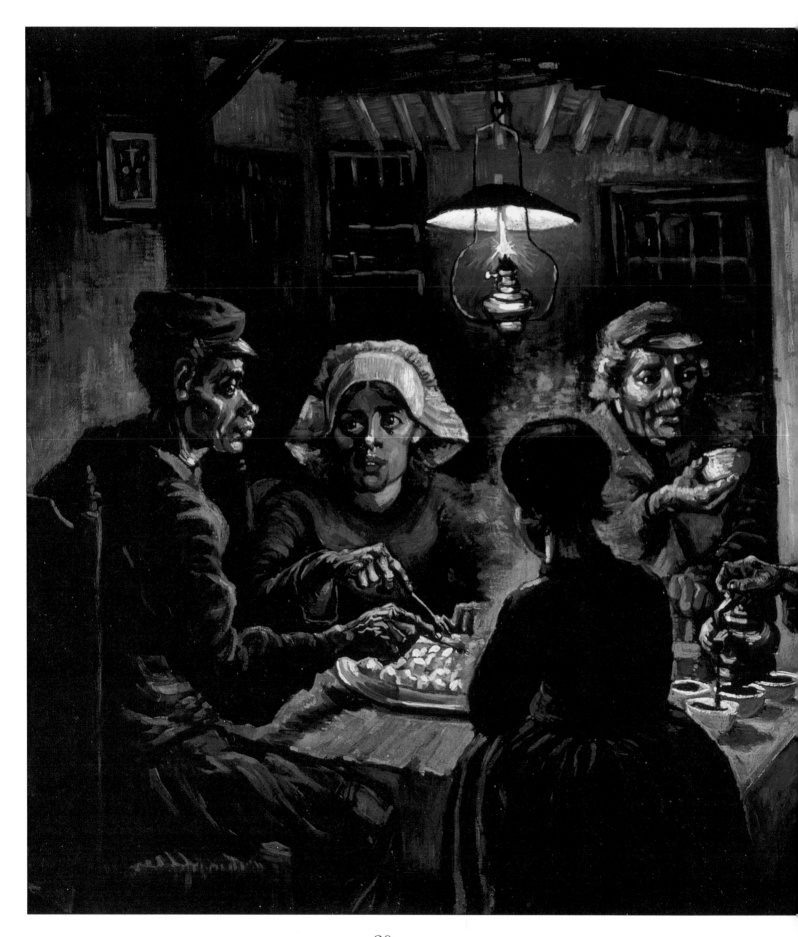

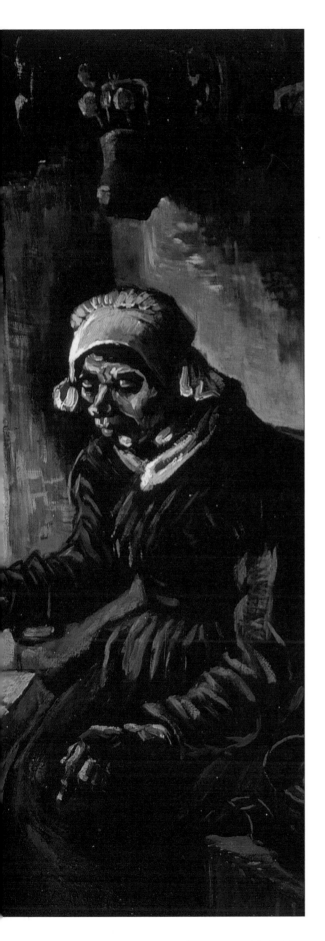

and Valadon), and the interview that followed was evidently traumatic. By the time it ended, Van Gogh had been more or less forced to say that he would leave three months later, abruptly ending his six-year career at Goupil's.

He later claimed that his offence was to have gone home over Christmas without permission, knowing perfectly well that it was a busy time for the firm. Such insubordination would certainly have been serious enough to get him fired, but he had probably become mutinous or unreliable even before then. His father, who until this time had sympathized with Vincent's problems, wrote to Theo of the 'bitter sorrow' caused Uncle Cent, who had been forced to agree to Vincent's departure, and of the whole affair as 'a shame and a scandal'. In his eyes Vincent seems to have been guilty of some insupportable breach of discipline, although he resolved to write to his son without reproaching him. For a time he wondered whether Vincent might not be able to start his own business, as Uncle Cent had done; in that case, the pastor wrote, he would not have to sell any works he believed to be bad – a comment which suggests that Vincent had been too free with his opinions about the works offered for sale at Goupil's.

If the idea of Vincent opening his own shop was ever seriously entertained, it was soon abandoned. On 1 April, 1876, he left Goupil's, ending a period of steady employment which had lasted for well over six years. A new phase of his life began, in which he turned even more fervently to religion for meaning and purpose.

LEFT: **The Potato Eaters**
1885
VAN GOGH MUSEUM
(VINCENT VAN GOGH
FOUNDATION),
AMSTERDAM

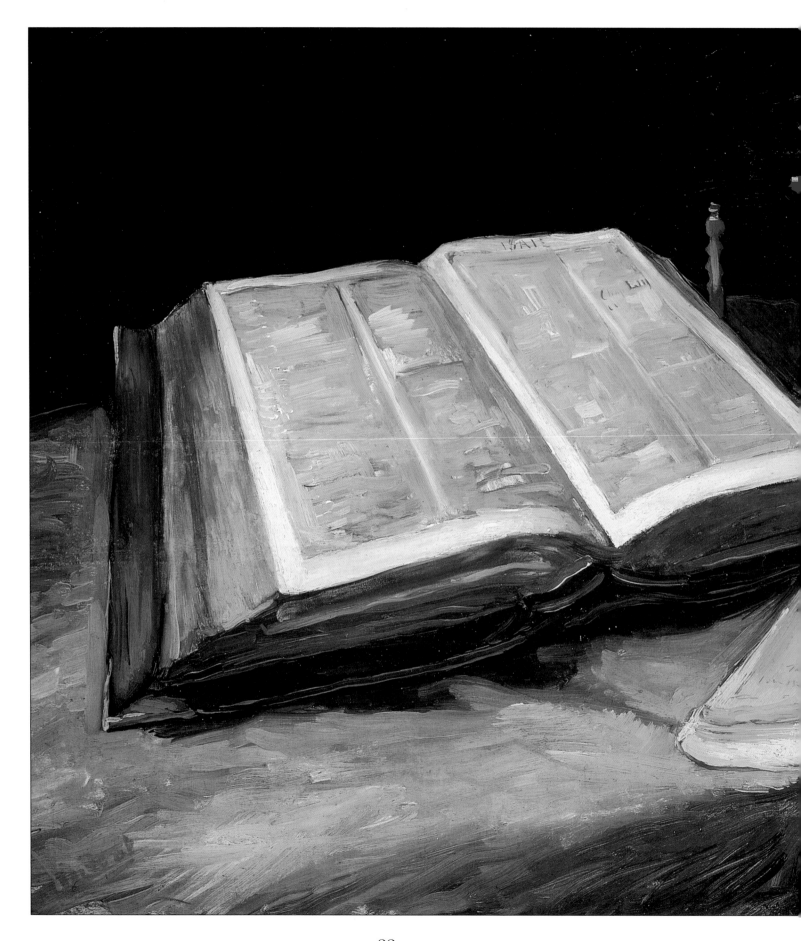

The Seeker

LEFT: **Still Life with Bible**
1885
VAN GOGH
MUSEUM
(VINCENT VAN GOGH
FOUNDATION),
AMSTERDAM

After leaving Goupil's, Van Gogh returned to Etten. Within days he had begun to apply for teaching posts in England. Despite his lack of experience, he succeeded with his second application – an event that might have made a more guileful individual suspicious. By mid-April he was installed in a boys' boarding school run by the Rev. William Stokes at Ramsgate, a little town on the coast of Kent. The school was a small, seedy place in Royal Road; Van Gogh and several of the boarders lodged in a house not far from the main building, and one of his letters describes with distaste the rotting boards and broken panes. He was engaged to teach French, German and arithmetic in return for bed and board, Stokes intimated that, if he proved satisfactory after a month, the question of a salary could be discussed.

In spite of it all, Van Gogh was happy in his new teacher/clergyman sphere of life, although, in a flash of insight, he wrote to Theo that he did not trust his happiness, or rather his capacity to remain in a state of contentment. He loved the sea, sent drawings of the school and Ramsgate home and, surprisingly, experienced

no great problems in teaching, although he was shrewd enough to realize that a docile class was not necessarily one that was learning very much. His opinion of Stokes is implicit in some of the incidental remarks in his letters: if the boys were noisier than usual on one of the head's bad-tempered days, they would be sent to bed without supper – a sad fate when they had little to look forward to except meals.

At the end of the summer term Stokes told his new master that he could stay on, but that the school was moving to new premises at Isleworth, a village close to the Thames which was at that time still separate from London. Van Gogh had always been a great walker, finding that the exercise banished petty pre-occupations and put him into a mystical communion with his surroundings. So preference as well as economy sent him on a long journey in June 1876 from Ramsgate to Welwyn, where his sister Anna was still teaching, and then south again to Isleworth. In his state of religious exaltation he had already come to feel that a man's personal appearance was a trivial matter; his father knew better and worried that Vincent's long walks and nights spent in the open would make him 'even less presentable'.

At Stokes' new establishment in the Twickenham Road, Van Gogh was told that he would have to go on working for nothing. It is hard not to see this as a mean premeditated trick, played to take advantage of an apparently helpless foreigner. It was too much for Van Gogh, even in his meekly religious frame of mind. He thought of taking up missionary work at a seaport, of America and of going back to Holland; then he had a stroke of luck, finding a place for himself close at hand in the Twickenham Road. His new employer, the Rev. Thomas Slade Jones, was prepared to take him on as a teacher at Holme House in return for his board and a very small salary – but a very small salary – of £15 a year.

Holme House was a more respectable establishment than Stokes' school, but it was still essentially a large private house in which the second floor served as a dormitory for the boys. Van Gogh lodged in a small room on the third floor, overlooking the playground at the back of the house. He got on well with Jones, who was favourably impressed by his new young teacher's religious fervour. Jones himself was an active Congregational minister in charge of a chapel at Turnham Green, and Van Gogh soon became a valued helper, taking Sunday school classes, organizing a children's service and attending prayer meetings at which he often got up and spoke. To his fellow workers in religion, who

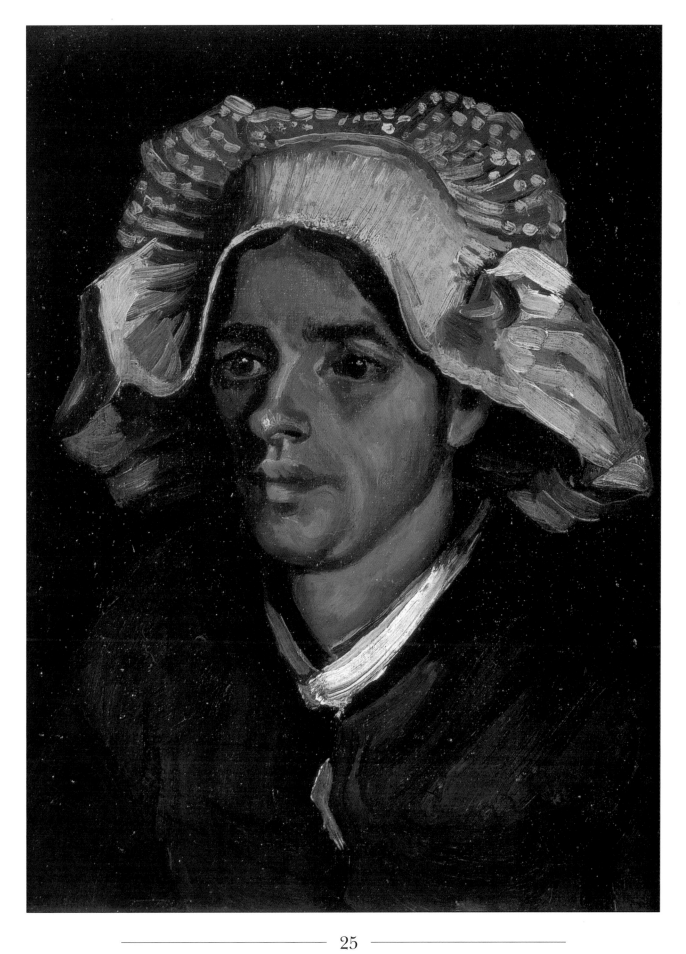

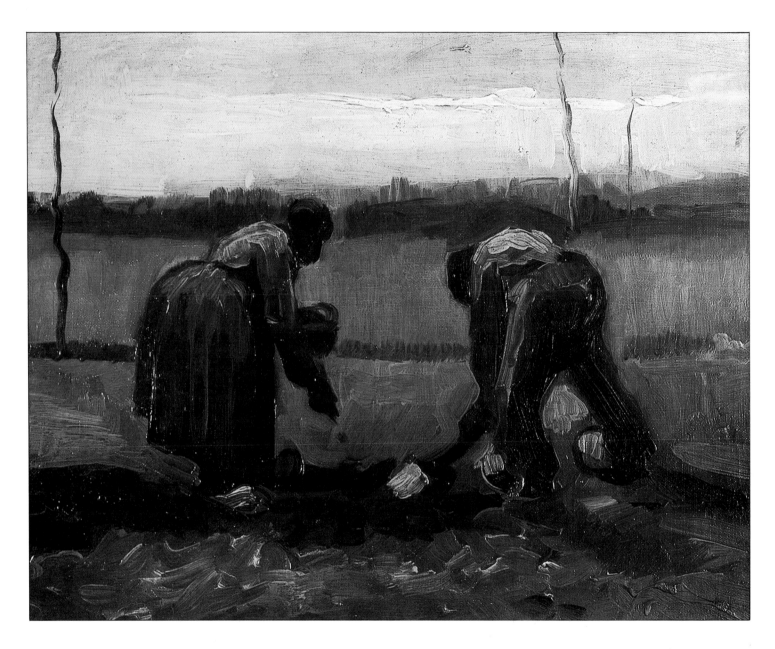

ABOVE: **Peasants Working in a Field** 1885
KUNSTHAUS, ZURICH

consistently mangled his surname, he became 'Mr Vincent', an interesting anticipation of his later practice of signing his canvases with his first name. Although he was constantly thinking about religion, he did still make time to visit Hampton Court Palace more than once, delighting in the gardens and the great collection of Old Master paintings.

Van Gogh had long made a habit of attending the services of a variety of Christian denominations; he had no time for doctrinal disputes, believing that the differences between the churches were unimportant. His attendance at Methodist prayer meetings led to an event that seems to have been the high point of his time at Isleworth: the first Sunday sermon that he delivered from the pulpit, allowing him to put himself forward as the evangelist he

longed to become. When he spoke at the Richmond Wesleyan Methodist Church, his text, taken from the Psalms, was poignantly applicable to his own case: 'I am a stranger in the earth: hide not thy commandments from me.' He praised the old belief that life is a pilgrimage (which meant, he said, that 'we are strangers on the earth'), stressing in orthodox fashion the presence of God as the pilgrim's companion, and the value of sorrow. In more personal vein he referred to 'the golden hours of our early days at home' and the sorrow of leaving to earn a living and make a way in the world – the motif of parting and absence that runs through so many of his letters, and surfaces in paintings such as *Memories of Etten* and the 'empty chair' pictures (pages138-9, 147, 148).

In retrospect, the most interesting feature of the sermon is what it tells us about the role of art in Van Gogh's perception of the world. Even at a time when religion was uppermost in his thoughts, he made his responses to a painting the basis for an impassioned description: 'I once saw a very beautiful picture, it was a landscape at evening. In the distance on the right hand side a row of hills appearing blue in the evening mist. Above those hills the splendour of the sunset, the grey clouds with their linings of silver and gold and purple. The landscape is a plain or heath covered with grass and heather, here and there the white stem of a birch tree and its yellow leaves, for it was in Autumn. Through the landscape a road leads to a high mountain far far away, on the top of that mountain a city whereon the setting sun casts a glory. On the road walks a pilgrim, staff in hand. He has been walking for a good long while already and he is very tired. And now he meets a woman, a figure in black...That Angel of God has been placed there to encourage the pilgrims and to answer their questions.'

The text is as Van Gogh copied it out for the benefit of his brother Theo, with only one or two commas added for ease of reading; it demonstrates his near-perfect grasp of written English, a fact worth bearing in mind when we come to his later studies. The picture Van Gogh had in mind during his sermon is believed to have been *God Speed!* by George Boughton, an English artist whom he is known to have admired. Boughton's canvas was on show at the 1874 Royal Academy summer exhibition, which Van Gogh visited although he failed to mention this particular work in his letters.

Yet this bland history painting, showing a pilgrim setting out for Canterbury in Chaucer's time (the fourteenth century), differs in all sorts of important respects from Van Gogh's description. Either *God Speed!* was not the work that inspired Van Gogh or,

more likely, he imposed his own vision on what he had looked at. To put it another way, he saw with a heightened vision that transformed the realities in front of him. This heightened, transforming vision caused him to be moved when he looked at quite conventional paintings and prints with moral or social messages. It would later enable him, as an artist, to reinterpret everyday realities into images of wonder or terror; but in his personal life this same capacity would lead him, again and again, to confuse his feelings and impulses with the realities of the world around him, with disastrous results. In this sense Van Gogh's life was all of a piece: his greatness and his misery flowed from the same source.

Another New Start

The religious fervour of Van Gogh's letters home worried rather than pleased his parents. Pastor Theodorus, who had led a life of practical if conventional piety, found himself irritated by Vincent's constant quoting of Biblical texts and suspected that his son was overwrought and increasingly unfit to cope with ordinary life. Urged to return to Etten for Christmas 1876, Van Gogh came back with his sister Anna, who had left Welwyn. His delight in his work at Isleworth had already given way to depression, and his parents were able to persuade him that it was pointless to go back to England, where he had no real prospects of even earning a decent salary. They probably hoped to keep a closer eye on him while finding him congenial work.

Once more Uncle Cent came to the rescue, introducing Vincent to a Mr Braat, a bookseller who was willing to try him out. Braat's shop was at Dordrecht, a medium-sized provincial town only some 30 kilometres from Etten. The position seemed a suitable one, for Van Gogh was passionately interested in reading as well as knowledgeable about fine prints, which the shop also sold. But his heart was simply not in it. According to a later account by one of Braat's sons, Van Gogh was compliant but fundamentally uninterested in learning the trade. When he might have been doing something useful he was often found at work on a private project, making Biblical translations or drawing little sketches. He was taciturn, solitary and 'excessively religious' – and still sported his English top hat, although it was by now in an advanced state of decay.

Clearly the younger Braat did not take to the new assistant. Like many observers, he noticed Van Gogh's small eyes and penetrating glance, but never saw the eyes flashing with enthusiasm.

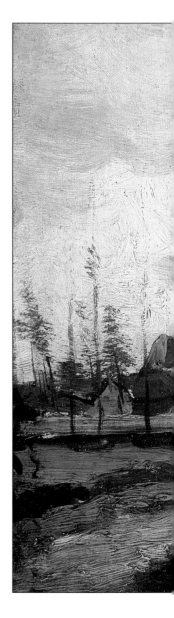

An alternative view is provided by P.C.Görlitz, a young trainee teacher who helped out in the bookstore. He was aware of Van Gogh's homely appearance and eccentricity, but also responded to his earnestness and his moments of humour.

Görlitz shared a room with Van Gogh and therefore had an opportunity to scrutinize him at close quarters. The two young men were closely compatible; Görlitz was studying every evening for his teacher's certificate, while Van Gogh spent his time reading the Bible, making extracts from it and composing sermons. The future artist revealed himself only when he and Görlitz took long walks together or visited galleries and museums, when he would wax eloquent about the sights they saw. Otherwise he was more preoccupied than ever with religion, living like an ascetic except for his one vice – his pipe. According to Görlitz, Van Gogh was not

Landscape with Church and Farms 1885
RIJKSMUSEUM VINCENT VAN GOGH, AMSTERDAM

deliberately neglectful of his employer's affairs, but could not resist jotting down a significant thought or text if it came into his mind. Görlitz also confirms that Van Gogh answered customers' inquiries all too candidly, assessing the value of the art works on sale without any consideration of the firm's interest in selling high-priced items.

Van Gogh's departure from Braat's establishment can only have been a matter of time. Görlitz claimed that Vincent kept his unhappiness from his parents and that it was he, Görlitz, who finally told them that their son was miserable and still longed to become a minister. Whatever the cause, Van Gogh left early in May 1877, after little more than three months in Dordrecht. Although he complained of being inundated by 'a torrent of reproaches', his family rallied round again and gave him his chance to realize his dearest wish. Since it was impossible to become a pastor without a degree, he was sent to Amsterdam, where he was to get up enough Latin and Greek to be admitted to the university. His parents smartened him up by buying him some new clothes from the best tailor in Breda, but apparently there was no barber in the provinces skilful enough to put his intractable head of hair into acceptable shape!

The Student

The prospect of financing Vincent's future years of study must have been daunting for Pastor Theodorus. However, the extensive Van Gogh connection proved its value once more, since Vincent was able to lodge at the official residence of his rear-admiral Uncle Jan, who was in command of the dock area. He received visits from his family and he called regularly on his aunt Willemina and her husband J.P. Stricker, a clergyman. He also met their daughter Kee and her husband Vos, envying their domestic happiness; Kee was later to play an important, although inadvertent, role in his life.

Apart from these contacts, Van Gogh's life followed a familiar pattern. He pinned prints all over the walls of his room to make it feel home-like and inspirational. He took long walks and visited galleries and museums – notably the Trippenhuis, the 'ancestor' of today's great Rijksmuseum. Above all, he immersed himself in religion, making an intense study of one Christian classic in particular. *The Imitation of Christ*, a fifteenth-century guide to self-perfection, was written by the Dutch mystic Thomas à Kempis and described the progress of the soul towards God; Van Gogh

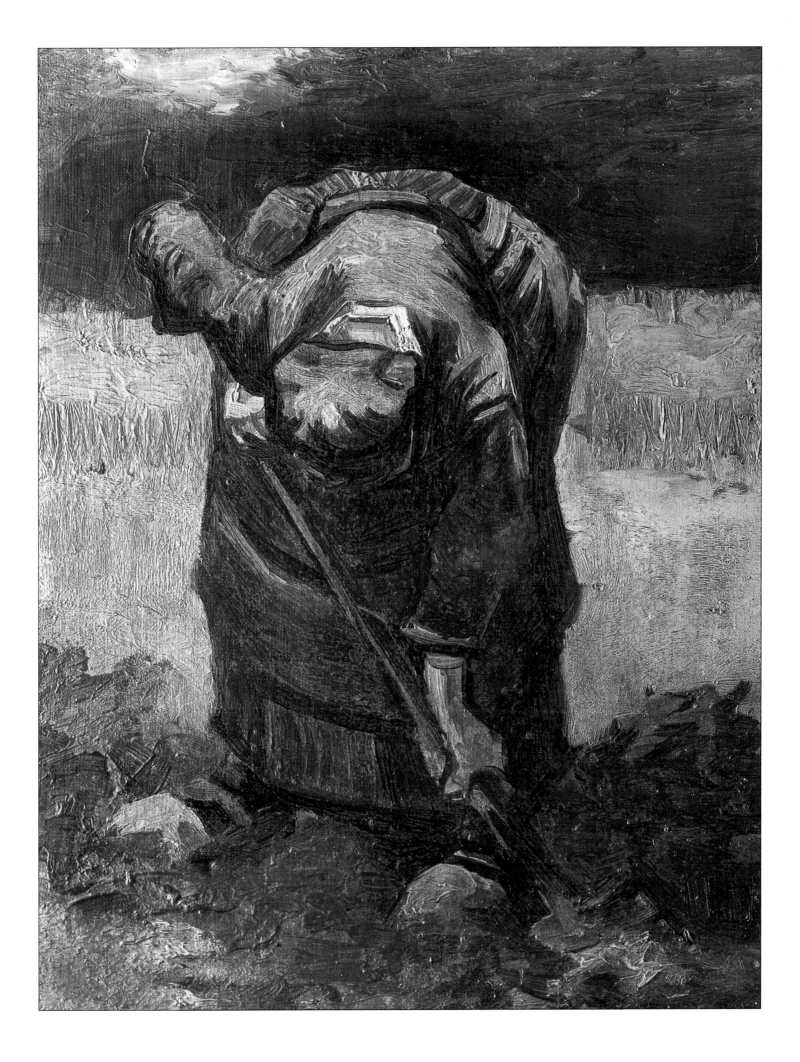

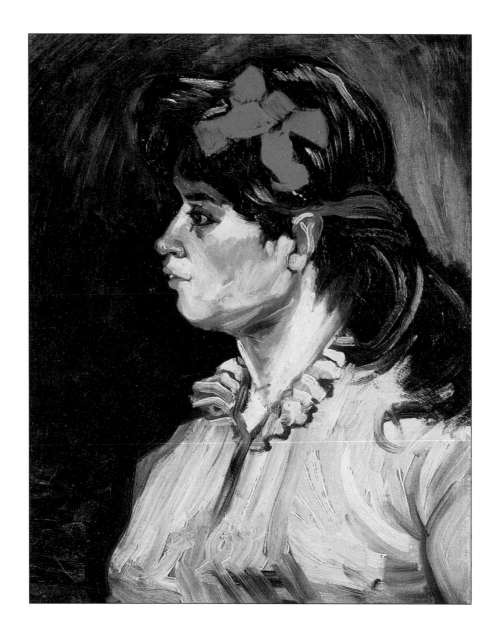

RIGHT: **Woman with a Red Ribbon** 1885
PRIVATE COLLECTION

owned copies in no fewer than four languages.

However desirable, imitating Christ was not enough in itself to qualify as a clergyman in nineteenth-century Holland. In Van Gogh's case, his concentration on this particular text reflected his emotional faith and impetuosity, traits potentially at odds with the disciplined study and behaviour expected of a would-be pastor in an established church. It may also have been significant that, during this period, Vincent often held up his father as a praiseworthy example or even a great man, as if trying desperately to convince himself that he should take Theodorus' sober, duty-doing piety as his model.

The conviction never genuinely established itself. Van Gogh's studies went badly from the beginning, undermined by his unwillingness to accept the system of which they were a part. Again we have a sympathetic account of Van Gogh's character and actions,

this time from the tutor employed to teach him Greek and Latin. The Jewish scholar M.B. Mendes da Costa was only two years older than his pupil, and the two young men seem to have discussed matters between them with considerable freedom. Mendes disagreed with descriptions of Van Gogh as rough and unkempt (so the tailor at Breda must have done a good job), although he was struck by his reticence and nervously expressive manner.

As a student Van Gogh made a good start with Latin; in characteristic fashion, he at once tried to use his beginner's knowledge to read *The Imitation of Christ* in the original. But the ancient Greek verbs defeated him. Mendes put himself out to make his lessons as interesting as possible, but to no avail. Van Gogh punished himself like a candidate for sanctity, cudgelling his back with a big stick, sleeping in an outhouse instead of his bed and walking around Amsterdam in bitter weather without a coat on. Then, knowing that Mendes disapproved of his austerities, he would turn up for his lesson with some snowdrops he had picked for his teacher!

In spite of these touching details, the suspicion remains that Van Gogh's failure was wilful rather than unlucky. We know that he was good at languages, writing letters to Theo in fluent English and French; so it is hard to believe that he could not master Greek verbs, however tricky, in the course of a year. Mendes himself describes Van Gogh's impatient attitude towards a study that he regarded as utterly irrelevant to the ministry as he visualized it. Why, he demanded of Mendes, were 'these horrors' – the verbs – supposed to be indispensable to someone like himself, who wanted to 'give peace to poor creatures and reconcile them to their existence here on earth'? Mendes might have retorted that this was hardly the complete duty of a pastor, but he in fact understood Van Gogh's point of view and, when not restricted by his professional role, sympathized with him. On the other hand, it is not necessary to be a partisan of Greek verbs to see that there was a contradiction between Van Gogh's declared longing to become a pastor and his unwillingness to do what was required to achieve the aim.

In June 1878, with Van Gogh's agreement, Mendes advised Uncle Jan that there was no point in his continuing his studies. Besides, Vincent was now fired with a new scheme to undergo a brief training in Belgium that would be all he needed to become a lay evangelist. By this time his parents were seriously worried, feeling that he might be a self-doomed creature, always finding

ways of making trouble for himself and never sticking at anything, and although they never admitted it, they must have found the implications for their own future lives rather cheerless. Nevertheless, Theodorus van Gogh went with Vincent to Laeken, just outside Brussels, where they had an interview with the principal of the evangelical college. They were accompanied and backed up by the Rev. Jones, who had stayed in touch with Van Gogh despite his abrupt departure from Isleworth; his presence in the Low Countries at this time seems to have been a matter of chance. For all his eccentricities and wilfulness, Van Gogh was seldom entirely abandoned unless he chose to be so; he evidently radiated a sincerity that made people of character willing to make allowances for him and try to help him find his proper place in the world.

The Evangelist

After initial difficulties he was accepted on a three-month probationary course at Laeken, studying there from August to October 1878. He failed yet again, ostensibly because he was a poor speaker, although his combination of asceticism and opinionativeness may well have been what alienated his teachers. But he refused to be discouraged, and his parents supported him in a scheme to win over the evangelical committee. He went to the main evangelical target area, a mining district around Mons known as the Borinage, and worked independently in the village of Pâturages for several weeks in December, hoping that the committee would be impressed by his show of initiative. The scheme succeeded: when the committee met again in January 1879, Van Gogh was taken on for a six-month trial at Wasmes, another village in the Borinage.

Van Gogh had walked the streets of great cities and seen poverty and degradation; but, for all his austerities, he had never lived among them. The blasted landscape and people of the Borinage stirred him to pity and compassion, even as his painter's eye noted the darkness of the days, the gnarled trees, the poor little houses at Pâturages, the sunken road, the pale-faced miners old before their time, their worn and faded wives – and the striking effect created by the colliers' sweep-black figures against the white landscape after it had snowed. As usual, he reinforced his descriptions by making analogies with works of art, citing two Old Masters of the grotesque and sinister, Brueghel and Dürer. Only later would he attempt to capture it all on his own account, in drawings and in

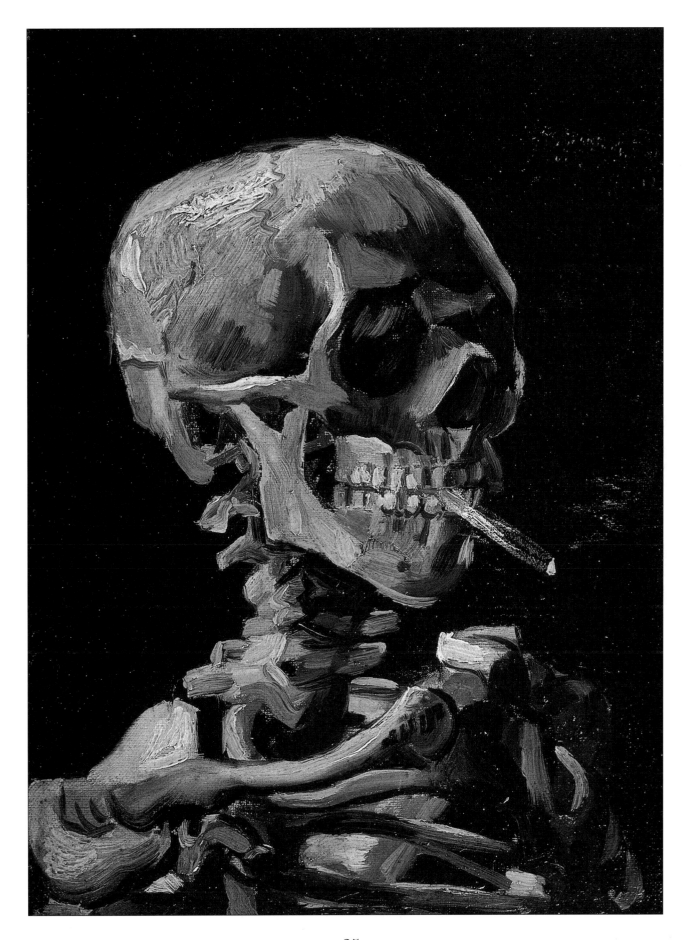

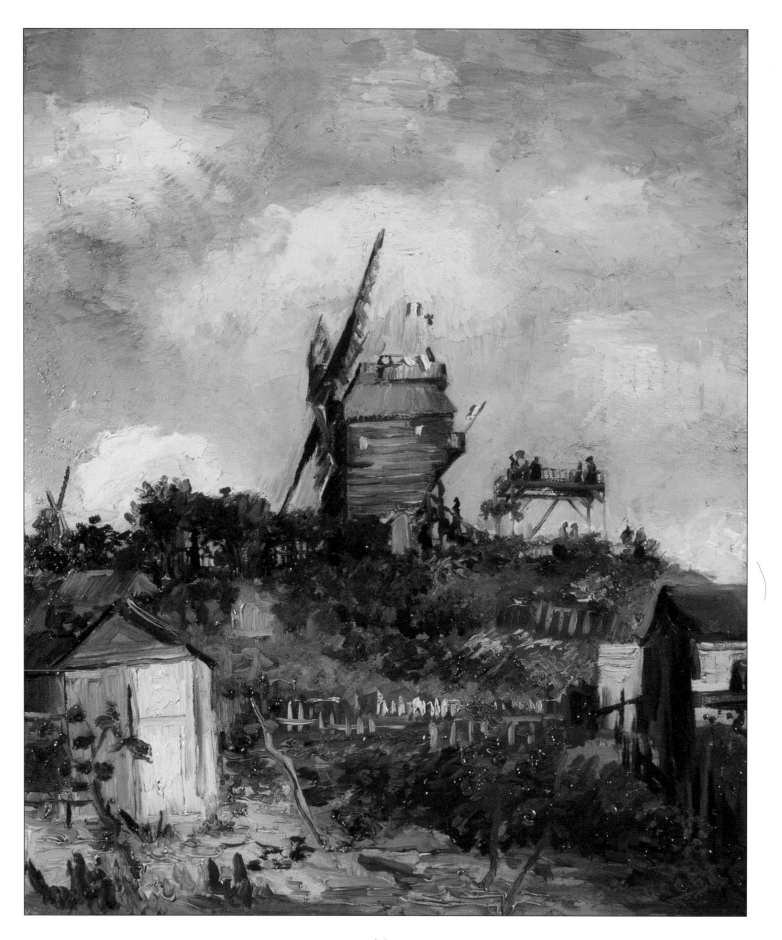

watercolours such as *Miners' Wives Carrying Sacks of Coal* (pages 6-7).

Van Gogh soon realized that bad conditions as well as poverty kept the people in squalor and sickness. The mines of the Borinage were unhealthy and unsafe, even by the not very stringent standards of the time, and fevers, injuries and fatalities were commonplace. Van Gogh made a point of descending into one of the most notoriously dangerous, the Marcasse. He sent Theo a vivid description of life 700 metres below the surface: the low, timber-shored passages, the cramped stalls in which the blackened colliers worked, upright or on their sides, the boys and girls employed to load the coal, the underground stable yard for the old horses used to drag the carts, the water seeping in, the strange light cast by the miners' lamps. He was sensitive enough to realize something that outsiders often overlooked – that, for the colliers themselves, these apparently infernal places (and not their villages above ground) were where they lived their real lives, a community apart from the rest of the world, andthat the aged and injured became homesick when exiled to the upper world.

Van Gogh's reaction to the Borinage was extreme but perhaps predictable. He left his relatively comfortable lodgings at Wasmes and gave away the respectable clothes with which he had been fitted out. Instead he moved into a shack and took to wearing an old army jacket and a cap. In a passion of self-denial he even stopped using soap and, according to one witness, actually succeeded in looking dirtier than the colliers. (This was possible since, in the old mining communities, the coal dust in the air coated everything above ground, so that cleanliness could only be maintained if everything and everybody was washed every day.) He gave away everything he could, sought out the afflicted in order to comfort them, attended to the sick; whether this should be called excessive, or obsessive, or saintly, must be a matter of opinion. If Van Gogh's compulsion to sacrifice himself does smack of the manic, it had its heroic moments, for example when, after a pit accident, he unhesitatingly tore up his linen to make dressings for the injured.

Not surprisingly, his employers, the Wasmes Chapter of the Union of Protestant Churches, decided to dispense with his services. In July 1879, when his trial period ran out, he was not kept on. The record of this decision is a rather curious one, since Van Gogh's care, sacrifice and devotion are recognized, and the ground of his dismissal is (again) only his supposed deficiency as a speaker. The reason evidently sounded so lame, even to those who composed the document, that an unconvincing sentence or so was added

to insist that this really was an important consideration. The conclusion seems inescapable: the Chapter was deeply embarrassed by their evangelist's behaviour, which corresponded to their formal ideals but not to their notions of propriety or practicality. Incidentally, the pastor of a nearby village in the Borinage, recalling Van Gogh in extreme old age, claimed that he expressed himself correctly in French (the language of the area) and 'was capable of speaking quite suitably'.

Despite his dismissal, Van Gogh remained in the Borinage for more than a year. He went to live in the village of Cuesmes and apparently worked independently as an evangelist, living in great poverty on the small allowance sent by his father. This is one of the obscurest episodes in his life, since he virtually cut himself off from his family and there are therefore few letters by him to tell us exactly what he was doing. Though humble towards the lowly, Van Gogh was easily angered by people who tried to advise him, and during this humiliating period he particularly resented any 'interference' on the part of his family.

Significantly, he even broke off contact with Theo, who was now working at Goupil's in Paris. Their relations were renewed when Theo came to see him in October 1879, but the visit prompted a long, self-justifying letter from Vincent. From this it appears that Theo had uttered the indiscreet word 'idleness' and had presumed to suggest several occupations that Vincent might take up. Since Theo was by no means insensitive, it seems likely that Van Gogh's evangelizing had come to a halt and that he was living in confusion and despair.

Almost a year later, in July 1880, Van Gogh broke a long silence to acknowledge 50 francs that Theo had sent him. He felt himself a 'suspect and impossible person' as far as his family was concerned, still thought much about the Gospels and was still bitter against the 'evangelical gentlemen', whom he compared to the conventional 'academic' artists of the day. Such images from painting were even more frequent than usual in this letter, along with an admission that he was often 'homesick for the land of pictures'. His aim in life, he declared, would become more definite as he worked and thought, just as a rough draft became a sketch and a sketch became a picture.

In retrospect these seem very clear signals. Sure enough, two months later Van Gogh wrote to tell his brother that he had emerged from his despair and had taken an important decision: to become an artist.

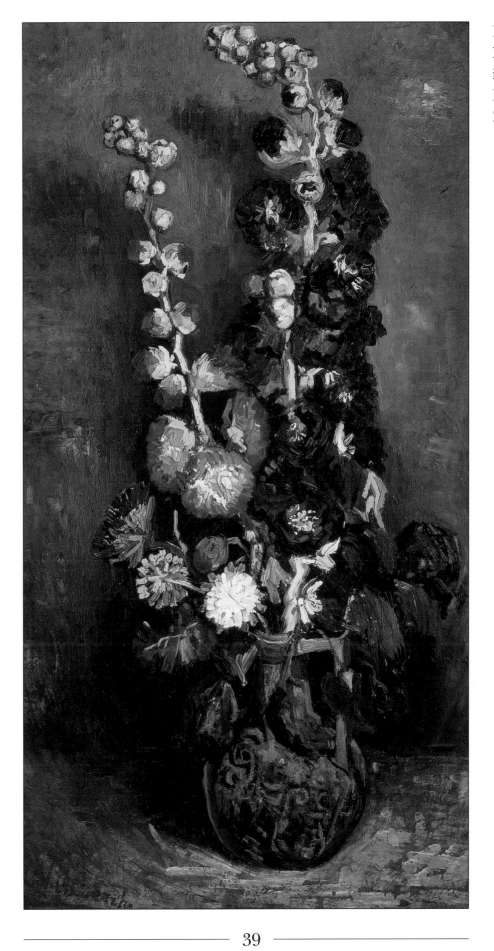

LEFT:
Hollyhocks in a Vase 1886
KUNSTHAUS, ZURICH

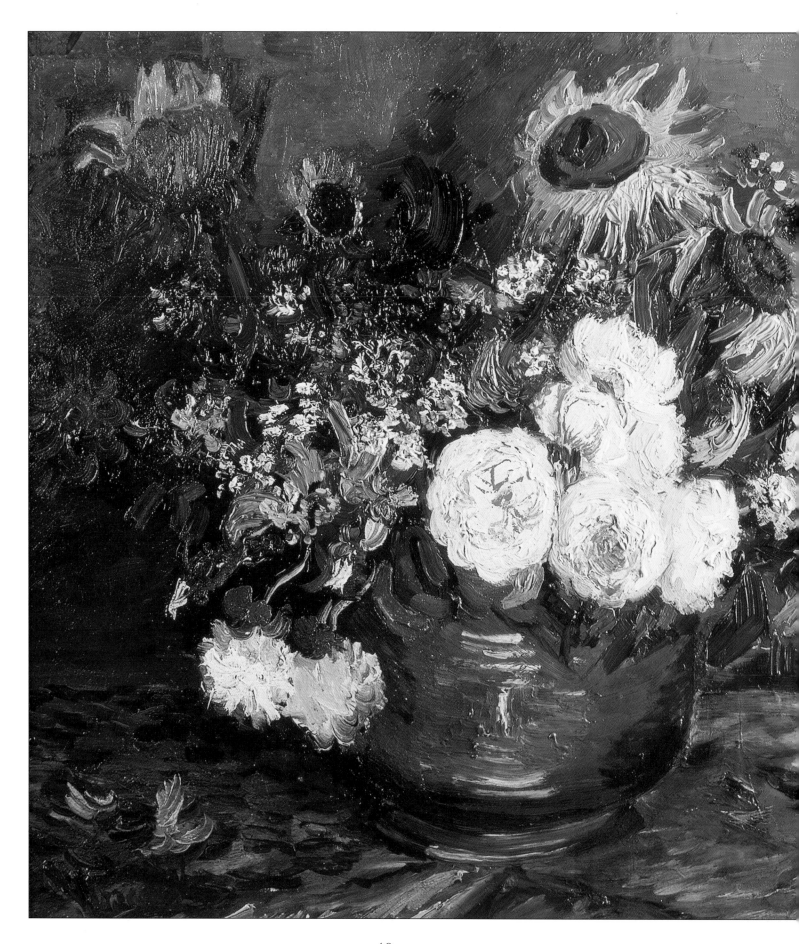

A Rage of Work

'It was when I was in just such deep misery that I felt my energies revive, and I said to myself: In spite of everything I shall rise again; I will take up my pencil, which I have forsaken in my great discouragement, and I will go on with my drawing. And from that moment everything has seemed transformed for me; and now I have started, and my pencil has become a little more docile with every day.'

In this way, with a dramatic flourish and a hinted resurrection simile, Van Gogh announced his new vocation to Theo. The words appear in a letter describing a visit he made to Courrières in northern France, where the artist Jules Breton lived. Breton was another of the now little-regarded artists whom Van Gogh admired for their sincere, if romanticized, concern for the poor and exploited. After walking for a week, Van Gogh arrived at Courrières, experiencing a sense of disappointment at the 'Methodist regularity' of the artist's brick-built studio. Too shy to knock at the door and introduce himself, he wandered about for a while and then simply left the village and tramped all the way back to the Borinage. He was able to exchange some of the drawings in his knapsack for food, but when his money ran out he had to

LEFT: **Sunflowers and Roses in a Bowl** 1886
STÄDTISCHE KUNSTHALLE, MANNHEIM

spend his nights in the open, sleeping in a broken wagon or a haystack, sometimes in the rain. According to his letter, it was on his return, when he was at the end of his strength, that his energies revived and he made the decision to take up his pencil. This is psychologically very convincing, except for the detail that his visit to Courrières took place in January 1880, while his announcement to Theo was made only in the following September. He had started writing to Theo again in July, so his delay in proclaiming his 'conversion' to art is rather odd, unless it was a more gradual or hesitant process than he cared to admit.

Theo's response was encouraging. He was already making Vincent an allowance out of his income and would do so until Vincent's death. Now he sent drawing materials and prints by favourite artists, such as Millet, for his brother to copy. Tersteeg, Van Gogh's chief during his time with Goupil's at The Hague, also rallied round, sending him books on anatomy and perspective. Van Gogh found them very dry, but worked away at them persistently, rather in contrast to his way with Greek verbs. Although he had drawn much before (often, for example at Laeken, having to give it up as too much of a distraction), he felt that he was making an entirely new start. By September he was in 'a rage of work', sketching peasants, weavers and miners. His immediate ambition was a modest, practical one that would not entail years of study: to become a book and magazine illustrator, like the English black-and-white artists he admired so much. This would enable him to earn a living quite soon, while giving him opportunities to tackle the contemporary scenes and social issues that were so important to him.

He worked on for a while at the Borinage, but despite his new-found vocation his circumstances remained depressing. He was lodging with a mining family, sharing the bedroom with the children. During the good weather he could draw in the open air, but the prospect of a solitary but noisy winter must have been daunting. In October 1880, assisted as usual by Theo, he left for Brussels, where he met an artist named van Rappard, five years his junior, who allowed him to use his studio for a time; Van Gogh and Rappard remained friends and correspondents for the next five years. On Rappard's suggestion he enrolled at the free drawing class of the Academy of Fine Arts, although there is no record of his actual attendance. In any case his stay in Brussels was brief: the city was expensive (the small hotel where he lived cost 50 out of the 60 francs on which he was supposed to live each month) and

after a hard winter in the city he was ready to move on. In April 1881, having made peace with his parents, he returned once more to Etten.

Kee

Initially Van Gogh came to Etten in a conciliatory frame of mind, prepared to dress and behave conventionally for the sake of his father's reputation. The first few weeks were uneventful and productive. Theo was there for a short stay when he arrived. Later van Rappard visited for a fortnight; the two artists went for long walks and worked side by side in the fields. Van Gogh continued to study drawing with great intensity, sketching at all hours and earning a reputation among the local people as a harmless eccentric.

Then the Van Goghs had a visitor: Kee Vos, the daughter of Vincent's Stricker uncle and aunt, whom he had got to know during his painful student days in Amsterdam. Vos had died in 1878 and Kee was now a widow in her mid-thirties with a four-year-old son. Van Gogh, recovered from the rigours of the Borinage, was a young man who needed a woman, and everything about Kee was designed to make him fall in love with her; he seems hardly to have asked himself whether the reverse was true. He was always attracted to older women and responded more urgently to an appearance of toil or suffering than to conventional beauty. Even the presence of a child – a ready-made family – appealed to his impatient nature when he became gripped by the idea of settling down.

Kee appears to have unwittingly encouraged Vincent by accompanying him on some of his drawing trips into the countryside, although she always brought the child with her. But his sudden proposal seems to have taken her thoroughly aback, just as it had Eugénie Loyer; evidently Van Gogh never had the air of an eligible bachelor. Kee excused herself in kindly fashion, intimating that she was in permanent mourning for her husband. When Van Gogh pressed her, she told him 'No, never, never'. She cut short her visit and returned to the Strickers at Amsterdam.

Van Gogh was not willing to accept her answer, even when his letters were returned unopened. There followed one of those sensational incidents that have made Van Gogh's biography seem like the stuff of fiction, and consequently a gift to novelists and movie-makers. He went to Amsterdam in pursuit of Kee (he had to borrow the rail fare from Theo) and called on the Strickers. They were embarrassed rather than outraged by his presence and persistence; Vincent was, after all, their nephew. Although Kee had

fled before he was allowed into the dining room, he continued to ask for her, placing his hand in the flame of a lamp and pleading to speak to her only for so long as he could bear to keep it there. This grand gesture, worthy of Dickens or Victor Hugo, certainly alarmed the old couple, but the only thing that happened was that the Rev. Stricker blew out the flame, tried to calm Van Gogh down and helped him to find lodgings for the night. After lingering in Amsterdam for two days, hoping for a miracle, Van Gogh returned to Etten via The Hague, where he found a little temporary comfort in the company of a woman of the streets. He did not give up hope at once, but he never saw Kee again.

This episode caused a rapid deterioration in Van Gogh's relations with his parents. At least that is how it appears from his letter to Theo, in which he represents his father as unhelpful and narrowly concerned with keeping up appearances and avoiding a breach with the Strickers. On the other hand, it may have suited Van Gogh to see things in this light and dismiss his father's complaints about his unconventional behaviour as a side issue. When their mutual irritation came out into the open, the subject was not Kee but the even more fraught one of religion. Van Gogh's experiences with the 'evangelical gentlemen' in the Borinage had made him detest organized Christianity, and everything we know about him suggests that he would not have managed to keep his feelings entirely to himself. Finally, on Christmas Day, he refused to be 'forced' to go to church, telling his father that he had attended regularly until then only as a matter of courtesy. As the argument developed into an outright quarrel, he denounced as 'horrible' the 'whole system' of institutional Christianity – which, of course, his father had made it his life's work to serve. Pastor Theodorus ordered his son to leave the house and, according to Van Gogh's account (possibly exaggerated), he did so that very day.

No doubt Van Gogh's ideas and way of life were bound to shock his parents sooner or later, but his behaviour on this occasion can hardly be defended. It shows him at his very worst, sensitive and touchy where his own emotions were concerned, yet too absorbed in his own inner drama to think of anyone else's feelings. Although the scene at Etten was an extreme example, it was part of a pattern in that he eventually quarrelled with everybody who came close to him except Theo, and even their relations were often volatile. The quarrels and the consuming loneliness from which he suffered were also part of the price of his unworldly, inner-directed genius.

OVERLEAF
PAGES 46-7:
The Allotments
1887
RIJKSMUSEUM
VINCENT VAN
GOGH,
AMSTERDAM

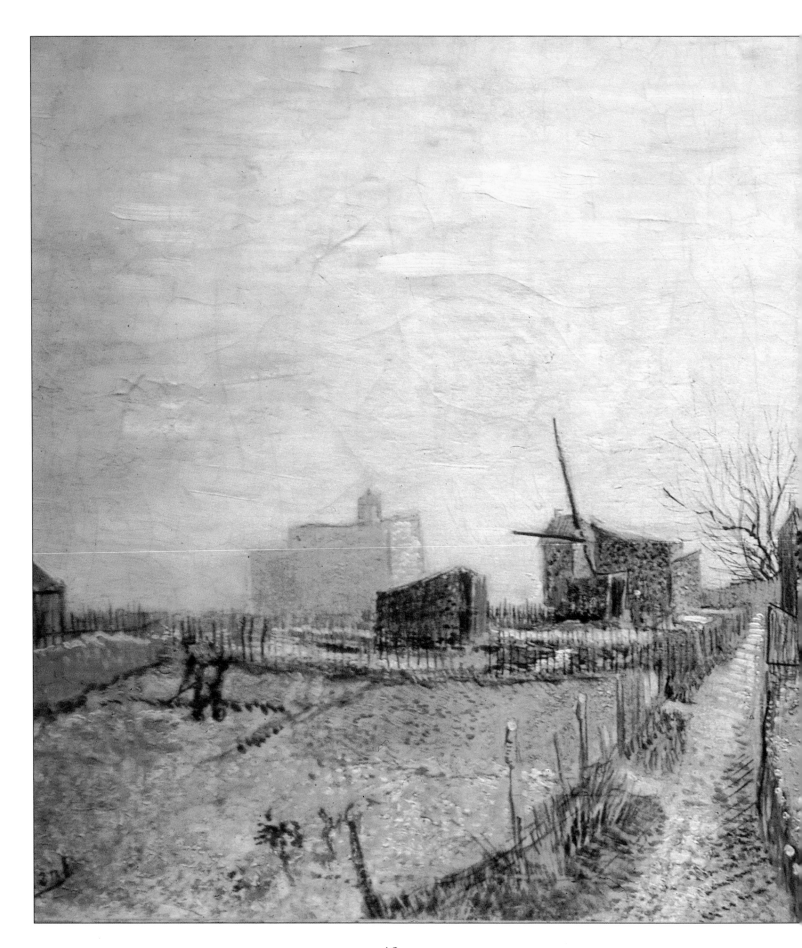

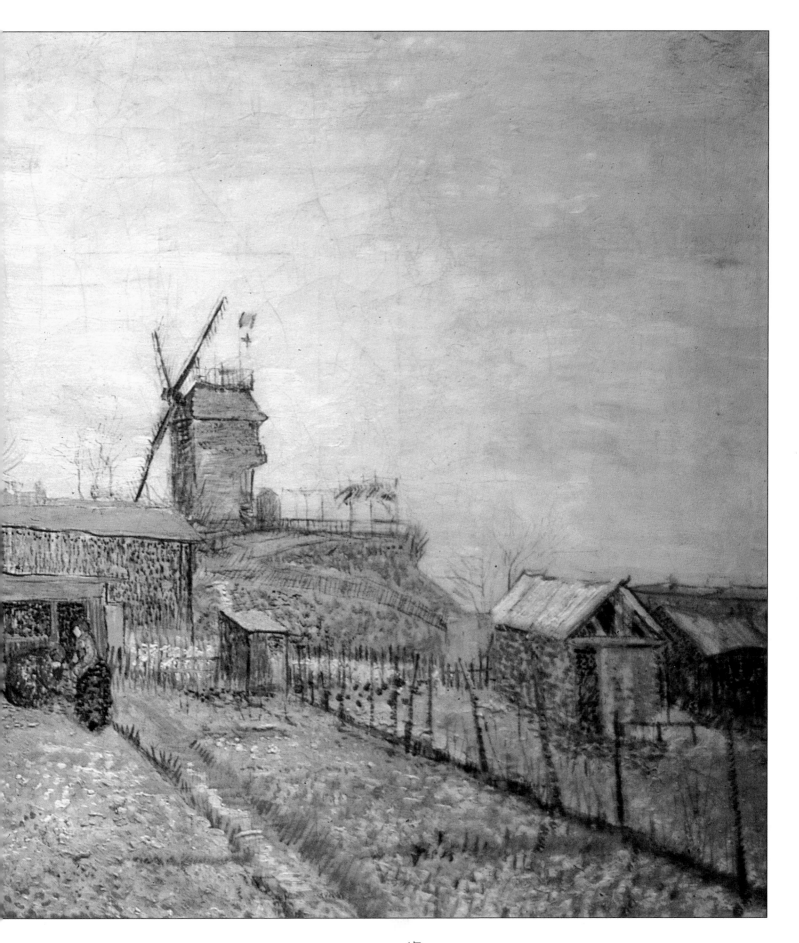

Fortunately, in the course of the year he had made useful contacts at The Hague, and he had moved there by the beginning of 1882. Even after quarrelling with his nearest relatives, the family connection stood him in good stead. One of his contacts was his cousin by marriage, Anton Mauve (1838–88), at that time one of Holland's best-known painters. He had already shown himself a generous friend, and when Van Gogh turned up at The Hague, Mauve helped him to find accommodation, lent him money and presented him with art materials. He also gave some lessons to Van Gogh, who seems to have been very demanding of the older painter's attention; but when Mauve set him to draw from plaster casts of classical statuary, there was trouble. Exercises of this kind were an accepted part of the curriculum in all the teaching academies of Europe and America, but Van Gogh insisted that he could work only from live models and actually smashed the casts. Needless to say, his relations with Mauve were cool for a while after this incident and they continued to fluctuate all through Van Gogh's stay at The Hague. However, the faults were not all on one side; Mauve himself is known to have been an eccentric and highly strung individual, encouraging one day and damning the next.

Van Gogh was also helped by his ex-boss Tersteeg; and in February 1882 his 'Uncle Cor' – yet another art-dealing Van Gogh – ordered a set of small pen drawings of The Hague from a wildly excited Vincent. But it was not long before these benefactors also began to look askance at him.

Van Gogh was undoubtedly hard to get on with for any length of time, but Mauve and the others may also have been alienated by rumours about his private life. Soon after arriving, he took up with a part-time streetwalker named Clasina Marina Hoornick, who may have been the woman who had consoled him a few weeks earlier in the wake of his futile visit to the Strickers in Amsterdam. Clasina, whom Van Gogh called Sien, had a daughter of five and was three months pregnant. Three years older than Van Gogh, pock-marked, bony and worn, she aroused the compassion that seems to have been an important element in his sexual make-up. On a more prosaic level, his finances and personal difficulties made it unlikely that he could find sexual satisfaction elsewhere. However, there is no doubt that Van Gogh did respect the sufferings of women forced into prostitution, as well as romanticizing them in a fashion not uncommon among nineteenth-century artists and writers.

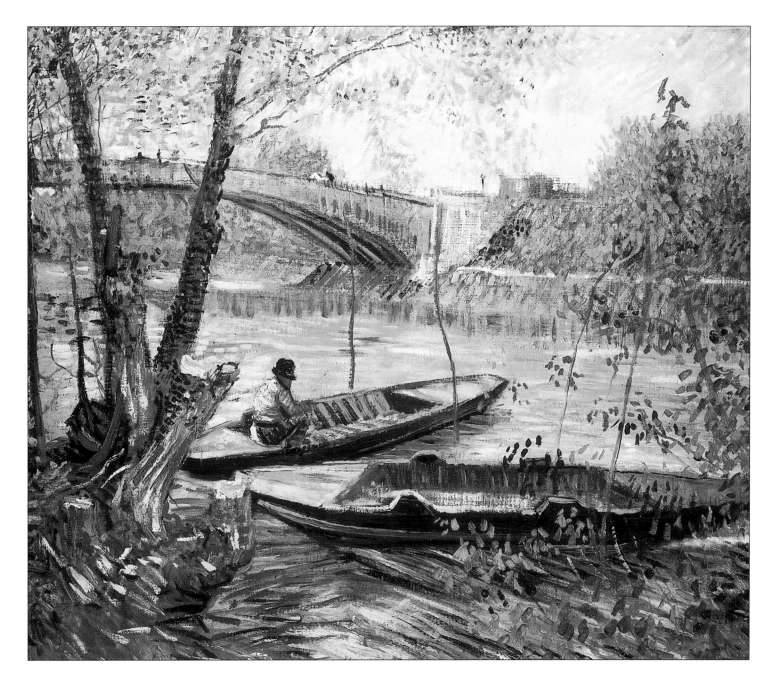

He soon took Sien and her daughter to live with him. This was a drastic decision, for none of his previous adventures could have cut him off from respectable society so thoroughly as his cohabitation with a 'fallen woman'. The Hague was a small town, provincial and puritanical, where such irregularities could not be concealed for long; even its artists were, or appeared to be, thoroughly respectable. When Van Gogh met Mauve on the sand dunes outside the town, Mauve refused to renew their relationship and ended by saying 'You have a vicious character', which was presumably a reference to his domestic arrangements. Tersteeg visited him, saw the woman and child, and denounced him as insane. He evidently

49

RIGHT: **Portrait of Alexander Reid** 1887
GLASGOW ART GALLERY AND MUSEUM

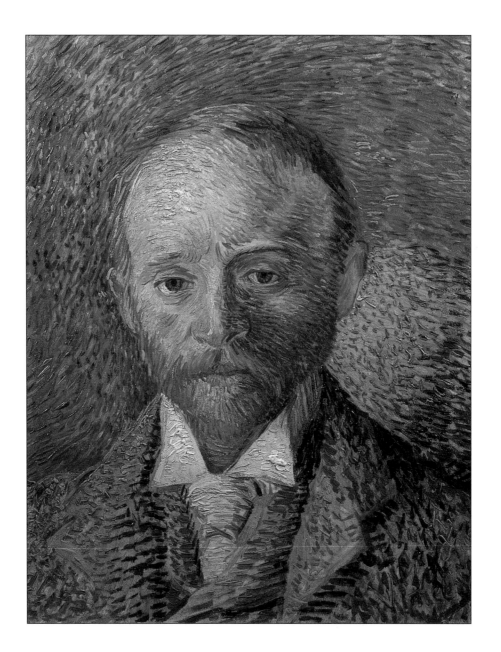

echoed the view of Van Gogh's father, who spoke of having him committed to an asylum; whether or not the threat was serious, Van Gogh never forgot or really forgave it. To Theodorus Van Gogh, his son's evolution from evangelist to free-thinking sinner must have seemed like a form of madness. He could not know that his son had found comfort with prostitutes much earlier, having held distinctly unorthodox ideas about the sins of the flesh even during his most pious phase.

Theo did know, but it was still several months before Vincent dared to tell him about the current situation. By this time Theo was an experienced Parisian; he was not shocked, only adamant that his brother should not marry Sien, as Vincent threatened to do, more to express his defiance of society than out of any real

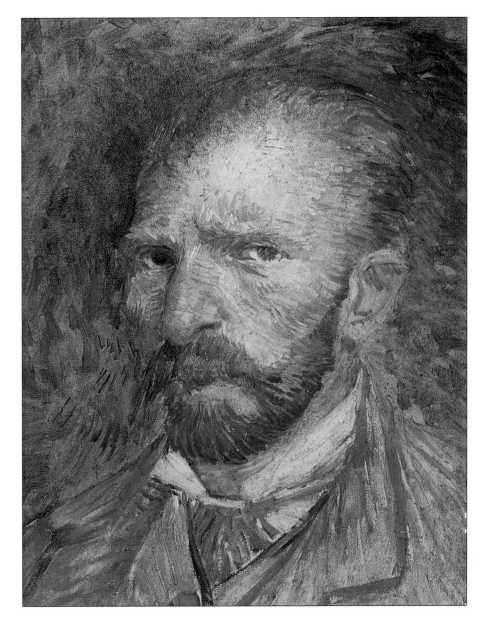

LEFT:
Self- Portrait
1887
RIJKSMUSEUM
KRÖLLER-MÜLLER,
OTTERLO

conviction that they could be happy together.

The vicissitudes of the summer failed to shake Van Gogh's attachment to Sien. In June she gave birth to a boy at Leiden, while he had to spend three weeks in a hospital at The Hague, being treated for a venereal infection that he had presumably caught from her. It took him several months to recover properly, but whether his ailments over the next few years were the result of the infection, his privations in the Borinage, or a combination of both cannot be determined with any certainty. One positive outcome of the experience was that Theodorus van Gogh visited him in hospital and father and son were reconciled. The pastor brought him gifts and even put a hat and coat for Sien in a subsequent parcel.

Reunited, Vincent and Sien found a larger studio to live in

and things looked promising. Vincent was delighted with the baby and maternity softened Sien, at least for the time being. Meanwhile, except when he was forced to rest in the hospital, Van Gogh drove himself hard, making drawings and watercolours. He was still intent upon moving hearts and consciences by his work, drawing pensioners from the almshouses and typical city sights including the crowds Outside the State Lottery Office (pages 8-9); during moments of ambition he dreamed of turning his studio into a place of refuge where unfortunates might simultaneously find shelter and serve as models for him.

Although the ordinary people he portrayed cannot have charged much, he often had difficulty in paying. Fortunately he now had free models at home. Some of Van Gogh's most effective early drawings were of Sien, who learned with difficulty to pose. Often, although not yet executed with assured mastery, they convey a stark emotion that inspires respect. This is particularly true of *Sorrow* (page11), a drawing in which a naked woman sits on a stone, with her knees drawn up and her head buried in her crossed arms. Her figure is drawn with some originality, for in representing her straggling hair, dug-like breasts and slack belly Van Gogh made no concessions to the established European tradition of the nude, who was normally shown as beautiful and, more often than not, sensual and inviting too. He incorporated into the picture a quotation from one of his favourite authors, the French historian Jules Michelet: 'How can it be that there is on earth a woman alone, forsaken?' Van Gogh was quite certainly thinking of Sien, pregnant and deserted, but the title and quotation make it clear that he was also striving to convey a more nearly universal message.

A Painter at Last

Until August 1882 Van Gogh concentrated on drawing, sometimes heightening the effect with touches of colour. When he painted, it was usually in watercolours. Although watercolour was a fine, delicate art in its own right, oil painting was recognized as the principal medium for ambitious or monumental works. Its technique was difficult to master, but in compensation it was highly flexible, allowing the painter to rework unsatisfactory passages, to render fine details and also to achieve a variety of surface effects through the thickness of the paint and the patterning of the brushwork. So in view of the importance that brilliant colour and thick, textured paint surfaces

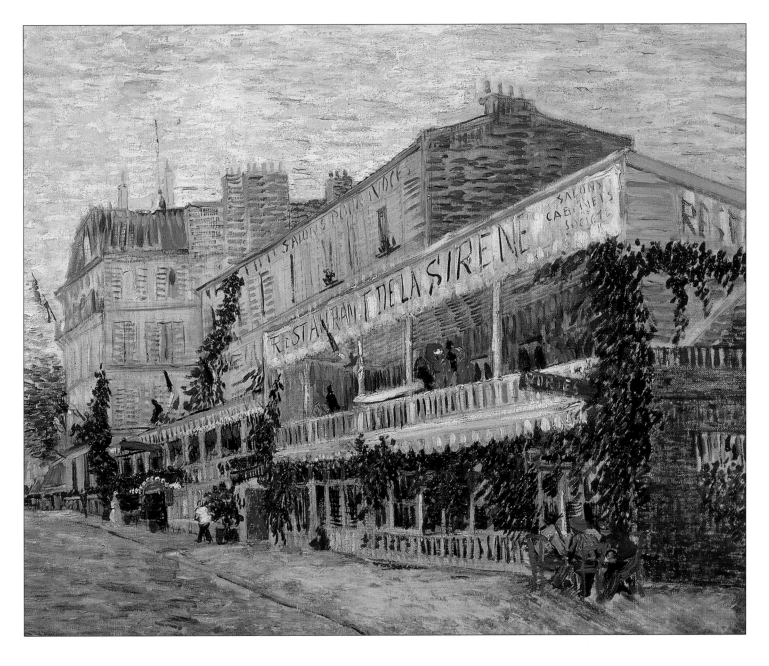

were to have in Van Gogh's mature work, it is astonishing that he should have held off for so long from experimenting in oils. Anton Mauve had even sent him the necessary equipment while he was at Etten, but Van Gogh seems not to have used it except for a couple of dark still lifes showing everyday objects. To judge by his later remarks, he felt that he was simply not ready.

Suddenly, in the summer of 1882, he became ready. In July he told Theo that he had 'made a new start with watercolours'. This was followed in August by a series of pictures in oils, mainly of woodlands or the dunes and beaches on the nearby coast at Scheveningen. There was no doubt about his sense of release: 'painting is such a joy to me', he told Theo, exulting in the fact

ABOVE: **The Restaurant de la Sirène, Asnières**
1887
MUSÉE D'ORSAY, PARIS

that his first efforts did not look like the work of a beginner. What he said was true, but he was also writing quite deliberately in a positive vein in order to retain or enlarge his brother's support. Painting would inevitably entail more expense than drawing, increasing the burden on Theo, who might reasonably have proposed that Vincent should stick to his original intention of becoming a black-and-white artist. So for some time to come Vincent described his progress and angled his letter-writing in such a way that Theo himself would be put in the position of 'deciding' that the painting should go on. Although he lamented his dependence on his brother, Van Gogh was not above manipulating him, even if it was the kind of manipulation that a child might practise on parents; by this time Vincent and Theo had reversed their conventional roles and it was Vincent who looked for approval, as well as financial support, from his wise, understanding and generous 'older brother'.

The early paintings by Van Gogh that have survived are dark in tone, in line with orthodox nineteenth-century practice. Although the French Impressionists had been using brighter colours since the 1860s, they had not yet won acceptance even in their own country. In Holland, the painters of The Hague School, who included Anton Mauve, had only recently digested the work of earlier French artists such as Camille Corot (1796–1875) and the painters of the Barbizon School, who had revived the art of the landscape. Van Gogh took up the Corot-Barbizon practice of working directly from nature, setting up his easel on the beach or in the woods. In a picture such as *Girl in White in the Woods* (pages 12-13), he used (or perhaps re-invented) one of Corot's pictorial tricks, putting in a point of bright colour to vivify an otherwise low-key scene. An interesting feature of this work, even more apparent in *The Beach at Scheveningen* (pages 14-15), is the freedom with which Van Gogh has handled the paint. We know from his letters that he squeezed it straight from the tube on to the canvas, modelling it into shape. Paint this thick (known as impasto) brought the surface of the picture to life and gave a three-dimensional quality to the scene, very much in contrast to the prevailing convention, which was that a canvas should have a smooth finish with no visible brushmarks, so that it appeared to be a window pane through which the painted scene could be viewed.

Only a dozen or so paintings by Van Gogh survive from the first nine months of 1883, most of them rural landscapes and farm pictures. He was not yet such a master of his medium that he could

make these prosaic subjects as interesting as his woodland and beach scenes, but in a painting of a cow he did very effectively capture the tangled hair and solemn bulk of the creature, and his *Bulb Fields* was pretty and colourful. During this period of low production his letters were filled with detailed, enthusiastic descriptions of landscapes – which suggests that he was often unable to put them on to canvas, either because of the technical difficulty or, more likely, because he lacked the resources to go on working. The extra expense of oil painting clearly unbalanced Van Gogh's precarious budget and created a situation in which the harder he worked the poorer he (and his surrogate family) became. Unable to sell his efforts, he had to stop painting for long periods for lack of resources, and in any case hunger undermined his will to achieve.

Drenthe

In these circumstances the deterioration in Van Gogh's domestic situation during 1883 is hardly surprising. He was reluctant to admit that all was not well and, right to the end, insisted that he and Sien were attached to each other even if they could not hope to be happy together. However, the way in which he began to refer to her, sympathetically, as 'the woman' suggests that conscience and compassion had a stronger hold on him than affection for Sien as an individual. In any case, her lack of interest in art and literature, her foul mouth, lethargy and fits of vague discontent made her difficult to live with (though possibly no more so than Van Gogh). Probably the most important fact was that, physical companionship aside, Van Gogh was as isolated as ever, with no one to reveal his thoughts to except his brother in Paris. At the same time his 'family' was a burden for an artist who was still incapable of supporting himself; and while he felt an increasing impulse to quit the city, if only because it was so expensive, he also realized that Sien would be bored and miserable in the country.

Urged on by Theo and conscious that, at 30, he must strive to reach artistic maturity soon, he finally brought himself to leave Sien, making the best of things by telling himself (and her) that he had at least rescued her from a desperate situation, and that she would now be able to fend for herself. With unusual realism he told her 'Perhaps you will not be able to stay quite straight, but go as straight as possible.' His feelings of guilt lingered for months, and for a time he would burst into tears whenever he

saw a woman carrying a small child.

Having left The Hague, Van Gogh travelled to Drenthe, a province in the north-east of Holland whose bleak fenland landscape had already attracted Mauve and other painters. Van Gogh settled in the village of Hoogevenn, and at first was full of enthusiasm, writing to Theo that 'everything is beautiful here'. After the city, it was like returning to a simpler, more elemental way of life; but this was not necessarily the best environment for a poor painter with a guilty conscience. Thoughts of Sien and the children – especially 'his' little boy – haunted Van Gogh and he soon became a prey to depression. His paintings of peat gatherers suggest the hostile nature of the landscape. In *Peasant Women in* a *Peat Field* and other works, the figures are seen in the anonymity of silhouette, as though the huge, oppressive skies had bent their backs and worn away every trace of individuality from them.

Disturbed by Vincent's despondency, Theo invited his brother to join him in Paris. Vincent responded by suggesting that Theo should throw up his job, become an artist and join him in Drenthe. Once the idea had occurred to him, he clung to it for a long time, attempting to brush aside Theo's refusals. By now he had become convinced that being an artist had a special moral value – or, to put it baldly, art had become Van Gogh's religion. His commitment to it was as extreme as it had been to Christian service, and the evangelist in him was by no means dead.

The scheme to recruit his brother owed more to faith than to reason, since two destitute Van Goghs (with no Theo to help them out) were not likely to survive for very long. However sincere Vincent may have been on one level, there were important secondary motivations for his insistence, connected with his suppressed resentment of the role reversal described a little earlier. If Theo had agreed to make a fresh start as a painter, Vincent would have been able to play the older brother again, giving advice instead of receiving it. Moreover, whatever the outcome of his scheme, by making the case in the way that he did, Vincent was effectively claiming that he was superior to his brother by virtue of being an artist. Naturally Vincent convinced himself only part of the time, and later on, despite Theo's tact, he would sometimes break out in anger against his brother's 'financial power'.

Meanwhile, as the nights drew in at Drenthe, Van Gogh found his loneliness unbearable. Before the end of the year he left to stay with his parents again, this time at his father's new parish at Nuenen.

RIGHT:
Self-portrait with a Straw Hat 1887 DETROIT INSTITUTE OF ARTS

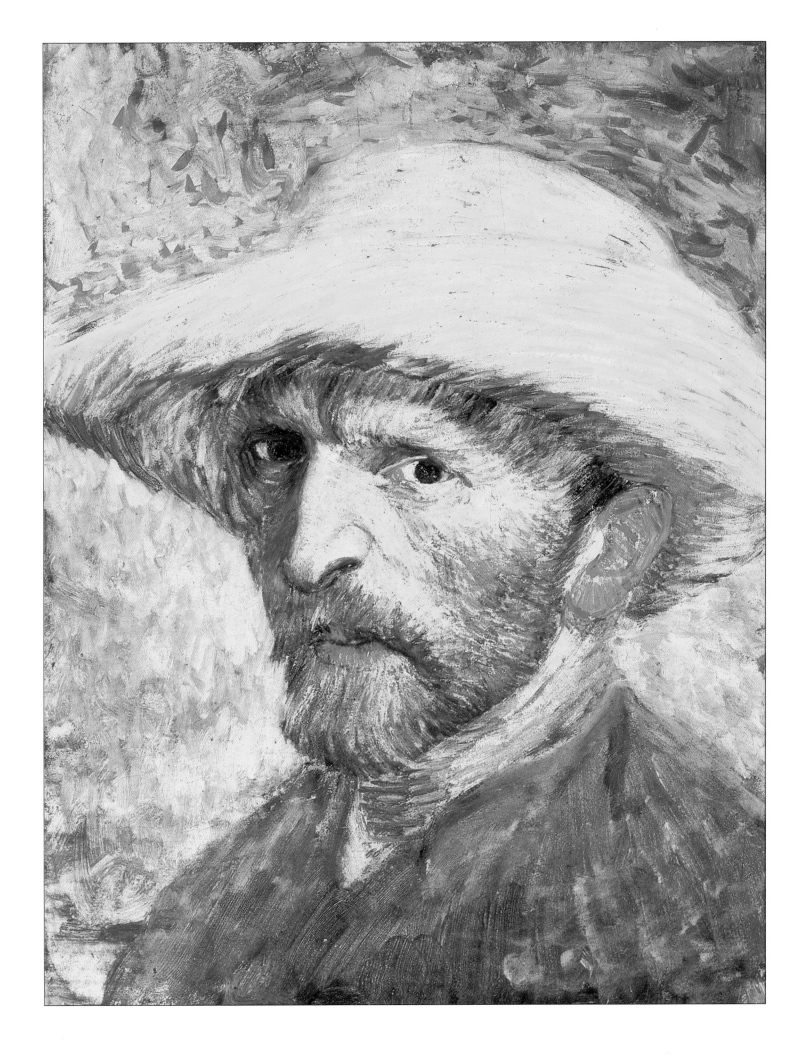

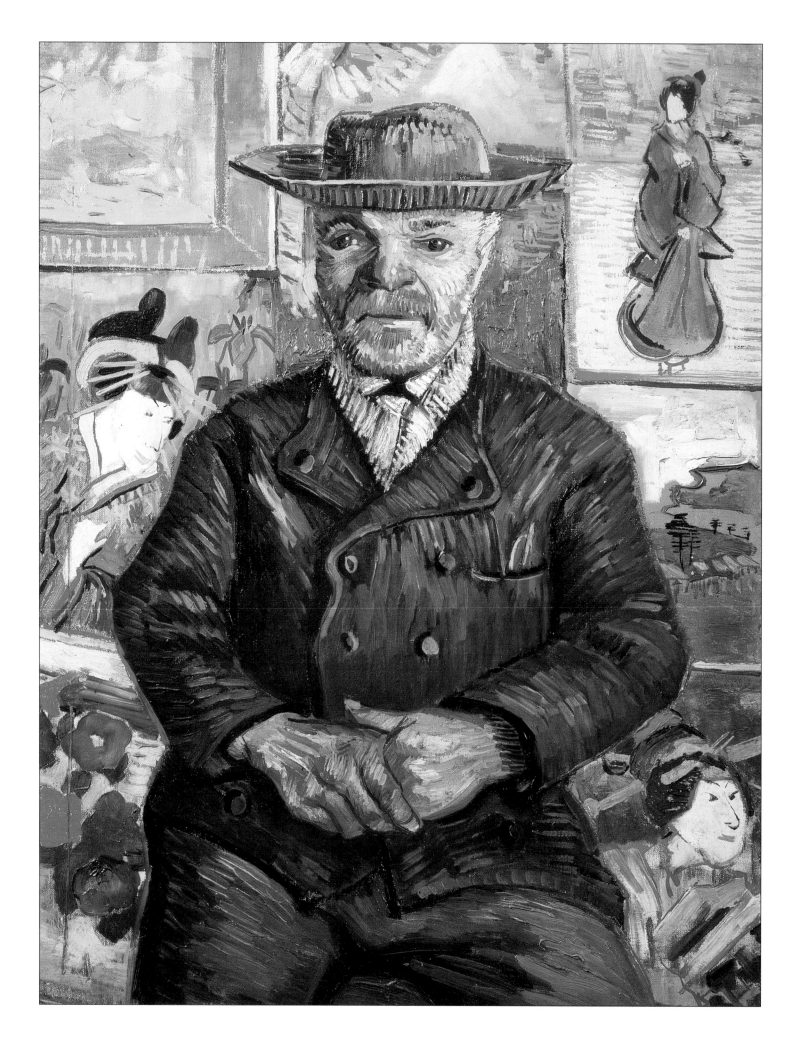

Nuenen and Antwerp

uenen was smaller than Etten, and in December 1883 it must have seemed unlikely that Van Gogh would spend almost two years there, in close proximity to his family. His parents put themselves out to understand and come to terms with their prodigal son, even repairing an old shed that had been used for laundering so that Vincent could have a private studio outside the parsonage. Relations remained uneasy and he was soon complaining to Theo that 'the welcome home was in every respect kind and cordial, but at bottom there is not the least change in what I must call their blindness to, and their total lack of understanding of, the relations between us.'

Evidently it never occurred to Van Gogh that a couple in their sixties were not likely to change their ideas radically, or that the onus of maintaining satisfactory relations might lie with him. In many ways he was at his most unreasonable in his dealings with his family, blaming his father for corrupting Theo by encouraging his business career, and blaming Theo alternately for remaining a businessman and for not pushing Vincent's paintings energetically

LEFT: **Portrait of Père Tanguy**
1887
PRIVATE
COLLECTION

enough. In calmer moments he recognized how much he owed Theo (and not just financially), and in February 1884 he began to pay Theo for his regular subsidies by sending him paintings. Soon he was sending all his paintings to Paris, declaring that everything he created was in reality a joint effort, for which Theo deserved at least half of the credit.

Margot

Nonetheless there were a number of emotional ups and downs during the Nuenen period. As always, Van Gogh was at his best when people were in trouble, and when his mother fractured her leg alighting from a train, he looked after her devotedly and made drawings of the church at Nuenen especially for her.

However, he was soon involved in drama and scandal again, although for once they were not entirely of his own making. Unmarried and in her forties, Margot Begemann was a neighbour of the Van Goghs. Her family situation, with a domineering father and older sisters who were also unmarried, explains much of her behaviour. She probably got to know Vincent when she visited his convalescent mother, and she soon began going out with him when he set off to paint in the countryside. She fell in love with him and declared herself; his response seems to have been ambiguous, but it was not an outright rejection and evidently the possibility of marriage was mentioned.

It is easy to understand the dismay of Vincent's parents, who knew that he was incapable of supporting a wife. In fact, both families opposed the match. Harsh things were said about Vincent by Margot's parents and she responded by taking poison; fortunately a local doctor pumped out her stomach and saved her life. Van Gogh's comments on the affair (as usual, made in his letters to Theo) are oddly aloof, as though it was all a sad business that had very little to do with him. He claimed that Margot had already tried to poison herself once (he had forced her to stick her finger down her throat) and that he had warned her family to treat her more circumspectly. Their only response had been to tell him he must wait two years before there could be any question of marriage – to which Van Gogh replied that if there was to be a marriage, it must be soon or not at all: hardly the attitude of an ardent lover. Of Margot herself, he remarked that it was a pity he had not met her ten years earlier, before she was 'spoiled' – though of course, he added, she was still of great value. Altogether it

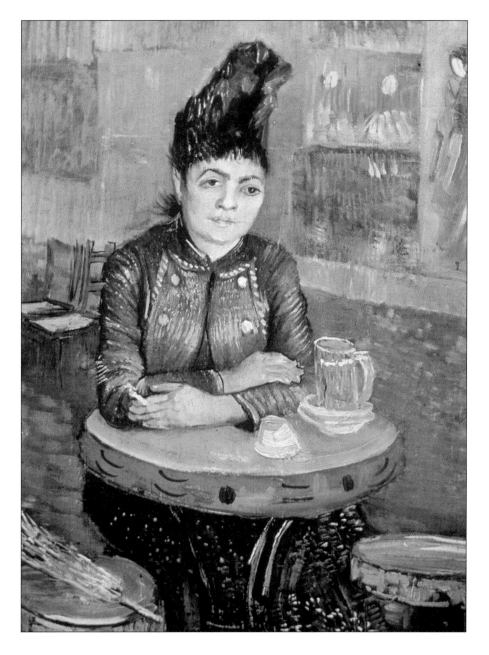

sounds as though Van Gogh had allowed himself to drift into a commitment that was not really welcome. If so, Margot's suicide attempt resolved the situation, ensuring that the 'lovers' would be separated when she was sent to Utrecht to recover.

In spite of these distractions, Van Gogh worked as hard as ever. His drawing showed astonishing progress. Whereas he had previously managed to express powerful feelings and ideas despite some uncertainty of touch, he now began to create strongly modelled forms, executed with great assurance. His studies of peasants at work caught the combination of physical effort and practised skill with which tasks were carried out, while his landscapes became more integrated and atmospheric. Among the most

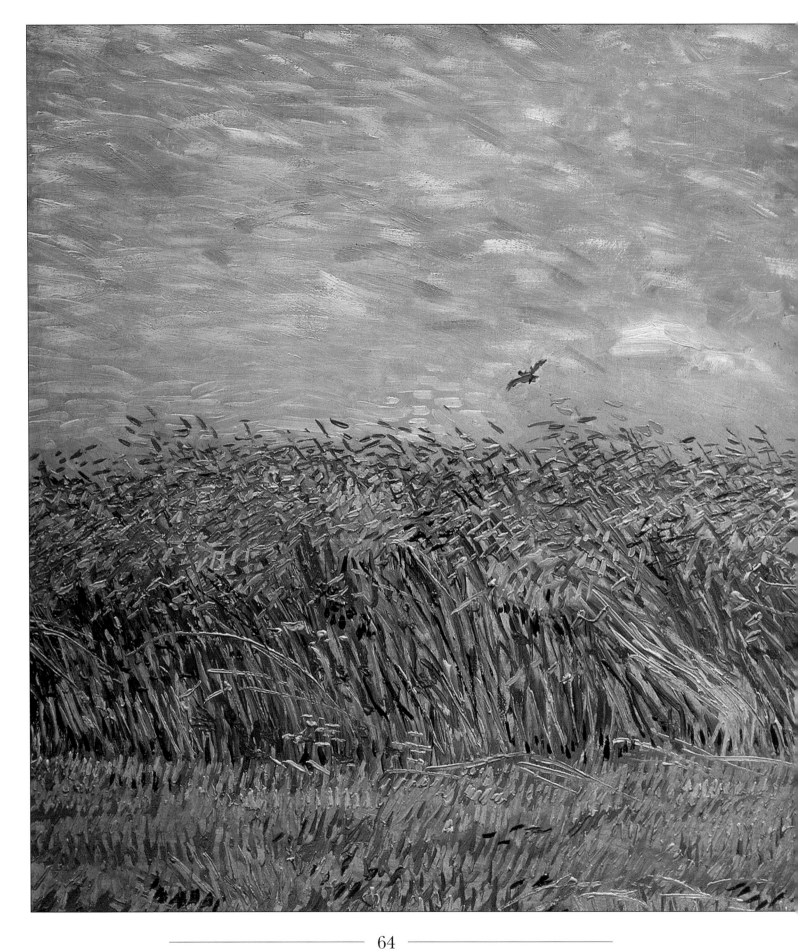

gripping are views of the parsonage garden which anticipate his expressive later manner. In one well-known drawing the dark figure of a woman and the long, bare tree branches, apparently reaching out, create a hauntingly sinister effect. He had not yet achieved this kind of mastery at painting, or alternatively was preoccupied with rather different effects, as in *The Parsonage Garden at Neunen in the Snow* (page16), where the wider view, with the church tower in the distance against a bright sky, creates a more tranquil atmosphere. The church tower, incidentally, was not Pastor Van Gogh's church, but all that remained of an older building which Vincent found pictorially (and perhaps symbolically) more rewarding.

More typical of this period was the large group of drawings, watercolours and oil paintings showing weavers working in their homes. In *Weaver: the Whole Loom, Facing Right* (pages 18-19), and others like it, the weaver has the air of a prisoner, caged within the contraption that gave him his poor livelihood, or even in danger of being devoured by it. Coincidentally or otherwise, weaving was in fact a declining craft and the people Van Gogh drew and painted were experiencing ever-greater hardship.

In March 1885 Theodorus van Gogh was struck down without warning by a stroke, collapsed, and died. The removal of this authority figure occasioned surprisingly little comment in Vincent's letters, which were full of his plans for the work that became *The Potato Eaters* (pages 20-1). But at some time over the next few months he painted *Still Life with Bible* (pages 22-3), which juxtaposes a big, leather-bound Bible, open at a passage from Isaiah, and a tattered paperback copy of Emile Zola's novel *La Joie de Vivre* ('The Joy of Life', 1884). Not everyone accepts that his intentions were symbolic in this painting, but it seems quite certain that Van Gogh, a passionate reader and a conscious, literary-minded artist, meant to bring about a confrontation between his father's mental world and his own. The Bible was, of course, the Pastor's guide and ultimate source of authority; the connection is reinforced by the presence of the snuffed-out candle, a traditional symbol of mortality. By contrast, Zola's books were utterly modern and, because of the brutal naturalism of his descriptions, controversial. They were among Van Gogh's great enthusiasms, almost incomprehensible to the Pastor and conventionally pious people of his generation. The passage from Isaiah speaks of suffering and promises redemption; in *La Joie de Vivre* the redemption is ever-present in the unconquerable vitality

and love of life that carries the principal character through all her misfortunes. Van Gogh is surely taking leave of Biblical certainties, represented by the central, secure position of the Good Book, and signalling his reliance on his own resources, however precarious (the novel is, literally, 'close to the edge').

The Potato Eaters

In 1885 Van Gogh's stay in Nuenen moved towards its artistic climax. Over the winter of 1884–5 he made a long series of peasant portraits, emphasizing the large, coarse features and work-and-weather-worn skins of the men and women, who are seen from every angle from full-face to profile. He also made studies of individual features such as hands, and of lamplit interiors. All this was done with a view to painting *The Potato Eaters* (pages 20-1), which Van Gogh continued to regard as his most significant work for at least a couple of years afterwards. Its importance to him is shown by the attention he paid to the preliminaries, since he usually preferred to attack and finish a painting in a single long session; he had, for example, done this in the case of *Still Life with Bible*. *The Potato Eaters* was done in the studio (not in a peasant's house) from preliminary studies, in the approved academic manner, although the result was unlike anything produced by academic – or any other – painters.

Van Gogh's aim was to outdo even the artist he most admired, Millet, in the realism with which he represented the lives of those who toiled on the land. The five members of a family are seated round a table on which dinner is about to be served. The younger woman on the left is organizing a dish of steaming potatoes into portions, while the other woman pours coffee into cups. A lamp casts a dim light on the scene, hardly showing up items beyond the table such as the clock, the religious picture and the stored utensils on the walls. The peasants' dark skins, on which the bones and protuberances are highlighted in yellow, emphasize their brutalization; interestingly, this element is much stronger in the finished painting than in the final large study or the lithograph that Van Gogh also made of the subject. The hands are as important as the faces in the picture and as powerful and unlovely. The grotesque aspect of the potato-eaters, although perhaps quite accurately recorded, now makes the painting look something of a caricature. But there is no doubt of the serious purpose that Van Gogh intended it to serve: 'I have tried to emphasize that these people, eating

their potatoes in the lamplight, have dug the earth with those very hands they put into the dish, and so it speaks of manual labour and the way in which they have earned their food'. He was certain that he had created a masterpiece at last, and when his friend Van Rappard severely criticized the lithograph version he had been sent, Van Gogh was outraged and ended their five-year friendship.

Having finished *The Potato Eaters* in May, Van Gogh continued to paint peasant life, taking as his subjects men and women digging (page 31) and the crooked thatched cottages in which they lived. Soon after his father's death he had quarrelled with his sister Anna and moved out to a studio he had set up in the local sexton's house. He showed no immediate urge to leave Nuenen, although even his family were now there only on sufferance

ABOVE:
Woods and Undergrowth
1887
RIJKSMUSEUM
VINCENT VAN
GOGH,
AMSTERDAM

ABOVE: **Four Sunflowers** 1887
RIJKSMUSEUM
KRÖLLER-MÜLLER,
OTTERLO

(Vincent's mother had been given a year's grace before she would have to leave the parsonage to make way for Theodorus' successor).

He was slightly less isolated than he had often been in the past, since he was giving lessons to several amateur artists. Most of them lived in the nearby town of Eindhoven, which Van Gogh visited from time to time in order to buy painting materials. He also took a few piano lessons from the Eindhoven church organist, having formed a conviction that colours and sounds were closely related. This was a commonly held belief among late nineteenth-century artists, but the organist was alarmed by Van Gogh's habit of breaking off to discourse on the relationship between Prussian blue and a given note and, fearing that he was teaching a

dangerous lunatic, discontinued the lessons.

Van Gogh's own activities as a teacher seem to have been unpaid, and the only commission he received in his entire career brought him nothing. This was from one of his students, a retired goldsmith named Hermans who had made a great deal of money as an antiques dealer. Wishing to decorate his dining room, he asked Van Gogh to paint a series of canvases which Hermans could copy on to panels. The work was carried out, but for some reason Hermans never paid up.

Such incidents were typical and inevitable, given Van Gogh's indifference to money: he probably never pressed Hermans for payment or, if the paintings in question failed to satisfy, refrained from asking for anything in return for his work. Similarly, when he painted a picture for another Eindhoven pupil, it looked so fine on the wall that Van Gogh decided not to sell it, but instead made his friend a present of it.

Reminiscences of Vincent

In this instance the friend was a tanner named Anton Kerssemakers, who has left a convincing account of what Van Gogh was like at this time. Kerssemakers was introduced to him at the local paint shop and went to see his work at Nuenen. His studio was a chaotic place, filled with all sorts of bric-a-brac – birds' nests and clogs for his still lifes, farm tools, a spinning wheel, caps, hats, bonnets, sketches and magazines, all heaped up on makeshift cupboard shelves and benches. Kerssemakers disliked Van Gogh's work on sight, and made a mental decision that the artist would not be a suitable teacher for him; but he found that what he had seen stuck in his mind and would not go away. He began to appreciate Van Gogh's work and the two men became friends. Van Gogh proved a demanding teacher, but an encouraging one when Kerssemakers (who was seven years older) became despondent and felt that he had started painting too late to get anywhere.

Van Gogh was already, by Dutch standards, a wildly eccentric figure, sporting a fur hat and shaggy coat. (The fur hat is still in evidence in a late self-portrait, page 154). He lived on dry bread and cheese, even refusing better fare when Kerssemakers offered it; his diet probably accounts for the fact that he had already lost a number of his teeth. His one luxury was a flask of brandy which accompanied him on painting expeditions, probably quite a sensible measure for a man who spent all day at work in the open.

Apparently indifferent to other people's opinions, he would suddenly squat and use his fingers to 'frame' a scene that appealed to him.

He also often used a home-made perspective frame, which was basically a rectangular grid on a pointed pole that could be stuck in the ground. Linear perspective is a study based on the fact that parallel lines appear to meet on the horizon; artists exploit this phenomenon to give an illusion of depth (three dimensions) to drawings or paintings, which actually exist in only two dimensions. When Van Gogh set up the rectangle so that it framed the scene, the lines of the grid (one vertical, one horizontal, plus two diagonals crossing from corner to corner of the rectangle) enabled him to fix the perspective. As he pointed out, mechanical aids of this kind had once been widely used by the Old Masters, although by the nineteenth century they had been replaced by academic instruction and textbooks. His adoption of the device bears witness to his independence of mind, and also to the long and hard struggle he endured to master the technical groundwork of his art.

Kerssemakers had other affectionate recollections of his friend's oddities. On one occasion he turned up to meet Van Gogh at Amsterdam railway station, only to find him surrounded by jocular onlookers while he calmly painted a small city view. Later, caught in the rain, Kerssemakers had to insist that they take a taxi to the museum; Van Gogh, although looking like a drowned cat in his furs, consented only to please his friend. At the museum he spent several hours gazing at Rembrandt's painting *The Jewish Bride*; later, when the two men stopped outside the Gallery Van Gogh, owned by Vincent's Uncle Cornelius, he recommended Kerssemakers to buy two books there, but would not come in himself, remarking sarcastically that he could not show himself to such a proper, wealthy family...

This accumulation of anecdotes prompts the suspicion that Van Gogh cultivated his eccentricities or perhaps exaggerated them a little to impress Kerssemakers. He was certainly not being entirely candid when Kerssemakers asked him why he signed his paintings with the single word 'Vincent'. The reason he gave was that Van Gogh was a difficult name for his potential customers in England and France to pronounce. This was true as far as pronunciation went (hence he had become 'Mr Vincent' in Isleworth), but it was hardly likely to affect the popularity of his pictures if they made their way to other lands. A more plausible explanation might be based on the fact that, in moods hostile to

RIGHT:
Japonaiserie: Oiran (after Eisen) 1887 VAN GOGH MUSEUM (VINCENT VAN GOGH FOUNDATION), AMSTERDAM

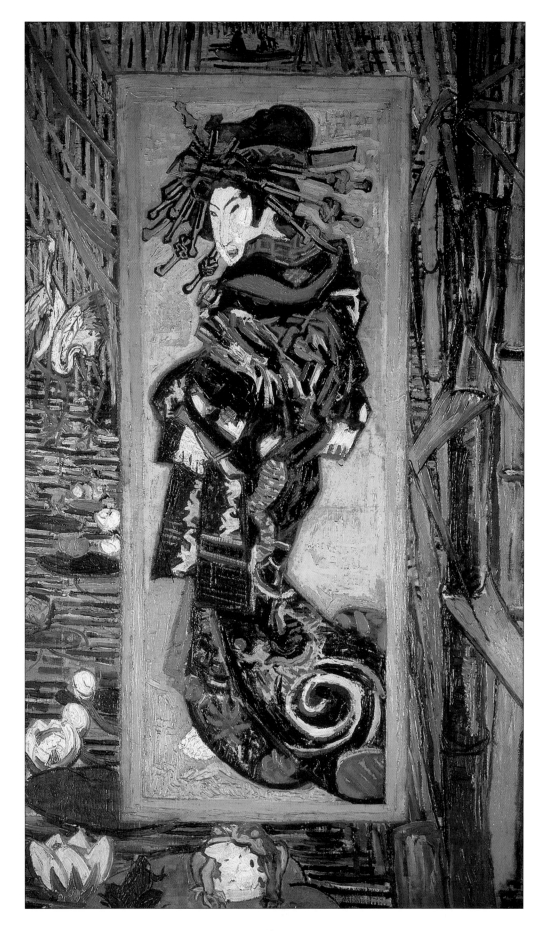

his father or his brother Theo, he would denounce 'the Van Goghs' as a commercially minded tribe to which he did not belong. If 'Van Gogh' deserved to be discarded, all that remained was Vincent. No doubt he was also alive to the effect of classic simplicity created by the use of a one-word name.

However, Kerssemakers' account of Van Gogh's peculiarities is confirmed by the Dutch painter L.W.R. Wenkebach, who visited Nuenen in order to repair the breach between Van Gogh and Van Rappard. He was received in friendly fashion, although he noticed that Van Gogh, the ardent portrayer of peasants, was in reality easily angered by them. And later, when some of his host's drawings fell on the floor, Wenkebach picked them up, revealing the fact that he was wearing gold cufflinks – which provoked Van Gogh to snap 'I can't stand people who wear such luxuries!' Wenkebach was too taken aback to respond, and Van Gogh almost immediately forgot about the episode – perhaps the surest sign of his remoteness from everyday realities. While they were out on a walk, Wenkebach managed to make peace with Van Gogh on Van Rappard's behalf, although the friendship never recovered its former warmth and soon petered out. At dinner with Kerssemakers, Van Gogh again flew into a rage when Wenkebach mentioned the eccentricities of a fellow painter; Kerssemakers, used to Van Gogh's ways, took it all calmly. Next day, to Wenkebach's surprise, Van Gogh turned up at the railway station in time to see him off, saying 'I hope you'll come again!'

Farewell to the Potato Eaters

In the course of 1885 life at Nuenen became more difficult for Van Gogh. One of his models, a young girl, became pregnant and rumours circulated that he was to blame. The local Catholic priest forbade his flock to model for him (whether because he was a Protestant or because he was a bohemian Bad Influence is not clear). Finally the sexton, influenced by the strength of local feeling, told him to start looking for another studio.

Van Gogh held out at Nuenen for a few weeks more, but he had exhausted its possibilities and his mother would soon be leaving the village to settle in Breda. Conscious that his work was still technically deficient in some important respects, he decided to study in Antwerp, just across the border in Belgium. Presumably believing that he would make a return visit in the near future, he left quantities of paintings and drawings behind him. Eventually

RIGHT:
Self-portrait
1887
MUSÉE D'ORSAY,
PARIS

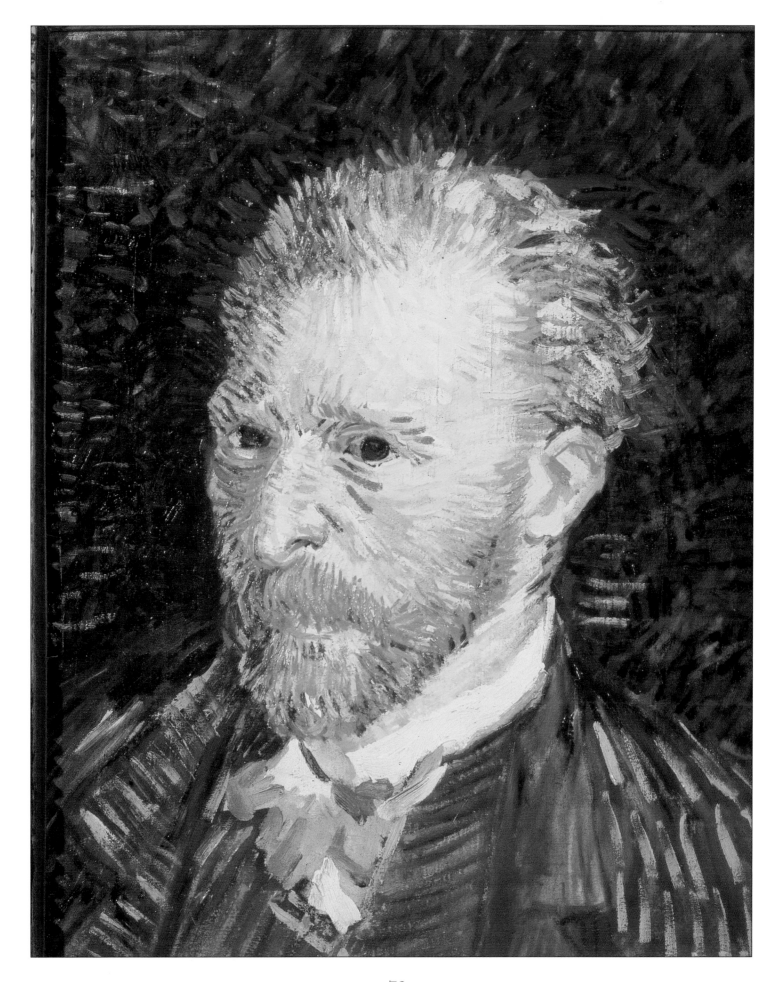

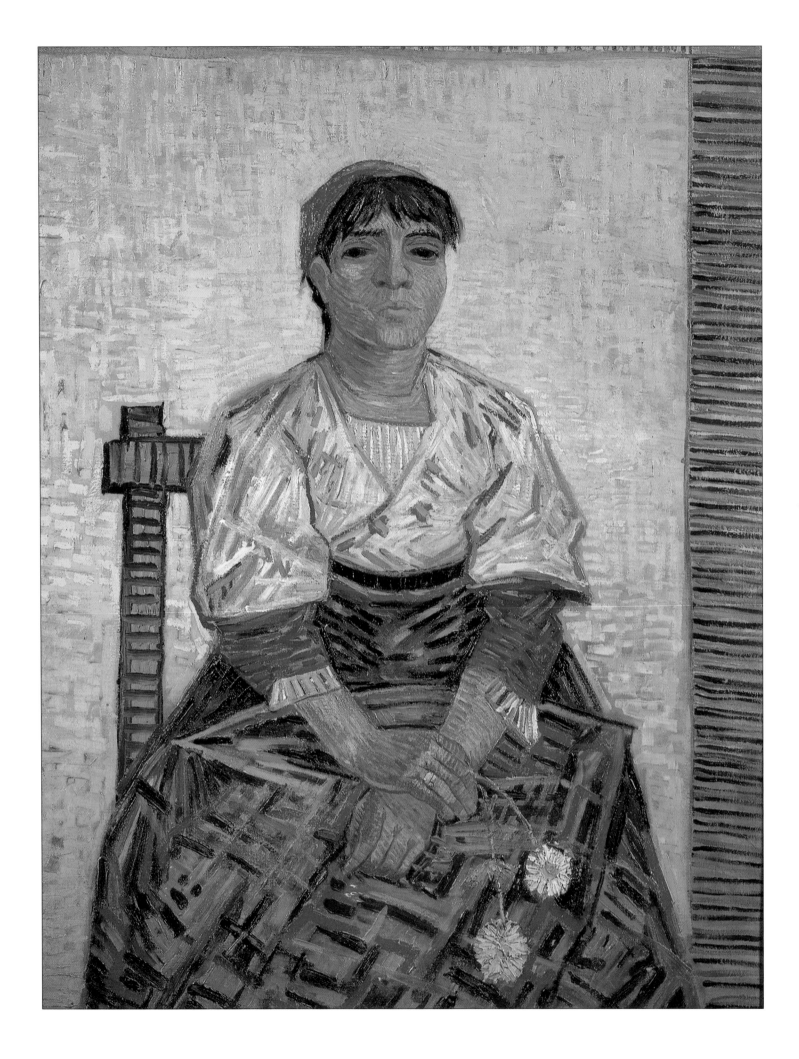

his mother cleared out his studio and disposed of the contents, most of which are said to have been destroyed or sold for a pittance.

Kerssemakers' version of his final meeting with the artist serves as a cheering pendant to this sad story. When Van Gogh gave him one of his paintings, still wet, as a leave-taking present, Kerssemakers pointed out that it was not signed. Van Gogh said that he would probably be coming back, but that in any case a signature was not really necessary: later on his work would be recognized (and, presumably, recognizable), and he would surely be written about when he was dead.

'I will make sure of that if life grants me the time,' he declared. It did, even though he had less than five years to live and would never see his native land again.

Interlude at Antwerp

Once in Belgium, Van Gogh seems to have felt a considerable sense of liberation. A busy port, Antwerp had a variety and bustle that came as a relief after the predictable seasonal round at little Nuenen. Van Gogh was drawn to the docks, painting at least one lively scene of quayside activity, and he was pleased to find that in this milieu he was taken for a sailor, with nothing notably eccentric about his appearance. At Nuenen he cannot have strayed far from the path of virtue (whatever some of the villagers thought), but now he rediscovered the pleasures of the flesh, both as purchaser and painter.

Appropriately, Antwerp had been the home of one of the greatest Flemish painters, Peter Paul Rubens (1577–1640), examples of whose luscious sensual nudes were still to be found in the city. Van Gogh studied them carefully, trying to unlock the master's secrets and responding to Rubens' brilliant, luminous colours. Towards the end of his time in Nuenen, Van Gogh had studied colour theory and had lightened his palette somewhat; the influence of Rubens encouraged this development, and colour became progressively more important in Van Gogh's work, eventually forming his principal means of expression. By comparison with his peasant portraits (page 25), *Woman with a Red Ribbon* (page 32) is a distinctly more colourful work, as well as emphasizing the girl's generous figure. We know from Van Gogh's letters that she was the opposite of the sorrowful Magdalene that Sien had been (at least in Van Gogh's imagination), chattering gaily to him about champagne and her night adventures.

During his stay in Antwerp, Van Gogh discovered a shop that sold Japanese prints, and was immediately delighted by them. In the past he had bought Biblical and social-message pictures and pinned them up in his room; now he did the same with examples of this exotic and colourful new art. The Japanese pictures were woodcuts, made by transferring an artist's original design on to a wooden block from which many prints could be taken. The craftsman cut away areas of the wooden surface, leaving only those parts that were to be inked and pressed on to paper to make the print; multi-coloured prints involved the use of several different blocks. In Japan such prints were a popular art form, made from original designs by such masters as Hokusai and Hiroshige. During the nineteenth century they became known in the West, influencing many artists by their adoption of unusual viewpoints, their dramatic cropping of figures and objects (so that the edge of the picture cut straight through them) and their strong, fluent outlines filled with pure colour. Japanese prints had been known in France since at least the 1860s and it is strange that Van Gogh, so widely read and so closely in touch with his Paris-based brother, should have been unaware of their existence. For him, immediately speaking, they constituted another revelation of the power of colour. As with most of his admirations, he would learn from the Japanese in the most direct fashion, making his own painted versions of the prints he owned (page 71).

The excitement of his discoveries in Antwerp was soon tempered by his experience of bitter poverty there. Life was more expensive in the city, and money had to be found to pay the rent of Van Gogh's little room above a paint shop. At Nuenen he had managed on his allowance from Theo, but now he really needed to sell work in order to live and paint. When he failed to do so, typically, he went hungry to pay for models and colours. In the not very long run this proved counter-productive, as he was increasingly troubled by his loose, rotten teeth and ended by paying a sorely missed fifty francs to have ten of them pulled out. He was also ill for much of the time, possibly, although by no means certainly, from syphilis. The macabre humour of *Skull with a Cigarette* (page 35), a work unlike any of his other paintings, seems like a comment on his situation.

In spite of it all, Van Gogh secured entry to the Academy at Antwerp, believing that in this big-city environment the teaching would be modern-minded and he would be brought up to date about developments in the art world. He was wrong on both

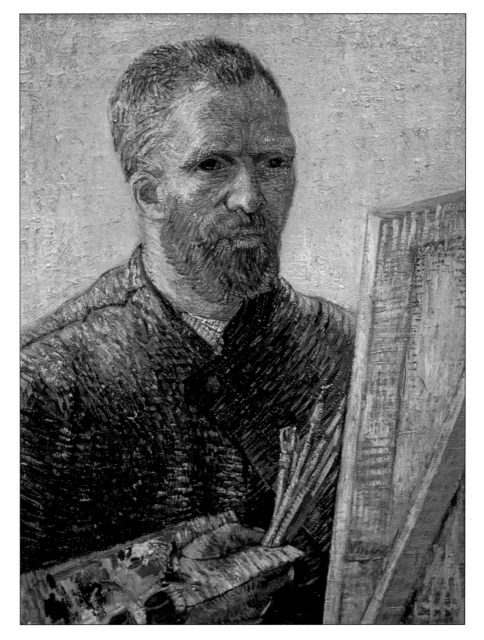

LEFT:
Self-portrait before his Easel
1887
RIJKSMUSEUM
VINCENT VAN
GOGH,
AMSTERDAM

counts. He turned up on the first day, a bizarre figure in a workman's smock and fur hat, and went into the painting class, where the students were set to work from the models, two male wrestlers locked in combat. Unable to afford a palette, Van Gogh had torn off a piece of a packing case. He proceeded to paint with furious speed, to the astonishment of his fellow-students. Then the director of the Academy entered, looked at Van Gogh's work, and immediately sent him off to the drawing class.

Van Gogh accepted this demotion with surprising docility, and even worked dutifully from plaster casts, knuckling down to a discipline that had once driven him to violence in Mauve's studio. At the Academy the casts were used not only on principle as models

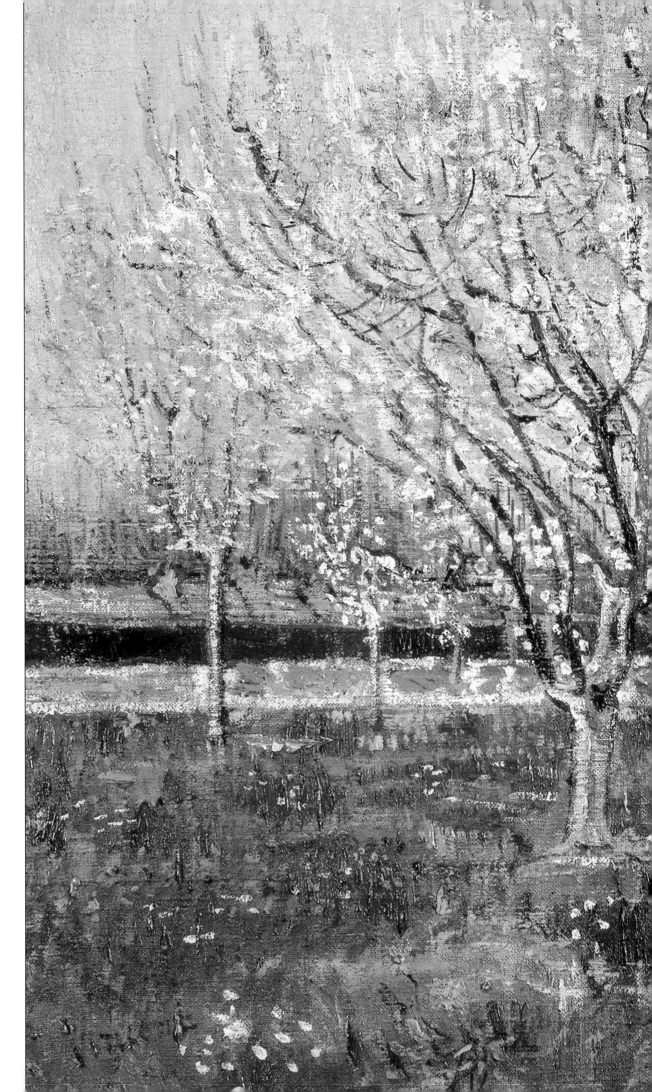

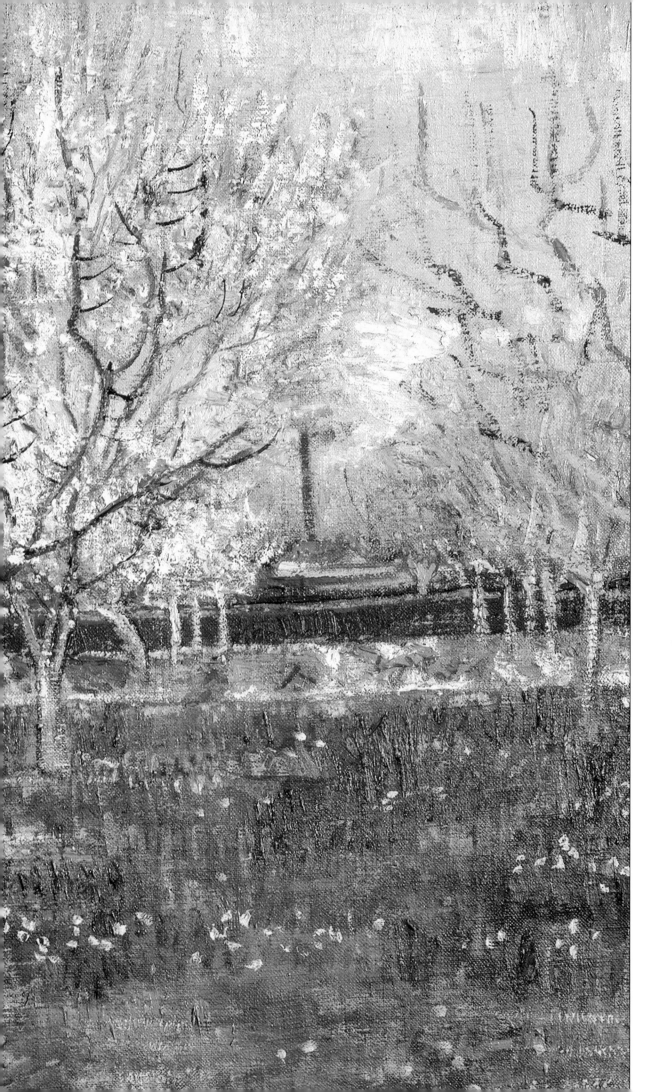

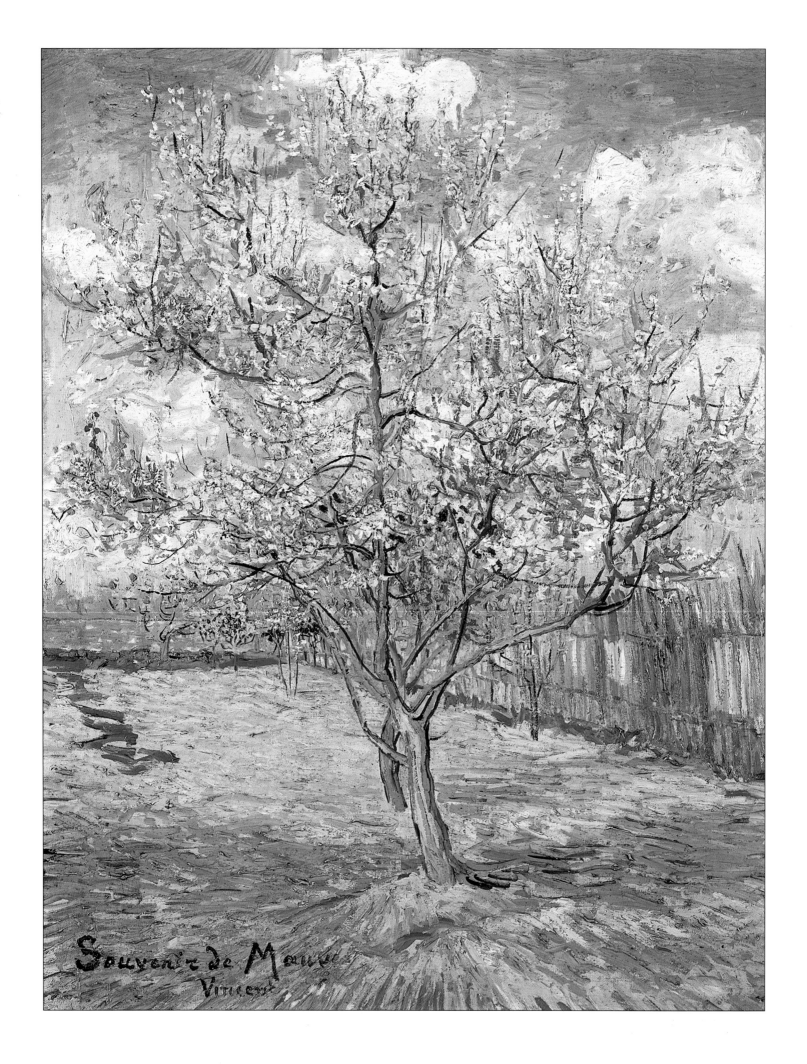

Souvenir de Mauve
Vincent

of classical correctness, but also as a substitute for female models, whom the authorities were too puritanical to employ. Some of the students had already got round this by clubbing together to hire a model for the evening, and Van Gogh joined two separate groups of this sort. One or two of his fellow-students proved to be reasonably sympathetic and Vincent enjoyed reminiscing about London with an Englishman, Horace Livens, who painted the first known portrait of him. It shows Van Gogh in profile, smoking a pipe and looking rather like Sherlock Holmes, but prematurely aged and careworn.

At the Academy, despite Van Gogh's assumed submissiveness, he proved to be a subversive influence. One of the students, influenced by his drawings of peasant figures, began to work in a similar vein, with powerfully modelled forms rather than the refined contours favoured by the Academy. The drawing teacher summoned and rebuked him, declaring that a repetition of such conduct would be regarded as deliberate impertinence. Vincent himself was unable to control his pencil. One day, rebuked for the way in which he had copied a cast of the celebrated Venus de Milo, he lost his temper and shouted that the drawing master did not know what a woman was: 'God damn it ! A woman must have hips, buttocks, a pelvis in which she can carry a baby!' After this, his days in Antwerp were clearly numbered.

Meanwhile he hesitated before deciding on his next move. Or perhaps it would be more accurate to say that Theo hesitated, or temporized. Although Vincent thought at moments of returning to the Borinage, where the miners had at last risen in near-revolt against the conditions in which they lived and worked, his heart was really set on going to Paris. It was a natural enough impulse: Theo was there and exciting, hard-to-fathom events were taking place in the Parisian art world. Theo himself was less enthusiastic. He already had domestic problems in the form of an obstreperous mistress, and he knew that living at close quarters with Vincent, however much he loved him, was certain to be something of an ordeal. He put off a decision, tried hard to find buyers for Vincent's work, and suggested alternative schemes. One morning early in March, a messenger brought him a note scribbled in black crayon from one of the main railway termini, the Gare du Nord: Vincent had ended the debate by catching a train and had arrived in Paris. 'Shall be at the Louvre from midday or sooner if you wish. Please let me know at what time you can come to the Salle Carrée'.

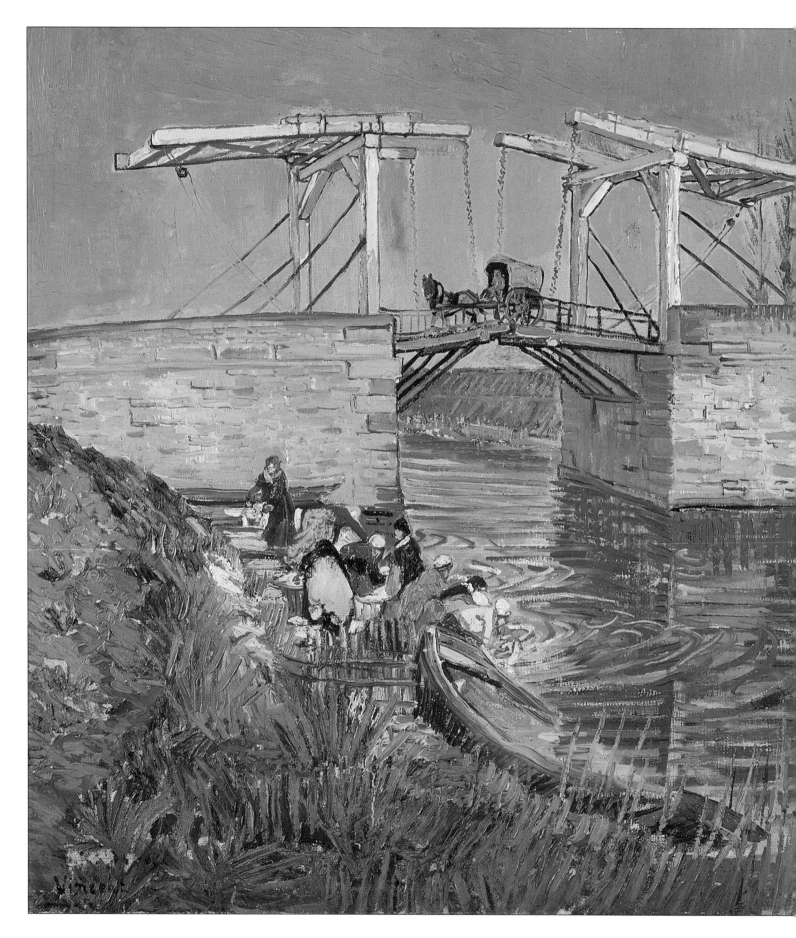

Painter in Paris

Vincent van Gogh was one of the great pioneers of modern art. Almost everything forward-looking in painting and sculpture was nourished in Paris between the 1850s and the early years of World War II. Not surprisingly, then, Van Gogh's experience of Paris was one of the crucial events in his life: without it he would have been an entirely different sort of artist.

Although his life had been passed within a day's journey of France, Van Gogh still knew very little about the schools and styles that had appeared on the art scene. Admiring Rubens and the more recent Romantic painting of Eugène Delacroix (1798–1863), he regarded himself as a bold colourist, unaware of how much further the Impressionists had gone. Theo had tried to describe and explain Impressionism in his letters, but it registered in Vincent's mind only as a general term for an anti-academic art, which he mainly identified with the realistic treatment of unglamorous subjects. This again highlights the nineteenth-century situation in which there were neither colour reproductions nor travelling exhibitions of contemporary works. The term 'Impressionism' had been coined in 1874, but 12 years later Van

LEFT: **The Langlois Drawbridge** 1888 Rijksmuseum KRÖLLER-MÜLLER, OTTERLO

Gogh, and many others like him, hardly knew what it meant. Their confusion was understandable, since many Parisians were ignorant of the new tendencies in the arts or regarded them as the work of publicity-seekers who would soon fall back into obscurity.

Academies and Artists

In France, even more than in Holland and Belgium, the art world was institutionalized. The Academy of Fine Arts and the associated teaching institution (the Ecole des Beaux-Arts) trained generations of painters and sculptors to work in certain approved ways, rewarding those who did with prizes, medals and commissions from the state. These were also the artists whose works were most likely to be seen by the public. Until the 1870s artists could not hope to reach a large audience unless their works were shown at an annual spring exhibition, familiarly known as the Salon. They could be shown only if they were approved by a jury – which directly or indirectly represented the outlook of the Academy and the Beaux-Arts. So it was next to impossible for a thoroughly unconventional work of art to reach the general public. If by some chance it did so, a hostile reception was almost guaranteed, since the public's taste had already been formed by the standards of the Academy and the Salon.

In other words, any sensible, career-minded painter or sculptor was well advised to work in the style promoted by the Academy and to tackle the kind of subject of which it approved. The situation was much the same all over Western Europe and in North America, even if the state was not quite so active in most places as it was in France. For obvious reasons, the huge quantity of nineteenth-century pictures and sculptures produced in the approved style is now labelled academic art.

The academic style was consciously dignified and called for considerable technical skill. In painting this meant that the subject was rendered in dark tones but in precise detail; the paint was smoothed down so that the artist's brushstrokes were invisible, leaving a scene of near-photographic clarity, as if viewed through a window. The subjects of painting were not prescribed, but the value placed upon different types of subject was well known. The history painting – a scene from the real or semi-legendary past – was by far the most prestigious, usually executed on the grand scale. Related, equally acceptable types were the 'Oriental' picture, showing succulently 'barbarian' scenes from lands beyond

Europe, and paintings based on classical myths from the birth of Venus to the death of Agamemnon. By comparison with these, landscapes and scenes from everyday life ('genre') were regarded as being of minor importance, while flower painting and still life were placed at the bottom of the hierarchy.

Despite its air of self-conscious nobility, nineteenth-century painting was actually escapist: most of contemporary reality – and above all the kind of social protest art that Van Gogh admired – was absent from it. Even before his arrival in Paris he had had a good deal of experience of academies and academic standards. Despite his penchant for anything with a moral or social message,

ABOVE: **Street in Saintes-Maries** 1888 PUSHKIN MUSEUM, MOSCOW

he had rejected the academic style in his own painting, finding it incompatible with his rapid working methods and tactile use of oil colours. But his attendance at the Antwerp Academy indicated that he still valued academic techniques, and his colour schemes remained relatively dark. Only in Paris would he find painters and paintings that owed nothing to the academic tradition, and experience an extraordinary liberation.

Impressionism and After

Van Gogh was a latecomer. Discontent with current orthodoxies had slowly gathered force among artists in France since the mid-nineteenth century. Some, like Jean-François Millet, managed to go their way without attracting too much controversy; others, notably Gustave Courbet (1819–77), revelled in it. Millet dignified – but also sentimentalized – the lives of peasants. Courbet was a self-proclaimed Realist, although he, too, took his subjects mainly from rural life, treating ordinary scenes with the kind of monumental seriousness previously reserved for celebrated historical figures.

However, the revolt against academicism became much more challenging with the emergence of Edouard Manet (1832–83) and the group of younger painters who became associated with him. Manet and Edgar Degas (1834–1917) pioneered an art based on life and leisure in a modern city – specifically Paris, with its then new boulevards, strolling dandies, cafés, cabarets, theatres and Longchamps racecourse. Manet became the more controversial figure because two of his paintings, *Déjeuner sur l'Herbe* (1863) and *Olympia* (1863; shown 1865), featured nude figures in modern settings, free from the 'classical' trappings that would have made them acceptable. The consequent outbursts of moral outrage tended to obscure the fact that the new subjects were treated in styles that, while not wholly outside the academic tradition, introduced some significant innovations. Manet, for example, eliminated much of the detail in which academic artists took pride, often brushing in areas of more or less pure colour and including cursory passages in which the brushwork was clearly visible. In general, he made little attempt to pretend that his paintings were tame copies of reality, but effectively displayed the fact that they were human creations – an attitude that had often been found in the art of the past, but one which was at odds with the main development of western painting since the Renaissance.

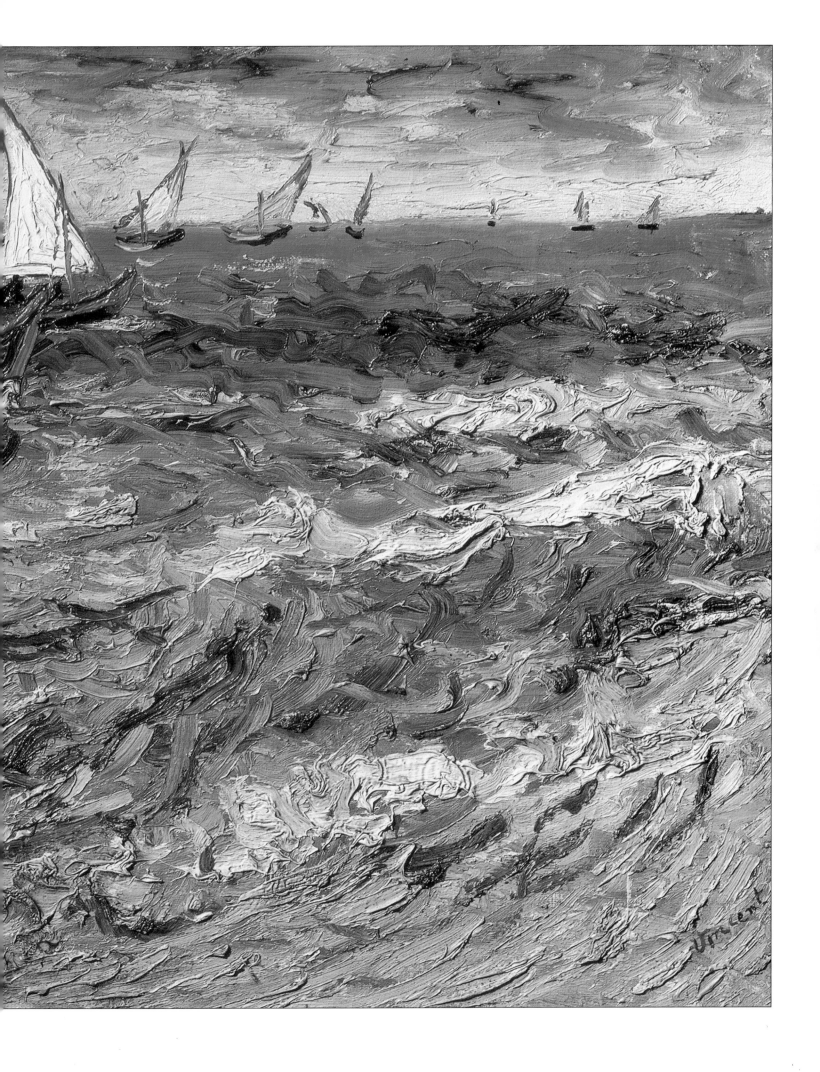

PREVIOUS PAGES
86-7: **Seascape at Saintes-Maries** 1888 PUSHKIN MUSEUM, MOSCOW

RIGHT:
Wheatfield with Sheaves 1888 ISRAEL MUSEUM, JERUSALEM

Manet's art, implicitly independent of the outside world ('autonomous') can plausibly be described as the beginning of the modern movement.

During the 1860s a new approach to landscape painting was developed by Claude Monet, Auguste Renoir, Camille Pissarro and Alfred Sisley. A little later a courageous woman artist, Berthe Morisot, began to work in a similar style, often for garden or

domestic scenes. These painters used a much brighter palette than academic artists, or even Manet, and they adopted a much freer type of brushwork in order to capture fleeting effects of light and atmosphere. The traditional method was to mix colours on the palette and apply them to create a smooth surface with carefully graduated tones. The new school painted with more or less pure colours, putting them on rapidly with little dabs or strokes; among other things, this enabled them to work more rapidly and also more spontaneously than academic artists. When dabs of two or more colours were placed close together and viewed from a certain distance, the spectator's eye perceived them as a single blended colour; but the effect of this 'optical mixing' was far more vibrant than anything that could be achieved with colours mixed on the palette, giving a sense of life and movement that revolutionized landscape painting in particular.

None of this made any impact on the general public until 1874, when these and other artists banded together to hold their own exhibition, independently of the official Salon. This alone made the exhibition important, since it represented the first serious breach in the Salon's monopoly; but the reception given to the paintings on show was generally unfriendly. To the critics and the public, the bright, atmospheric landscapes of Monet and the others looked merely sketchy and half-finished. Accustomed to 'invisible' brushwork, spectators were contemptuous of canvases that had to be viewed at a distance, feeling cheated when they approached closer and saw only a 'rough' multicoloured surface. A satirical writer named Louis Leroy wrote a spoof account of the exhibition, making great play with the notion that the works on display were just 'impressions', and that 'impressionism' was on the march; the words caught the public fancy and these painters have been known ever since as the Impressionists.

Van Gogh had visited Paris for a few days in 1873, but his real acquaintance with the city began in November 1874, after his misfortunes with Eugénie Loyer. The 1874 Impressionist exhibition had been held in the previous April, so it was stale news by the time he arrived, and it is perhaps not surprising that he knew nothing of an event that had been widely dismissed as a failure. But when he was transferred permanently to Paris in May 1875, a disastrous sale of Impressionist paintings at the premier auction house, the Hôtel Drouot, was fresh in the public memory. As an employee at Goupil's he might have been expected to acquaint himself with events in the art world, even if only in the

form of gossip. Either Goupil's remained aloof from it all or, more likely, Van Gogh had no time for anything beyond his duties and his religious devotions. He had left France well before the second Impressionist exhibition had opened in April 1876, and thereafter had little more than Theo's descriptions to keep him informed of the six exhibitions held between 1876 and 1882. As we have seen, they meant very little to him, and he came to Paris in 1886 believing that Delacroix represented the last word in colour, and perhaps that a socially conscious art (Millet, not Manet) constituted the main challenge to academicism.

In reality Impressionism had ceased to exist as a movement by 1886 and new trends were already emerging. One of the most important aspects of Impressionism was as a trail-blazer, showing that alternatives to academic art were viable. By doing so it opened the way for other styles, movements and personalities, including such 'Post-Impressionist' giants as Cézanne, Gauguin and Van Gogh himself. All three worked their way through Impressionism before creating styles of their own which had an enduring impact on the development of modern art.

Van Gogh came to Paris in time to see the final Impressionist exhibition, which ran from mid-May to mid-June 1886. However, there was little of the original type of Impressionist work to be seen and a great deal of a related movement that has come to be known as Neo-Impressionism. This was a self-proclaimed 'scientific' version of Impressionism, based on optical mixing; instead of the spontaneous, intuitive brushwork of the Impressionists, the Neo-Impressionists used uniform dots or points of colour, building up their compositions laboriously and according to the dictates of the latest colour theories. Their 'dotting' technique is known as divisionism or, more popularly, pointillism. Its greatest exponent was a young man, Georges Seurat (1859–91), whose masterpiece, the very large *Sunday Afternoon on the Grande Jatte* (1886), hung with other Neo-Impressionist works in a separate room at the 1886 show.

Although the pointillist technique was a kind of rigorous extension of Impressionist brushwork, the final result was disconcertingly different. While the Impressionist painting recorded the passing moment, its Neo-Impressionist equivalent, organized by its uniform 'dots', was more monumental, 'eternal' and classical in its effect.

Van Gogh was exposed to both Impressionism and Neo-Impressionism simultaneously, and their influences were felt, slowly but surely, in his painting. Both encouraged him to lighten his

palette even further, but neither offered him quite what he wanted and few of his Paris paintings can be called pure examples of either style. *The Moulin de la Galette* (page 36) and *A Fisherman in his Boat* (page 49), for example, owe a good deal to Impressionism, but never entirely sacrifice solidity to atmosphere. The monumentality of Neo-Impressionism probably appealed more strongly to Van Gogh's temperament, but in paintings such as the *Portrait of Alexander Reid* (page 50) and *The Restaurant de la Sirène* (page 53) the brushwork consists of patterned strokes, energetically applied, rather than calmly regular dots. In fact, it is impossible to imagine Van Gogh painting as the 'dotters' did, spending several months or more on a single canvas.

Paris is Paris

The impact of Paris on Van Gogh is most evident in his canvases. His actual movements are not easy to trace, as we have few letters written by him: he was living with Theo, his principal correspondent, so there was no need to communicate with the pen except during Theo's brief trips to Holland in the summers of 1886 and 1887. Theo's resistance to living with his brother collapsed as soon as Vincent arrived, and the two of them shared Theo's flat in the Rue Laval (now the Rue Vincent Massé). Although the flat was too small for Vincent to work in, he seems to have found his new life exhilarating. He had the company of his brother to assuage his loneliness and a great city's picturesque views and variety of life to entertain him. Above all, he was now in a place where art was taken seriously and artists were not necessarily expected to dress and behave like sober citizens. In fact a new era of Parisian bohemianism had begun; curiously enough, the Impressionists had been middle-class in their habits despite their daringly colourful canvases, whereas the Post-Impressionists and many other artists in the closing years of the century were, wittingly or otherwise, rebels, outcasts or eccentrics.

After being out of things for so long, Van Gogh was grateful to the city whose charm and artistic ethos he had so singularly failed to appreciate on earlier visits. Always a great admirer of French writers, from now on he used French in his correspondence. He made an exception for Horace Livens in Antwerp, to whom he wrote in his excellent English, praising his new home: 'And mind my dear fellow, Paris is Paris. There is but one Paris and however hard living may be here, and if it became worse and harder even – the French air

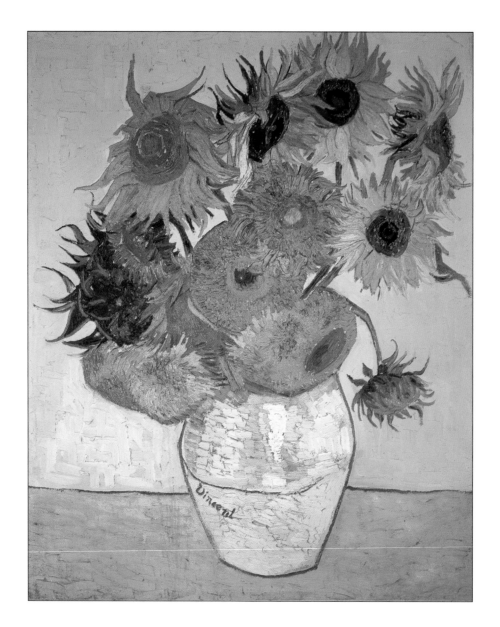

clears up the brain and does good – a world of good.'

In Paris, Van Gogh was prolific, painting some 230 pictures in two years. In the course of 1886 he often took some aspect of the city itself as his subject. He painted vistas of the roofs of Paris from the heights of Montmartre, as well as street scenes and well-known places such as the Pont du Carrousel, the Jardin du Luxembourg and the large park, the Bois de Boulogne, in which fashionable people strolled or rode about.

Above all he painted Montmartre itself, which was effectively home territory and the area he knew best during his first year in the capital. Montmartre was nicknamed the Butte (the Mound) because it rose up from the Boulevard de Clichy to the height on which stood the still-unfinished church of the Sacré-Coeur. Theo van Gogh's flat in the Rue Laval was just below the Boulevard de

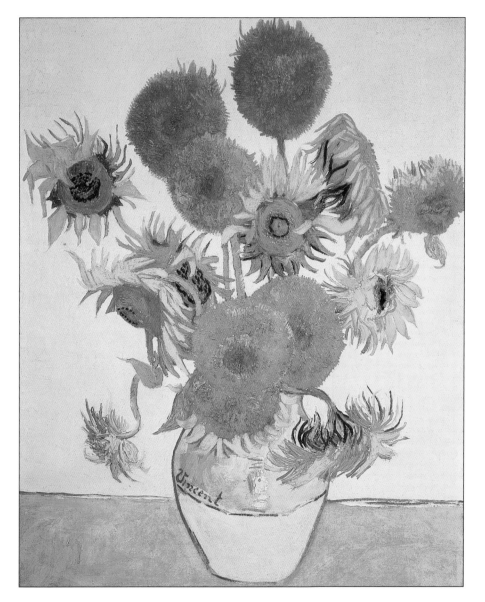

Clichy; later he and Vincent would move to the Rue Lepic, which wound up the side of the Butte. For centuries Montmartre had been a hill village outside Paris, best known for its many mills (*moulins* in French). Eventually it began to attract Parisian customers by the cheapness of its wine, which was not liable for the tolls that had to be paid on liquor entering the capital. The windmills began to disappear and Montmartre became a centre for nightlife entertainment. Its links with the arts and artists also became stronger after the nearby Batignolles district attracted painters from the 1860s; studios spread along the Boulevard de Clichy and artists migrated up the Butte, creating a bohemian sub-culture whose legend long outlived its reality.

When Van Gogh painted it, Montmartre had still not quite lost its village atmosphere, which he captured in such pleasant

canvases as *Sloping Path in Montmartre* (1886), *Street Scene: Le Moulin à Poivre* (1887), and *The Allotments* (page 46-7). His favourite subject of all was one of the few surviving windmills, the *Moulin de la Galette* (page 36), which is seen in a number of pictures from various angles and distances. Some of them also show the neighbouring quarry, but none gives any indication that the Moulin de la Galette had long been functioning as a working-class dance hall; it was as such that Renoir had painted it as long before as 1876 and that Toulouse-Lautrec would record it in 1889. Although he had become a Parisian, Van Gogh rather surprisingly lacked any impulse to take mass urban pleasures as his subject, whether in a spirit of harmless gaiety, like Renoir, or in the illusionless vein of his friend Lautrec.

At Cormon's

Lautrec was one of several important contacts that Van Gogh made after once more entering a teaching institution. Just when he did so remains doubtful, but it may have been quite soon after his arrival in Paris, given his lack of working space at the Rue Laval apartment. This would account for his choice of a studio run by a leading academic artist named Fernand Cormon (1845–1924). Acclaimed in his day, Cormon had exploited the vogue for history painting by going one better: he practised *prehistory* painting, executing grandiose absurdities such as *Cain* and *Return from a Bear Hunt in the Stone Age*. Like many academic teachers, he was easier-going than his theories and maxims suggested, even encouraging his students to work in the open air, directly from nature. He was, after all, younger than first-generation Impressionists such as Monet and Renoir, and only eight years older than Van Gogh. But why he accepted Van Gogh into his relatively small, exclusive studio is still a mystery: perhaps, having had a good deal of trouble from youthful rebels, he believed that an older man would provide a steadying influence.

If so, he was not entirely wrong. Van Gogh was too old and too much in earnest to join in with the horseplay and practical joking of the younger students, and some sense of a dangerous quality in the Dutchman prompted them not to try any of their tricks on him. As always, he impressed those around him with his intense application and furious speed of work – and with the demonic energy that led him to come back to the studio in the afternoons when it was empty and he could draw from the casts without

interruption. Having developed according to his own inner logic, he now found working from casts a valuable exercise, even making half-a-dozen or so painted studies of classical torsos. He was certainly not looking for trouble at Cormon's, but he might well have found it if Cormon had not chosen to ignore his unorthodox procedures. When the master toured the studio, inspecting his student's efforts, he saw that Van Gogh had ignored his instruction to the class to copy what they saw in front of them, altering nothing. Instead of dutifully painting the model seated on a stool, Van Gogh created a brilliant blue couch which set off the model's golden skin, each colour intensifying the other.

The story is told by Toulouse-Lautrec's biographer, François Gauzi, who claimed to have been an eye-witness; but it must be said that the description of the painting does not sound like the

BELOW: **The Yellow House** 1888 RIJKSMUSEUM VINCENT VAN GOGH, AMSTERDAM

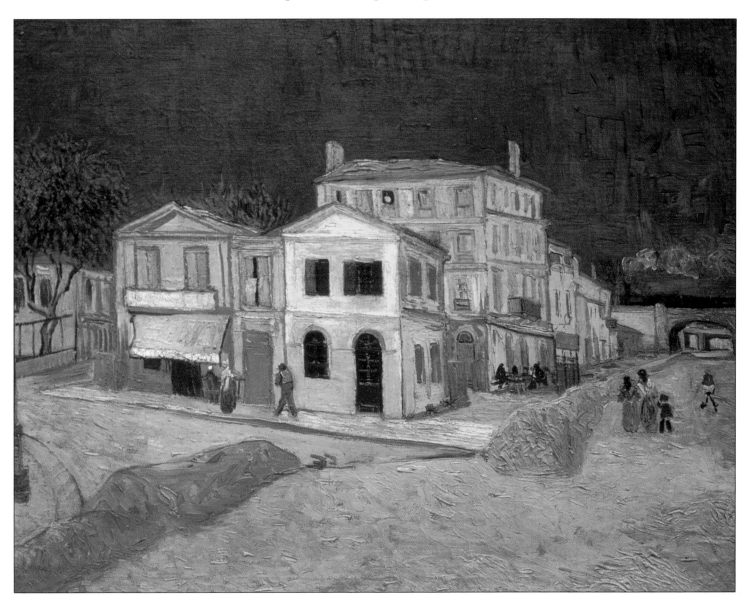

kind of work that Van Gogh was doing in 1886. Gauzi further undermines his credibility by claiming that Van Gogh had only drawn from the model until this time, so that the intense blue-gold picture, painted with his usual colour-splashing urgency, was the first he had done in the studio. This is not an impossibility, of course, but conveniently dramatic enough to raise doubts about the reliability of Gauzi's recollections. However, an encounter of some sort did presumably take place between Cormon and Van Gogh, causing the other students to look forward with relish to an explosion; but Cormon wisely ignored Van Gogh's derelictions with the brush and simply corrected technical points to do with his drawing. There was no confrontation and when Van Gogh stopped going to Cormon's after three or four months, it was (as far as is known) his own decision. If it is true that his original motive for joining was to obtain the space in which to work, he probably left soon after it became available in June 1886, when Theo took a bigger apartment.

Cormon's, like so many of the studios run by academic masters, harboured young men who would one day challenge their most cherished ideas. The most talented of these became Van Gogh's friends, bringing him into contact with a younger generation for whom Impressionism and Neo-Impressionism, however liberating, were not necessarily the last word in modernity. Henri Marie Raymond de Toulouse-Lautrec Montfa (1864–1901) came from an ineffably noble family and would never have been more than an amateur artist if he had been able to follow the usual aristocratic round of duties and pleasures. However, during his teens he had twice broken thigh bones after apparently harmless falls, and his legs had stopped growing; the real cause was almost certainly a genetic deficiency produced by inbreeding (his father and mother were first cousins). As a result, Lautrec had the head and torso of a normal man set on stunted, unsteady legs, with an ungainly, waddling walk that no doubt made him seem a figure of fun in the eyes of the insensitive. True to his upper-class background, he reacted to his afflictions with a mixture of stoicism and self-mockery, heavily laced with absinthe. In time he became the supreme recorder of his chosen milieu, the Moulin Rouge and other gamy Montmartre nightspots, and of the high-class brothels in central Paris. Unlike so many of his fellow-artists he achieved a considerable degree of popular success as a painter and mould-breaking poster designer, but alcohol and syphilis undermined his frail constitution and he died when he was still only 36 years old.

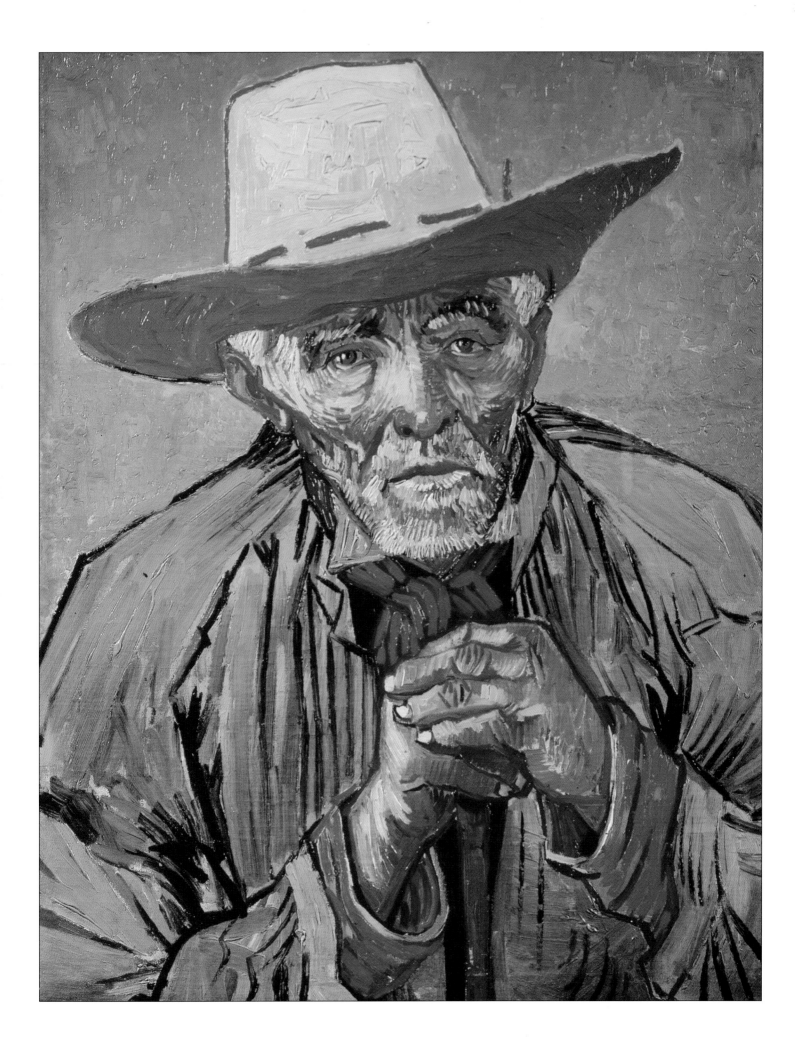

However, when Van Gogh met him, Lautrec was 22 years old and still finding his way as an artist, although he had already painted some excellent portraits which illustrated his skill as a draughtsman, and employed brushwork of an unusual kind, done with long, trailing strokes. Just how friendly Lautrec and Van Gogh became is a matter of some dispute. One account implies that Van Gogh would often carry one of his canvases up to Lautrec's studio, place it in a well-lighted corner and wait patiently while Lautrec and his cronies drank and debated matters of art. Eventually, when no one noticed him or his work, Van Gogh would carry it away, only to return the following week in the vain hope that some of those present would be more forthcoming. This does not sound much like Van Gogh, although the story does come from Lautrec's sometime model and lover Suzanne Valadon, who was very much in evidence at this time. On the other hand, she presents herself as more perceptive and more sympathetic towards Van Gogh than the others, so an urge towards self-glorification may have led her to exaggerate or embroider. As with so much anecdotal material concerning Van Gogh, Valadon's story was written long after his death, when the knowledge that he was recognized as a great master encouraged the survivors to colour and dramatize their memories.

An even less convincing story has it that Lautrec, weary of Van Gogh's company, encouraged his eventual departure from Paris by picturing the South of France as a place of perpetual sunshine! Since Van Gogh was neither illiterate nor ill-informed, the objections are obvious. Against such anecdotal material we can set the fact that they exhibited together while both were in Paris, that Lautrec was prepared to fight a duel in defence of Van Gogh, and that in July 1890, about three weeks before Van Gogh's death, Lautrec took the trouble to visit and lunch with him. Although the existence of a portrait is not direct proof of friendship, Lautrec's pastel of Van Gogh at a café table (page 54), painted early in 1887, is a superbly insightful work, capturing the man's contained intensity and force; its subject can only have been a figure for whom Lautrec had a considerable respect.

Portraits of Vincent

Another friend from Cormon's was John Peter Russell, a big Australian who had fallen out with his wealthy family and settled down in Paris with his Italian mistress and their child. Unlike Lautrec, Russell had only a modest talent, and he is now remembered

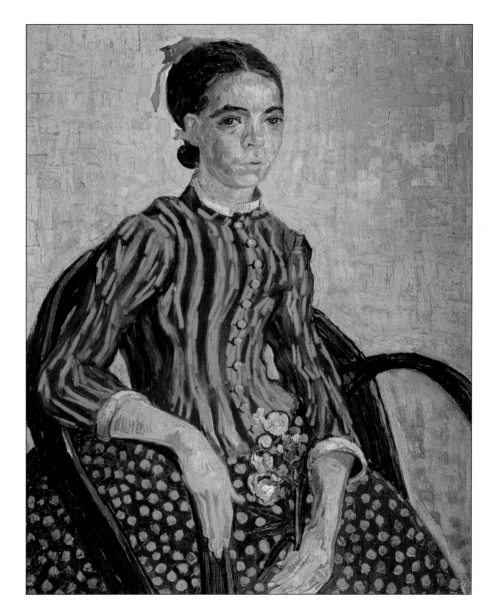

LEFT: **La Mousmé**
1888
NATIONAL
GALLERY OF ART,
WASHINGTON, DC

mainly for his connection with Van Gogh, in particular for the portrait of the artist that he painted early in 1887. Van Gogh is shown in three-quarter view, looking out of the corners of his eyes at us; in his raised right hand he grips a pencil or brush. The picture is good academic work of its kind, showing its subject in a dignified light but without the intensity conveyed by Lautrec's pastel portrait; only Van Gogh's gaze is a little unusual in its slightly wild persistence. Archibald Hartrick, a friend of Russell's who knew Van Gogh fairly well, claimed that it was the best extant likeness of the artist; we have no adequate photograph of Van Gogh as an adult to help us judge, but Hartrick may well have been right.

Hartrick was a Scottish artist in his early twenties who met Van Gogh at Russell's studio in the Impasse Hélène, a cul-de-sac off the Boulevard de Clichy. He wrote of their relationship half a century

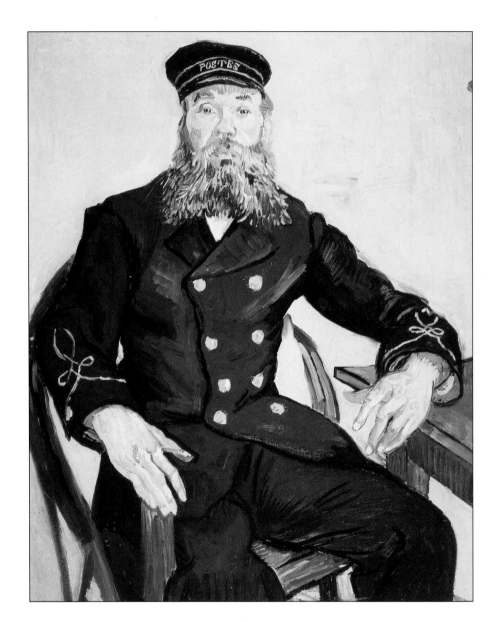

later, in his autobiography, *A Painter's Pilgrimage through Fifty Years* (1939). Like other late memoirs, the chapter dealing with Van Gogh is coloured with the writer's awareness of his subject's great fame and probably exaggerates the extent of their contacts. What makes Hartrick's account memorable is that, despite this element of hindsight, an unmistakable note of antagonism runs through it. Either Hartrick found Van Gogh personally distasteful or he disliked his work and resented his posthumous success; in fact, his remarks suggest that both may well have been the case.

Describing Van Gogh, Hartrick disputes the idea that the Dutchman was particularly robust. But this reasonable point is made in language that betrays his feelings: 'to my eye Van Gogh was a rather weedy little man, with pinched features, red hair and beard, and a light blue eye'. His personal habits were equally

repellent. 'He had an extraordinary way of pouring out sentences, if he got started, in Dutch, English and French, then glancing back at you over his shoulder, and hissing through his teeth. In fact, when thus excited, he looked more than a little mad; and at other times he was apt to be morose, as if suspicious.' Later, in more kindly vein, Hartrick wrote that 'In some aspects Van Gogh was personally as simple as a child, expressing pleasure and pain loudly in a childlike manner. The direct way he showed his likes and dislikes was sometimes very disconcerting, but without malice or conscious knowledge that he was giving offence.' All of this, seen from the nineteenth-century British stiff-upper-lip point of view, is very convincing and agrees very well with what we know of Van Gogh from other sources.

Hartrick's feelings about Van Gogh's work are equally ill-

BELOW: **Boats with Men Unloading Sand** 1888 MUSEUM FOLKWANG, ESSEN

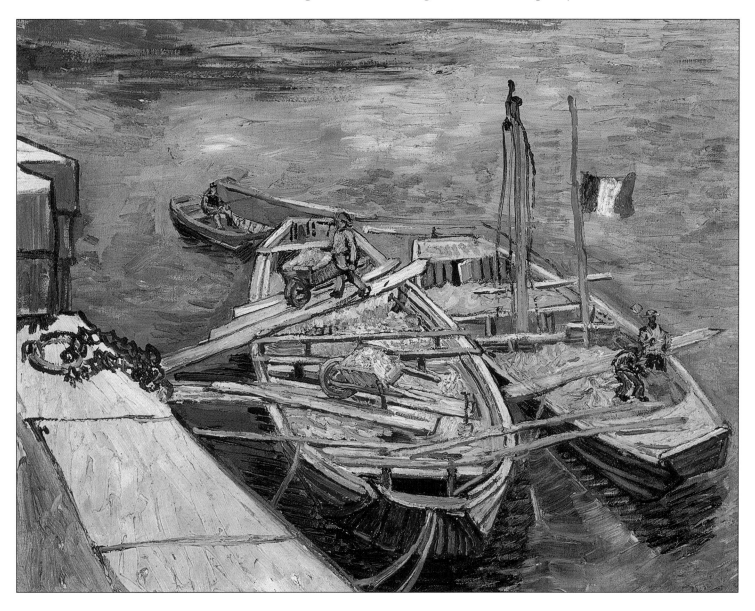

concealed. 'When I knew him, I don't think anybody in Paris called him mad; but I frankly confess that neither myself, nor any of those I remember of his friends, foresaw that Van Gogh would be talked of specially and considered a great genius in the future.' Clearly Hartrick could not bring himself to write that Van Gogh would be recognized, rather than 'talked of' and 'considered' as a great genius! 'We thought him "cracked" but harmless, perhaps not interesting enough to bother much about. Though he was always an artist in temperament, we considered his work too unskilful in handling to make an appeal to the student mind' – presumably by contrast with the mind of the general public, which eventually did see something in Van Gogh's work. Hartrick's memoir gives us a view of Van Gogh as he must have appeared to many of his contemporaries, and demonstrates that hostility may be more clear-sighted in some respects than respectful admiration.

Tradition and Innovation

Yet another friend of Van Gogh's from Cormon's was Louis Anquetin (1861–1932), who was regarded for a long time as the most promising young painter of his generation. He was Cormon's most outstanding student, with a distinguished career as an academic artist in front of him, until he discovered Neo-Impressionism and other 'advanced' movements. Anquetin was one of the originators of cloisonnism, a method of painting characterized by the use of strong, fluent, simplified outlines filled with pure colours. The effect is comparable to stained glass or cloisonné enamels, in which differently coloured enamels are poured into partitioned areas to form a design. The theory underlying cloisonnism was that art should 'synthesize' visual impressions, simplifying forms and colours in order to produce a more vivid and integrated effect; for obvious reasons this style was known as Synthetism. As well as Anquetin's co-pioneer, Emile Bernard (described below), Paul Gauguin worked in cloisonnist style for a time and Van Gogh experimented with similar effects at a relatively late date, coming closest to pure cloisonnism in paintings such as *The Dance Hall at Arles* (page140).

Despite his considerable gifts, Anquetin never became the great master so many of his friends had predicted. Early in the 1890s he seemed to lose impetus and retreated into a study of Old Master techniques. A similar life-pattern can be seen in a number of nineteenth- and twentieth-century painters, suggesting that modern artists have faced difficulties of a distinctive kind not

found in earlier centuries. The cause probably lies in the relationship between the artist and tradition. In the past, most artists worked within a tradition, knowing what was expected of them, striving to out-perform others within the tradition and even enlarging the tradition without destroying it. The nineteenth-century academic style represented the last stale, degenerate stage of the European tradition that had begun with the Italian Renaissance. The advent of Impressionism, Neo-Impressionism and other movements put an end to it (although it proved surprisingly tenacious, refusing to give up the ghost until well into the twentieth century), but there was no new tradition to replace it. The artist moved out into uncharted territory where it was easy to become bemused by rival '-isms', dominated by stronger personalities or overwhelmed by creative fatigue. In these new circumstances talent was no longer a guarantee of achievement, and precocious ability might even prove to be a disadvantage in the long run. Strangely enough, this was most marked in the Post-Impressionist era towards the end of the nineteenth century, whose three great figures – Cézanne, Gauguin and Van Gogh – could all legitimately be described as late starters and/or slow developers. At the age of 30, none of them showed exceptional ability (Gauguin had scarcely begun, even as an amateur), but some powerful force drove them on, longer, harder and further than their contemporaries, and some equally powerful instinct enabled them to learn from others while finding their own direction. Although it would be absurd to call Van Gogh untalented, he did work from and through surprising crudities of drawing and painting, often taking a step backwards in one area as he mastered another. Sometimes it is hard to resist the impression that he made himself into a great artist by sheer will-power.

During his two years in Paris he was exposed to an extraordinary variety of influences and was, presumably, a little humbled by discovering that, far from being a daring rebel, he was just a self-taught provincial, out of touch with even the revolution-before-last in painting. Yet although Van Gogh absorbed Japanese prints, Impressionism, Neo-Impressionism and Synthetism, he digested them all with extraordinary rapidity, forged his own style and created the equivalent of a lifetime's work in the couple of years left to him.

However, there is still a good deal to say about Van Gogh's first year in Paris. Views of Montmartre and paintings of plaster casts were only a small part of his output. As though some hidden

RIGHT: **Gypsy
Encampment
outside Arles**
1888
MUSÉE D'ORSAY,
PARIS

spring had been released on his arrival, he began the series of self-portraits that constitutes one of his greatest achievements, placing him beside another Dutch master of the genre, Rembrandt van Rijn; Van Gogh would eventually paint no less than 37 between 1886 and 1890. Artists have often fallen back on self-portraiture when other models were scarce or too expensive, but this cannot explain Van Gogh's adoption of the genre, since he had endured long periods of poverty before leaving Holland without painting a single self-portrait. Evidently this form of self-examination was linked in some way with his decision to move south and was part of a more general change of orientation.

The most striking feature of this change was that Van Gogh's profound concern with the subject of working people and the way in which they earned their living – digging, planting, harrowing, reaping, heaving coal, weaving at a loom – disappeared quite abruptly; the only apparent exceptions are occasional figures seen from a distance (for example, *The Sower*, right), as part of a landscape rather than as wheels in the social and economic machine. There appears to be no simple, straightforward reason for this momentous change, although a mystical explanation might invoke 'the spirit of the age' which was urging painters away from 'objective' representation and towards self-expression and art as an end in itself.

When Van Gogh painted a self-portrait, he was following an individual impulse, yet the impulse was also typical of his generation. In fact, this kind of self-scrutiny was another of the characteristics that separated the Post-Impressionists from their predecessors. Whereas Monet, Renoir and Pissarro painted only a handful of self-portraits, Cézanne, Gauguin and Van Gogh painted dozens of them, as though obsessed by the mystery of their own existence. Van Gogh's self-portraits chronicle the development of his technique and artistic preoccupations, but they are also psychological documents reflecting changes in his state of mind and health. The earliest are painted in the earth colours of Dutch academicism and show him in a hat and outdoor clothes, as though he might have to leave at any moment. A little later he is more settled, with a pipe in his mouth, but still dressed in brown and so gaunt that he looks far older than his years. Gradually the colours lighten, the brushstrokes become more emphatic and patterned, and Van Gogh reveals himself in a variety of moods and costumes (pages 51, 59, 73, 77, 110, 154 and 175).

One other type of painting absorbed Van Gogh during his first

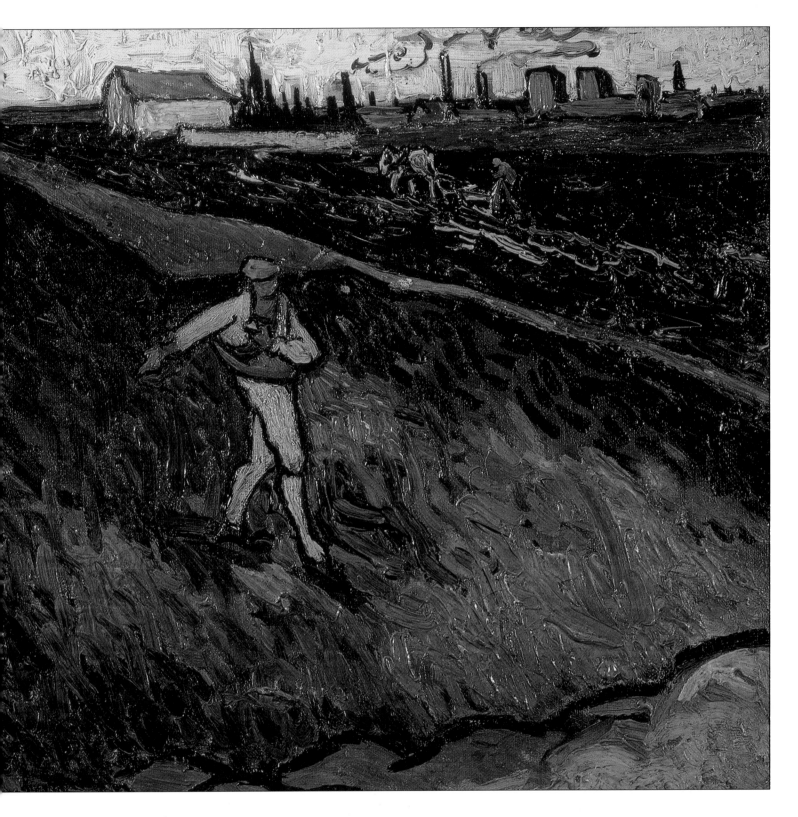

year in Paris. Still life painting was one of the great achievements of Dutch art, especially in the seventeenth century; but it came at the bottom of the nineteenth-century academic hierarchy, presumably because it offered no great occasions for pretentiousness and melodrama. In 1886 Van Gogh painted a few

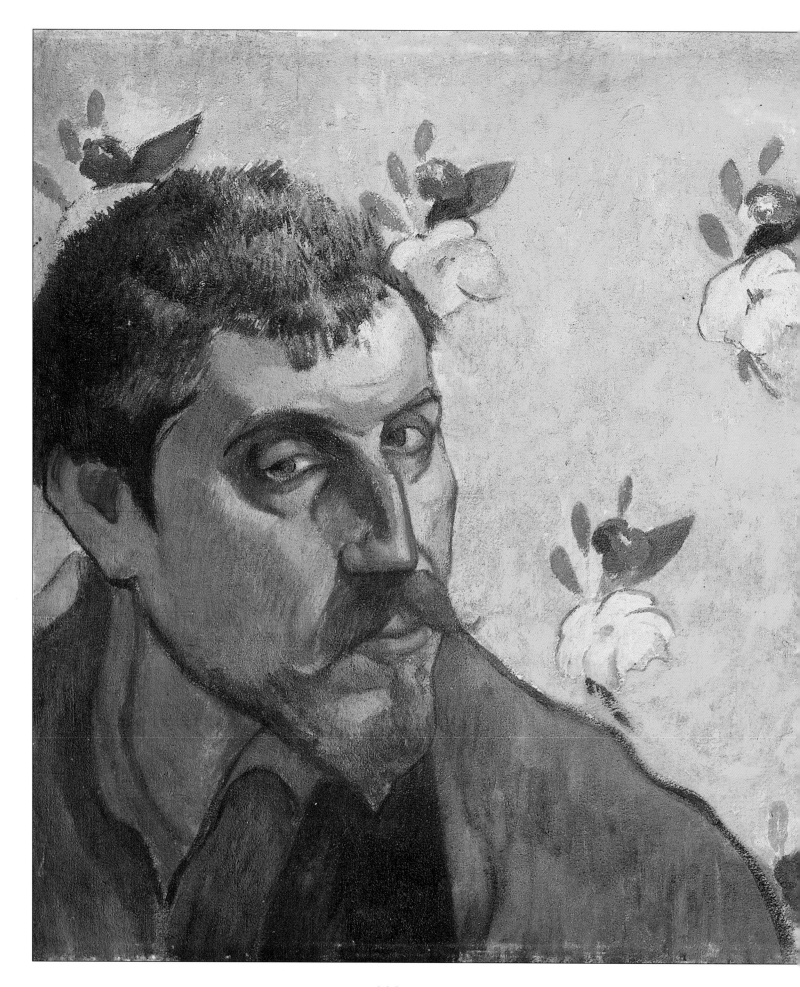

les misérables
...... Vincent
PGauguin 88

still-lifes featuring fish and the well-known *Pair of Boots*, which are thoroughly broken in and perhaps broken down, with gaping entrances and multi-creased uppers. They can be interpreted as symbols of toil, but the fact that they are both left boots suggests that some less portentous explanation is required.

Parisian Flowers

However, canvases of this kind were outnumbered by almost 40 flower paintings done by Van Gogh during 1886. He may well have begun because the Rue Laval apartment was too cramped for him to paint anything but small subjects, but he was also inspired to work in the style of an artist whom Theo had discovered some time before – Adolphe Monticelli (1824–86), a Provençal who had made something of a name for himself in the Paris of the 1860s, only to return to his native Marseilles and drop out of sight.

Monticelli was an original who used quantities of pure colour, building up his pictures into thickly impasted and modelled surfaces. He belonged to no school and seems to have painted with an intuitive urgency that made his work immensely sympathetic to Van Gogh. Heavy impasto had been a characteristic of Van Gogh's early paintings, and Monticelli's example undoubtedly encouraged him to use it again from time to time; eventually it would be an indispensable element in some of his greatest works. More dangerously, he seems to have hero-worshipped Monticelli, admiring his reputedly wild, alcoholic way of life. Van Gogh's wish to meet Monticelli seems to have triggered his first impulse to leave Paris for the south, although that soon disappeared for the time being. This was just as well since, unknown to Van Gogh, Monticelli had just died. When Van Gogh did reach Provence, he made a pilgrimage to one of Monticelli's haunts, Saintes-Maries-de-la-Mer, where he experienced Mediterranean colour in all its brilliance. Flower paintings such as *Hollyhocks in a Vase* (page 39) and *Sunflowers and Roses in a Bowl* (page 40-1) represent only part of Van Gogh's debt to the older painter, whose non-naturalistic use of colour made a deep and eventually significant impression on him. Surprisingly, even his connection with Van Gogh has failed to make Monticelli known and his popular reputation has never really recovered from his plunge into provincial obscurity during the 1870s.

A shared enthusiasm for Monticelli's work brought Vincent and Theo into touch with a Scottish picture dealer named Alexander Reid, whom Vincent had known years before at

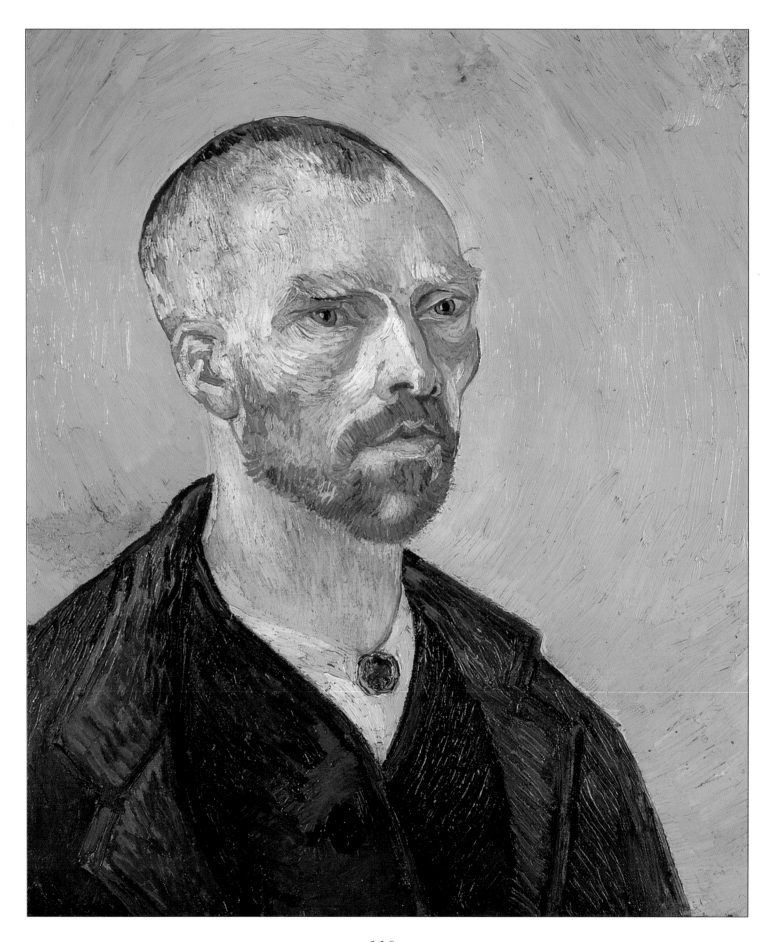

Goupil's. Reid gave Vincent one of Monticelli's paintings and, in return, Vincent twice painted his portrait. In the earlier example (probably late 1886) Reid is sitting rather awkwardly in an armchair, but the bust portrait of early 1887 (page50) is more characterful and also technically more interesting for the way in which Van Gogh has modified the pointillist brushwork, converting its calm dots into flowing, dynamic lines of force, like the patterns made by iron filings on a sheet of paper when a magnet is held beneath it.

Van Gogh's least flattering memorialist, Archibald Hartrick, saw a good deal of his fellow Scot, Alexander Reid, and recalled that 'He was a young man then, younger, I fancy, than Van Gogh'. He was only a year younger in fact, but Hartrick's memory was almost certainly accurate as far as appearances went: Reid, by no means a young-looking 32, still had the edge on the Van Gogh shown in the self-portraits (pages 51 and 59). Hartrick also makes the interesting assertion that Reid and Van Gogh resembled each other to an uncanny extent: 'The likeness was so marked that they might have been twins. I have often hesitated, until I got close, as to which of them I was meeting. They even dressed somewhat similarly, though I doubt if Vincent ever possessed anything like the Harris tweeds Reid usually wore.' Apart from their common ginger-red hair, this is not borne out by the painted portraits of Reid and Van Gogh (among other things Reid seems to have been a far more dapper and better-groomed figure), but perhaps when they were wearing hats, as everybody then did in the street, the resemblance became more marked. It is hard to imagine any reason why Hartrick should have invented a fictitious resemblance, since there were no significant correspondences between the two men's lives: in 1889 Reid, having finished an extended 'work experience' tour of duty in Paris, went back to the family firm in Glasgow and pursued a relatively uneventful career as a picture dealer, quite unlike Van Gogh's short and sensational existence after he left Paris. Relations between Reid and the Van Goghs seem to have cooled before he left, but Vincent bore him in mind as a useful contact, hoping in an optimistic moment to find a market for his work in Scotland.

Vincent, Theo and 'S'

Although most of his schemes foundered, Van Gogh was certainly aware of the commercial side of art; it was, after all, part of his early experience as well as being the means by which his brother

earned his living. On the other hand. Vincent was often resentful of Theo's failure to sell his work, refusing to understand the difficulties of his brother's position. Goupil's was now known as Boussod and Valadon's, and Theo managed the smaller of its two Paris branches, on the Boulevard Montmartre. His 'advanced' tastes in art were not shared by his employers and he was only grudgingly allowed to use the upstairs gallery to show paintings by Monet and Degas, who had made their Parisian debuts in the 1860s. Even so, the profit margins on their works were derisory by comparison with those of the Gérômes and Meissoniers – the famous academic masters – whose grandiose compositions were retailed at the main Boussod and Valadon showroom in the Avenue de l'Opéra.

In these circumstances Theo could not have risked displaying works by an unknown like Vincent; and if he had done so, the fact that Vincent was his brother would have cast doubt upon his probity as well as his judgement. The best that he could do was to try and interest other dealers in Vincent's paintings; but he had no success. Before Vincent's arrival, Theo himself had not been convinced that his brother had any pronounced ability, since his canvases inevitably suffered when set beside those of the major Impressionists. Theo gradually revised his opinion during the two years that Vincent spent in Paris, but this did little to ease their personal relations, which were often strained.

The first year was particularly difficult, since they got off to a bad start in the Rue Laval. In June 1886 they moved to the larger apartment at 54 Rue Lepic, which boasted two bedrooms and at least some space – still quite restricted – where Vincent could work. However, the improvement was slight, since Vincent remained maddeningly difficult to live with; he created a wilderness of bohemian squalor, got into heated arguments that drove away visitors, raged and sulked, and pursued the tired Theo into his bedroom and kept him talking most of the night. One of Theo's friends, Andries Bonger, noted how ill he looked and blamed Vincent, who made his life a burden to him and reproached him 'with all kinds of things of which he is quite innocent'. At about this time Vincent seemed to be recovering from his earlier ailments while Theo went into a decline, a state of affairs that it is tempting to read as symptomatic of their unbalanced but symbiotic relationship.

In the summer of 1886 Theo visited his family in Holland, doubtless pleased to get away from the strain of life at the Rue

Lepic. Vincent cannot take all the blame for his brother's worn-out state, since Theo had also fled from a different kind of problem. His difficulties with his mistress had not ended with Vincent's arrival and she continued to visit the Rue Lepic even when Theo was in Holland, evidently making scenes and finally moving in, despite the fact that Vincent was still in residence and sharing the apartment for the time being with Andries Bonger. The details of the affair are obscure and the woman is known only as 'S'; presumably Theo had discarded her and she was unwilling to accept that their relations were at an end. Vincent and Andries seem to have been frightened of what she might do and at a loss for a way of making her go. Vincent even recklessly suggested that it might divert her wrath if he married her; quite what he expected to achieve by this is never likely to be known. Although the suggestion was probably no more than a momentary impulse, 'S' must be

given a place, along with Eugénie Loyer and Sien Hoornik, on the list of assorted, peculiarly unsuitable women with whom he contemplated matrimony. After Theo's return we hear no more of 'S', who presumably decamped or was forcibly ejected.

The exact timing of many of Van Gogh's Parisian encounters has so far proved impossible to establish. He may have been at Cormon's in the spring or the autumn of 1886, although the balance of evidence seems to favour the spring; he seems likely to have met Lautrec and Anquetin in the studio, but it is possible that these contacts were not made until 1887; and so on. What is less questionable is the impact of new styles and techniques on his work. In 1886 he had clearly become acquainted with Impressionism and had come under the powerful influence of

BELOW: **Starry Night over the River Rhône** 1888
MUSÉE D'ORSAY, PARIS

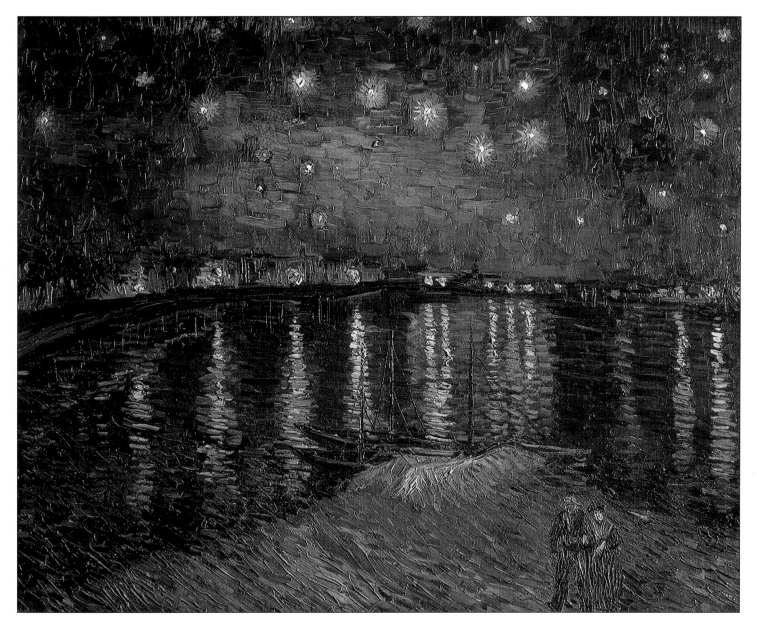

Monticelli. But he was still finding it difficult to break with Dutch academicism, so that his pictures varied greatly in tone, from the brightness of *The Moulin de la Galette* (page 36) and the flower paintings to the relative drabness of *The Outskirts of Paris* (pages 42-43), painted several months later. Then, from about the spring of 1887, earth colours effectively disappeared from his palette and he was at last a thoroughly 'modern' artist. This found expression in two self-portraits in which, uniquely, he appears as quite the smart Parisian, and with a new group of outdoor Montmartre paintings, such as *The Allotments* (pages 46-7), which reflect the village atmosphere of the quarter.

All through 1887 Van Gogh continued to paint prolifically, with increasing mastery and yet in a variety of styles that makes his work hard to describe in general terms. It was during this period that he engaged most closely with pointillism, although most often using the technique in cavalier fashion in, for example, *Woods and Undergrowth* (page 67), the *Portrait of Alexander Reid* and *The Restaurant de la Sirène* (page 53). Yet these canvases are roughly contemporary with *A Fisherman in his Boat* (page 49), in which the brushstrokes, although visibly marshalled, are long and strong, and also with the charming watercolour *Street Scene* (page 57) and the dramatic *Self-Portrait with a Straw Hat* (page 59).

It may be significant that Van Gogh's eclecticism as a Parisian painter was matched by the range of human contacts that he was still making in the city. Among them was one of the most intriguing non-artists in the history of nineteenth-century art: Julien Tanguy, usually known as Père Tanguy. Van Gogh met him late in 1886, presumably at Tanguy's shop, which sold artists' materials. A grizzled, chunky little man, Tanguy (1825–94) was over 60, with a a revolutionary past. He had taken part in the Paris Commune, a radical political authority that won power in the capital during the Franco-Prussian war, and was briefly imprisoned when the Commune was bloodily suppressed by government forces in May 1871. Having turned paint-seller and acquired his own premises in the Rue Clauzel, he became the friend and helper of artistic revolutionaries, willingly exchanging materials for finished canvases by painters he admired, even though their work was virtually impossible to sell. As he remained solvent, his admirations were patently few, but they were choice. By 1886 he was acquiring many canvases by Cézanne, who nevertheless owed him an alarming amount of money; and he would soon bring large numbers of Van Goghs into his 'museum'. Tanguy even succeeded

LEFT: **Portrait of Eugène Boch, 'The Poet'** 1888
MUSÉE D'ORSAY, PARIS

in selling one of Van Gogh's paintings for 20 francs – better than nothing, but still a derisory sum that probably failed to cover the cost of the materials. Contrary to legend, Van Gogh did sell a few pictures during his lifetime, although not through 'official channels' or, with a single exception, at reasonable prices.

Van Gogh painted three portraits of Tanguy; two of them are closely similar, emphasizing the old man's working-class origins and 'Buddha-like' personality (page 60). Despite his wife's objections, Tanguy was generous with credit and after Van Gogh left Paris he had some difficulty in recovering the money due to him. Vincent, who had obviously never kept a proper record, denied that he owed so much, but Theo eventually paid up. Evidently there were no hard feelings, for Theo later stored quantities of Vincent's works in Tanguy's attic, and after the painter's death the old man was among the mourners at the funeral.

Friends and Rivals

During the early months of 1887, Van Gogh's immersion in Parisian life was so complete that he seemed to have become a true citizen of the capital. He and his friends now spent much of their leisure time at the Café du Tambourin on the Boulevard de Clichy. Run by an Italian ex-model, Agostina Segatori, it was a place with a consciously arty atmosphere; the tables and stools were designed to resemble tambourines, as we can see in Van Gogh's portrait of Segatori (page 63), and she and her serving girls wore Neapolitan costume at work. The picture shows her, cigarette in hand, sitting pensively in the café with a mug of beer beside her. The glimpse of a Japanese print on the wall suggests that the painting was done during an exhibition of such prints, organized by Van Gogh at the café in March 1887.

A Love Affair

For a time Van Gogh was a regular at the Tambourin, having arranged to trade pictures for meals; as the food at the café was

known for its lavishness, he may well have been properly fed for the first time in years. Rumour had it that his contacts with La Segatori were more intimate than those of customer and proprietress, and this seems to be confirmed by the volatile nature of their relationship. It is also tempting to link this affair with the two self-portraits, painted in about March 1887, which are the only ones in which Van Gogh presents himself as positively smart, wearing neat, small-lapelled summer jackets and fashionable-looking hats.

Sex was certainly on Van Gogh's mind, to judge from three remarkable canvases that he painted at about this time. In Holland he had had no opportunity to work from a nude model for some years, but at the Antwerp Academy he had produced a number of fine drawings which emphasized the beauty of the female body in classical fashion. But there is nothing to prepare us for the ripe, rich sexuality of the paintings, which feature a reclining brown-skinned woman, her eyes closed, who seems to float in sensual abandon on an expanse of silky sheets and hangings. In two of the pictures she wears white stockings that end just above the knee, but despite this staple erotic element, neither her face nor her body are conventionally beautiful. The direct physicality of her large hips and heavy breasts and thighs is complemented by her face; in the single painting and the drawing in which it is visible, it has a mask-like post-coital quality that has shocked even modern writers into describing it as 'bestial' and 'simian'.

The woman's identity is unknown, but it seems more than likely that the model was La Segatori herself. Allowing for the different settings and circumstances, the woman in the café portrait bears some resemblance to the dark, naked odalisque, and they also look about the same age: La Segatori, who had posed for Corot (dead since 1875), was probably in her forties. Her physical type is suggested by the fact that she had also posed for the immensely popular harem and slave-market scenes painted by Jean-Léon Gérôme. Evidently his paintings of this nude woman meant something special to Van Gogh: for some reason he signed almost none of his Parisian works, but one of the reclining nudes has 'Vincent' painted across the bottom right-hand corner in unusually large characters!

Unfortunately the affair was soon over. By July, Van Gogh and Segatori had parted and there was bad feeling over the ownership of some of the paintings left behind at the café. Van Gogh stopped eating there, making a similar canvases-for-meals arrangement with a new establishment, the Restaurant du Chalet in the Avenue

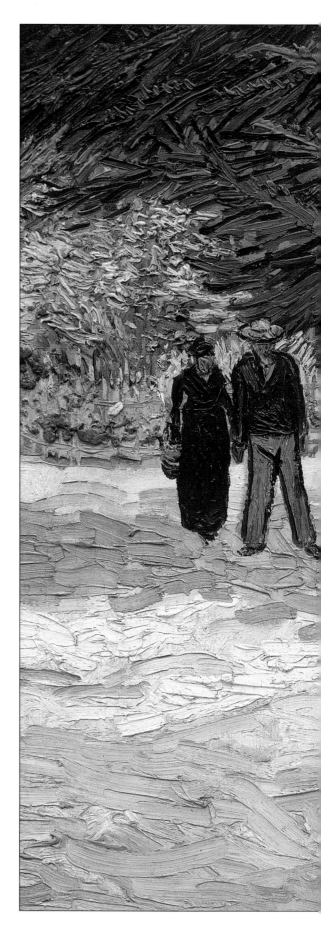

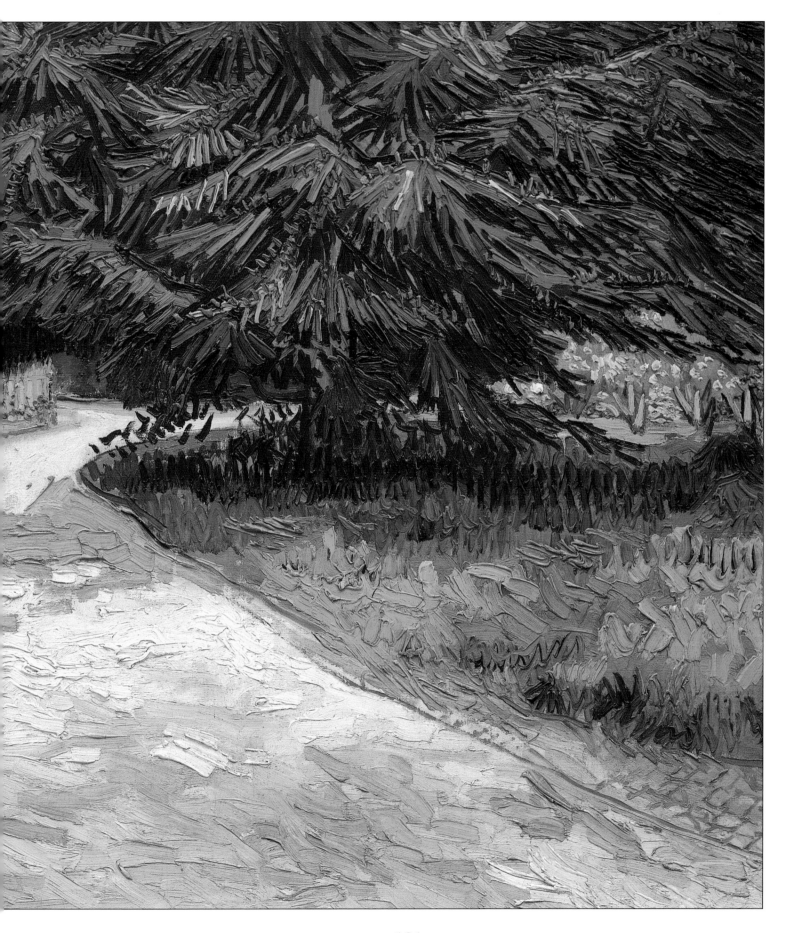

PREVIOUS PAGES
120-1: **The
Poet's Garden**
1888
PRIVATE
COLLECTION

de Clichy. However, *The Italian Woman* (page 74), painted around the end of the year, may be a portrait of Segatori, or perhaps a reminiscence of her, although its main interest for us lies in the extent to which Van Gogh had by then broken with literal naturalism, producing a foursquare, idol-like image.

There were other women in Van Gogh's life around this time, unless he was exaggerating when he wrote to his sister Wil, 'I still go on having the most impossible, and not very seemly, love affairs, from which I emerge as a rule damaged and shamed, and little else.' As if he had forgotten Eugénie, Kee, Sien and Margot, he continued, 'And in my opinion I am quite right in this, because I tell myself that in the years gone by, when I should have been in love, I gave myself up to religious and socialistic devotions, and considered art a holier thing than I do now.' In this context, 'socialistic' must mean something like the modern term 'social work' and presumably refers to Van Gogh's activities in the Borinage, since his sympathy for the wretched was never linked with a definite political philosophy or programme. The underlying feeling in this passage – of fear that he might have wasted his life – seems to have haunted Van Gogh during this period. It sometimes led him to believe that love and art were mutually exclusive and that 'this rotten painting' had ruined him. To Theo he quoted a saying that 'The love of art makes one lose real love'.

Meanwhile his involvement with art and artists became more rather than less intense. Tanguy's shop served as a meeting place for the avant-garde and it was there that Van Gogh made friends with two young men who belonged to rival groups that regarded each other with fierce ideological dislike. Paul Signac (1863–1935) was a Neo-Impressionist, devotedly following the 'dotting' trail blazed by Georges Seurat, whereas Emile Bernard (1868–1941) adhered to the developing cloisonnist style, with its pools of colour and strong, simplified outlines. Both of these artists – much younger men than Van Gogh – became formidable theoreticians whose writings illuminated the history of modern art. Bernard was more personally combative, and indeed his critical faculty soon overpowered his creativity; he is now mainly remembered for his influence on Gauguin and for his championing of Cézanne. Surprisingly, Van Gogh made friends with both Signac and Bernard, although he never subscribed wholeheartedly to the theories of either. During the spring and summer of 1887 he made a number of painting trips down river to the pleasure resort of Asnières – sometimes in the company of Signac, sometimes with

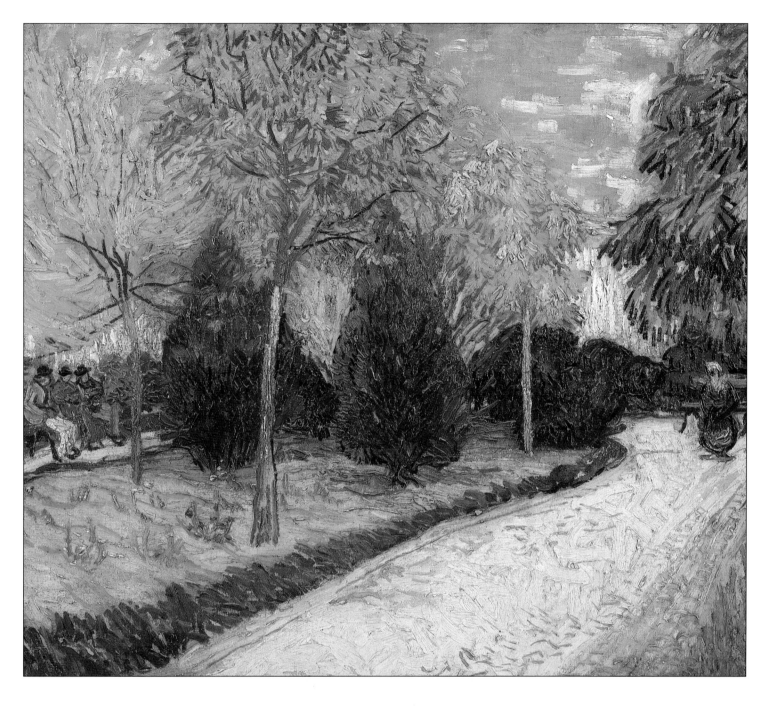

Bernard, but never (so strong were the sectarian rivalries) with both. He painted the local restaurant (page 53), but also executed a number of river, park and woodland scenes, as well as *Wheatfield with a Lark* (pages 64-5). With its breeze-blown stalks and rising lark, this painting is reminiscent of Impressionism, not in its technique so much as in the sense of joy in the natural world that it imparts. It inevitably evokes comparisons with other wheatfield paintings by Van Gogh, including the last, *Wheatfield with Crows* (pages 252-3), which has so often been seen in a sinister light because of the artist's suicide.

ABOVE: **The Public Gardens, Arles, in Autumn** 1888 PRIVATE COLLECTION

The only surviving photograph of Van Gogh as an adult was taken on one of his expeditions with Bernard. Unfortunately, of the two men, seated at a table beside the river, it is Bernard who is facing the camera; all that can be seen of Van Gogh is a back view of his hat and coat. This is tantalizing; but perhaps it is appropriate that we should know Van Gogh only through painted images, most of which are his own.

The antagonism between his friends, and between the rival schools of painting they championed, was a disillusioning experience for Van Gogh, who was moving towards a new crisis. He was starting to feel his age and, despairing of marriage, children and a normal

settled life, idealized the artist's way of life and dreamed of becoming part of a mutually supportive brotherhood or guild. As a beginning, he habitually tried to persuade the artists he met to exchange canvases with him, presumably in the belief that such demonstrations generated feelings of solidarity. His interest in such ideas was probably strengthened by his contacts with Camille Pissarro (1830–1903), the oldest and also the most overtly radical-minded of the first-generation Impressionists; Pissarro's son Lucien (1863–1944) also became a friend of Van Gogh's. Still only in his fifties, Camille Pissarro was a patriarchal figure with a big white beard, fatherly in attitude as well as appearance. He enjoyed working with fellow artists, was always willing to learn and because of his kindly, undogmatic personality was a profoundly influential teacher. Cézanne and Gauguin – both moody, difficult personalities – acknowledged him as their master and never succeeded in falling out with him. When Van Gogh met him, Pissarro had recently demonstrated his open-mindedness by abandoning his old painting style and taking up pointillism (although in the long run the technique proved too constraining and lacking in spontaneity, and he gave it up).

Pissarro's political radicalism had by this time crystallized into anarchism, a form of socialism based on the belief that men and women can live together co-operatively, in free association, without the need for any state apparatus. In practice Pissarro seems to have thought in terms of rural communities; like Van Gogh he had admired Millet's works and in the 1880s he painted a number of scenes of peasant life. He had been involved in co-operative ventures and had attempted to found the original Impressionist association (1873) on egalitarian principles, only to meet with indifference or hostility from his colleagues. His influence may well have fortified Van Gogh's growing conviction that there was a better life to be had outside the city, and that artists might live together harmoniously in some 'new Japan'.

Japonaiseries

Ever since his revelation in Antwerp, Van Gogh had greatly admired the art of Japan and, like many Europeans, he idealized the society that produced it. Although he had organized an exhibition of prints at the Café Tambourin in March 1887, he absorbed them into his own work during the following autumn. Characteristically, he learned by making copies of two prints in his

OVERLEAF PAGES 126-7:
The Sower 1888
PRIVATE
COLLECTION

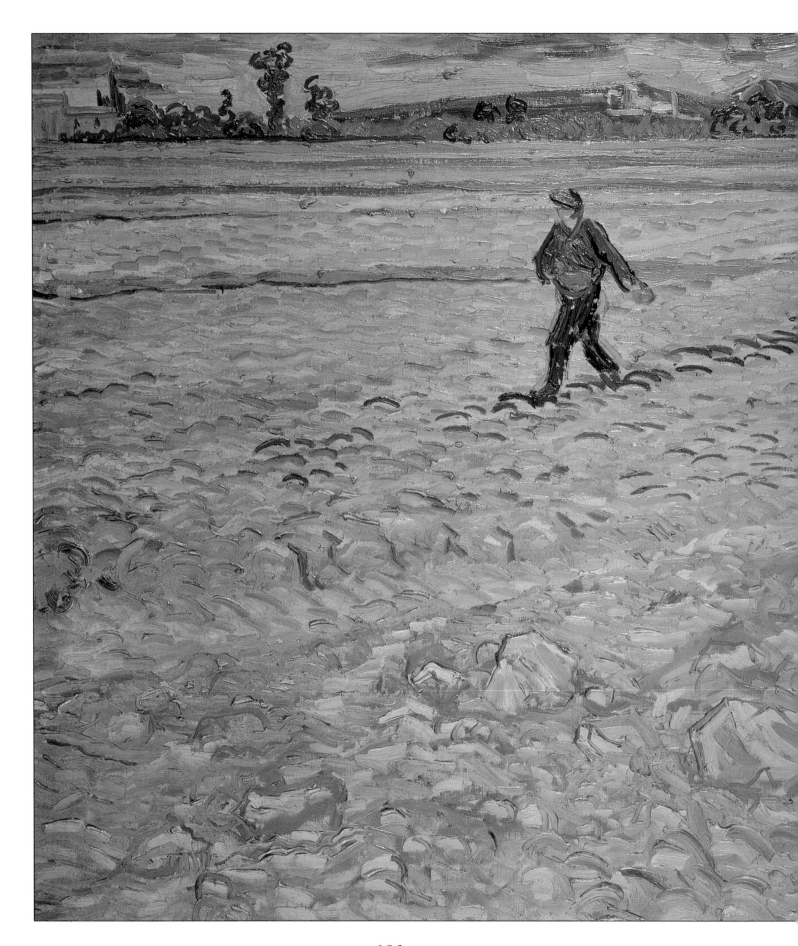

own collection, Hiroshige's *Flowering Plum Tree* and *Sudden Shower at Atake*, and by making a variation on Eisen's *Oiran* (page 71), based on the cover of a magazine, *Paris Illustré*, published in May 1886. In all three, Van Gogh was not content to copy. The 'Hiroshiges' differ from the original in details and are decorated with made-up 'Japanese' characters, while *Oiran* is painted with an un-Japanese (or un-print-like) freedom and equipped with a large, assertively painted frame that further distanced the canvas from the original. In the border of his *Oiran* Van Gogh painted a crane and a frog, two creatures whose names were used in French slang to denote prostitutes; this is evidently one of Van Gogh's rare jokes, referring to the subject of the original, whom romantic westerners usually describe as a courtesan.

These pictures belong to the kind of pseudo-Japanese art that is known as *japonaiserie*; it was high fashion in the nineteenth century, when Japan played the part of a never-never land on which westerners could impose their fantasies. There is also a hint of the 'Japanese' in a number of still lifes that Van Gogh painted in late 1887; and the 'Buddhistic' portraits of Père Tanguy (page 60), with their background of Japanese prints, reaffirm their impact on Van Gogh. At the same time they show him adapting rather than taking over the prints' style and use of colour; above all, his brushstrokes (absent, of course, from the prints) remained the essential means by which he built up his paintings. In *Père Tanguy*, *The Italian Woman* (page 74) and several self-portraits from late 1887 (page 73), the strong hatched brushing gives their subjects an idol-like appearance that belongs to a 'Japan' entirely of his own imagining.

While he dreamed of Japan, he also acted with some success as an exhibition organizer. Holding a contemporary show was a more difficult proposition than an exhibition of Japanese prints, but in November 1887 Van Gogh persuaded the proprietor of the Restaurant du Chalet (where he received meals in return for paintings) to let him use the large, high hall of the restaurant, which is said to have been spacious enough to allow the hanging of a thousand canvases. Van Gogh's show was smaller than that, but it brought together works by Bernard, Anquetin, Toulouse-Lautrec, a Dutch painter named Hans Koning and Van Gogh himself. According to Emile Bernard, there were about 100 Van Goghs and these gave the exhibition its dominant impression of life and colour.

To Van Gogh, he and his friends were 'the painters of the Petit Boulevard' – the 'Little Boulevard' as opposed to the Grand

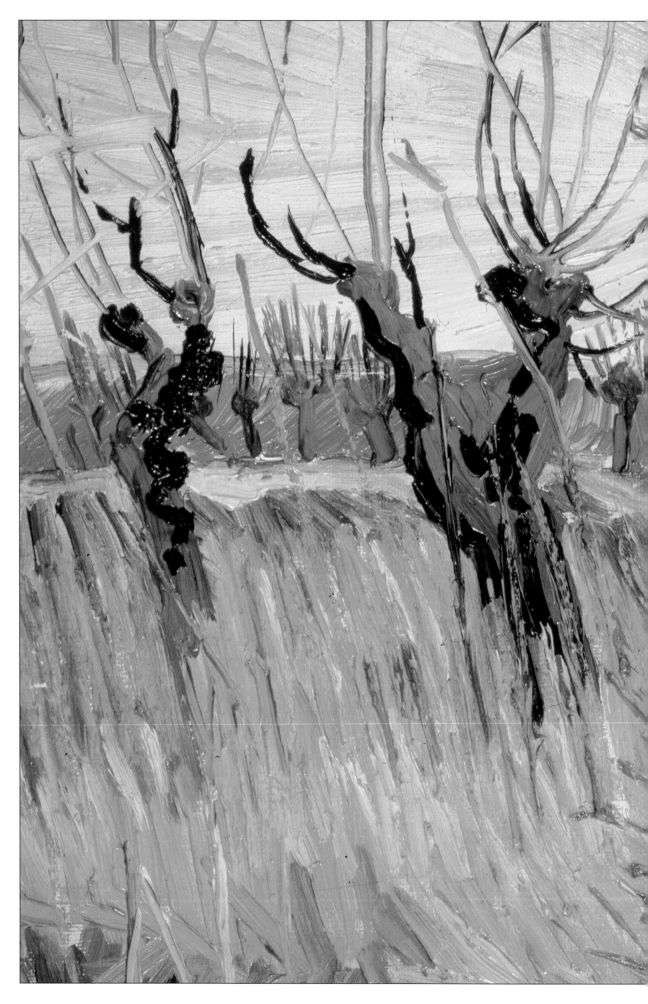

RIGHT: **Pollarded Willows and Setting Sun** 1888
RIJKSMUSEUM
KRÖLLER-MÜLLER,
OTTERLO

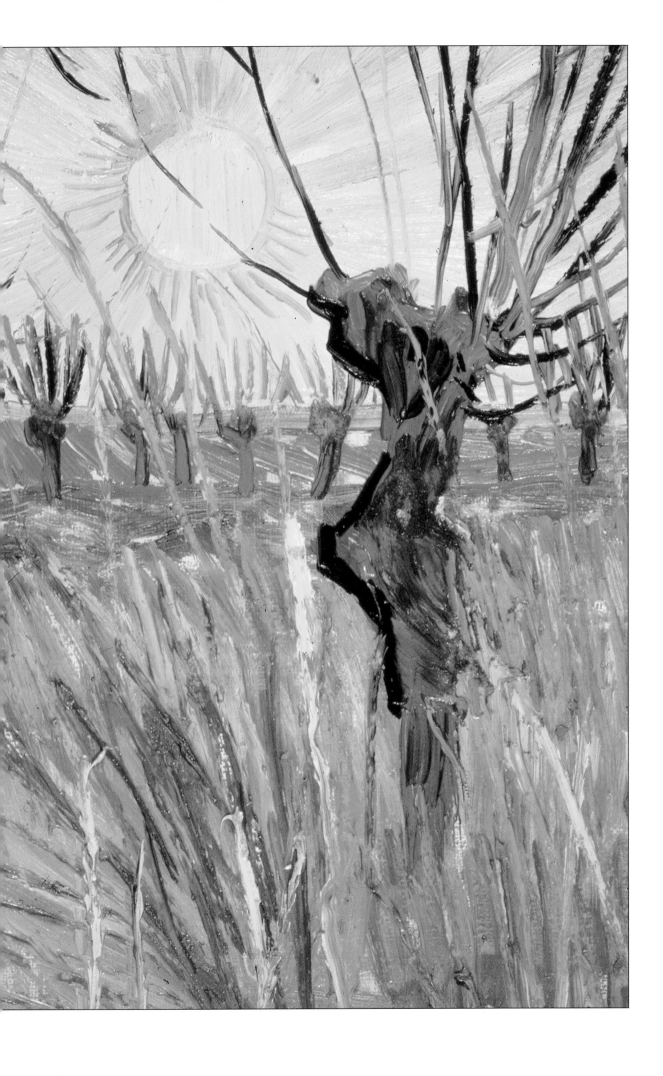

Boulevard, where high-priced paintings could be seen and bought. Originally he had proposed to invite the Neo-Impressionists to exhibit, but their participation was vetoed by the others. Seurat, whom Van Gogh had never met, did come to see the show, but at a time when Van Gogh was not present. Pissarro turned up with a minor Impressionist, Armand Guillaumin (1841–1927), whom Van Gogh had got to know shortly before, and Gauguin, just back from Martinique, also looked in. One artist who was present, Antonio Cristobal, later claimed that Pissarro, Guillaumin and Gauguin sent in works while the exhibition was in progress. As the uncertainty about this point demonstrates, Van Gogh's exhibition was a 'fringe event' that made little impact on the public, the critics, or even the diners in the Restaurant du Chalet. However, Bernard and Anquetin did sell works, so Van Gogh felt that the effort had been worthwhile. His lack of commitment to any one group was emphasized when he also exhibited alongside Seurat and Signac in the rehearsal room of the new avant-garde Théâtre Libre run by André Antoine.

RIGHT: **Les Alyscamps** 1888 RIJKSMUSEUM KRÖLLER-MÜLLER, OTTERLO

Enter Gauguin

Whether or not Gauguin exhibited with the painters of the Petit Boulevard, his arrival in Paris was a fateful event in Van Gogh's life. It is possible that the two men had met briefly the year before, but their famous friendship certainly began in the winter of 1887–8, when Gauguin, Van Gogh and Emile Bernard formed a threesome. Five years older than Van Gogh, widely travelled, with an ex-sailor's toughness and apparent self-assurance, Gauguin could pass for a heroic figure, and when Van Gogh saw the intense tropical colour of his friend's Martinique canvases, he was doubly admiring of a man who appeared to have lived and painted like a master. Gauguin had once had to struggle and intrigue for any kind of acknowledgement of his gifts; now he played up with a will to Van Gogh's illusions.

Paul Gauguin (1848–1903) became an artist by a route every bit as bizarrely circuitous as Van Gogh's. The son of a journalist, he spent part of his childhood in Peru, which may or may not account for his lifelong fascination with exotic places. He joined the merchant marine at 17, served in the Franco-Prussian war of 1870–1 and then took a job with Bertin's, a stockbroking firm. He prospered, married a Danish woman, Mette Gad, and eventually became the father of five children. His income enabled him to buy

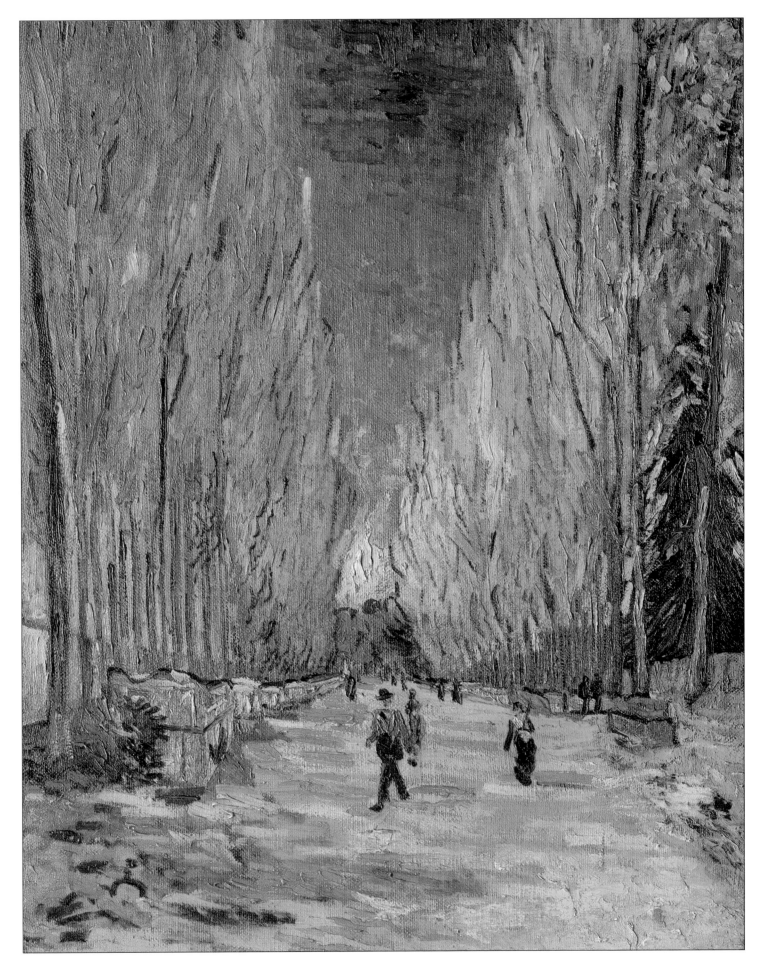

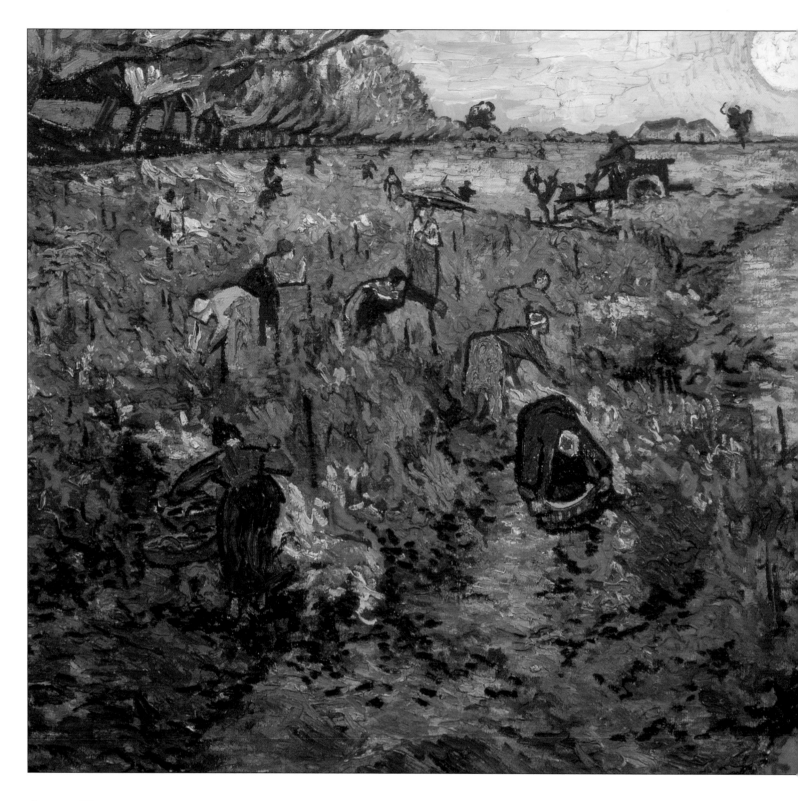

ABOVE: **The Red Vineyard** 1888
PUSHKIN MUSEUM, MOSCOW

pictures and do a little painting of his own at weekends. The popular image of Gauguin is of a man who broke with his conventionally successful life through a single irresistible impulse, but the truth is less dramatic. During the 1870s he became steadily more absorbed by painting and in 1876 even had a work accepted for the official annual exhibition, the Salon. Not long afterwards he got to know Pissarro, working regularly with him in the countryside outside Paris at Pontoise and Osny. Thanks to Pissarro's advocacy

he was able to exhibit with the Impressionists in their last five shows (1879–86), although his presence was probably tolerated at first as that of a well-off amateur who regularly purchased the works of his professional colleagues.

In reality Gauguin worked hard to master skills that had become second nature to other artists of his age. In an attempt to improve his standing among the Impressionists he took a significant part in organizing the exhibitions; convinced of his own shrewdness, he patently enjoyed the intrigues and in-fighting that inevitably took place. But trying to keep two careers going was a strain, and he would certainly have preferred to start painting full-time. Whether he would have done so without a little help from fate is another matter. In 1882 there was a general financial collapse which greatly reduced his income, and this made it relatively painless for him to give up his job the following year, persuading himself that in the new situation painting offered greater opportunities than stocks and shares!

In 1883–4 several months spent in the provincial city of Rouen, where Gauguin expected to be welcomed by an affluent middle-class clientele, showed that commercial success in painting was not so easily achieved. Mette decamped for Copenhagen and Gauguin soon followed her, spending a long, miserable winter with in-laws who were even less appreciative of his pictures than the Rouen bourgeoisie. In June 1885 he left Mette in Copenhagen and returned to France; they corresponded and made plans for years, but never in fact lived together again.

Like many painters of his generation, Gauguin was unable to find himself as an artist while tied to a family (another of those curious differences between Impressionists and Post-Impressionists), and it was from this time that he emerged as a distinctive personality. His painting was still fundamentally Impressionist, in a style derived from Pissarro, although it already showed signs of a taste for more prominent and solid figures and brooding or mysterious atmospheres.

Impatient to find a simpler and more meaningful way of life (and one that was cheaper), in 1886 Gauguin made the first of several trips to Brittany, where older non-French customs and traditions still lingered. At Pont-Aven there was an artists' colony where Gauguin could lord it over younger and less metropolitan figures and the local people were ready to oblige by donning their not-too-long-discarded folk costumes for the benefit of the newcomers.

This was the first manifestation of Gauguin's primitivism, the urge to break with city life and civilization that would finally lead

him to Tahiti, the Marquesas and a place in artistic legend. His 1887 trip to Martinique had represented his first attempt to escape for good. To his wife he wrote 'I am off to Panama to live like a savage', before leaving France with high hopes in the company of a disciple named Charles Laval. They were quickly disillusioned and instead of living on fruit and sunshine, found themselves compelled to work as labourers for the company that was building the Panama Canal. They finally managed to get away to the island of Martinique, 'a fine place where life is easy and cheap', until their idyll in a hut beside the shore was shattered by the onset of a variety of tropical diseases.

A malarial Gauguin worked his way back to France, arriving in poor condition but with a handful of everyday scenes and landscapes painted in Martinique. Their brilliant colours, strongly indicated forms and density of design marked a definitive break with the atmospherics of what we now call Impressionism. (Gauguin, like Van Gogh, used the term more widely, almost as a synonym for 'avant-garde', so that he referred to himself for years to come as an Impressionist.) Gauguin was moving in roughly the same direction as Bernard and Anquetin, towards a heightened and simplified style of painting, and indeed he and Bernard would quarrel over which of them was the true originator of Synthetism/cloisonnism.

Van Gogh's well-founded admiration for the Martinique paintings got his friendship with Gauguin off to a good start and the two artists met frequently during the winter of 1887–8. Gauguin had the pleasure of playing the master to Van Gogh's hero-worshipper, but he also had a more practical reason for cultivating Vincent: Theo. For 'painters of the Petit Boulevard', Theo's gallery on the Boulevard Montmartre offered their best chance of making a sale; and Gauguin's character contained a strong streak of opportunism and commercial ambition, although most of his self-interested manoeuvres were no more successful than Vincent's (usually) more idealistic schemes. In this instance, however, his friendship with Vincent almost certainly hastened Theo's decision to take a group of Gauguin's paintings in December 1887.

Gauguin was delighted, since Theo did sell some of his work, and he believed – or at least told his wife – that the gallery was becoming 'the centre of Impressionism'. It was true in a way, but the implied prediction – that the gallery would soon put Gauguin and his colleagues on the map – was wildly over-optimistic. In the meantime,

RIGHT:
L'Arlésienne
1888
METROPOLITAN
MUSEUM OF ART,
NEW YORK

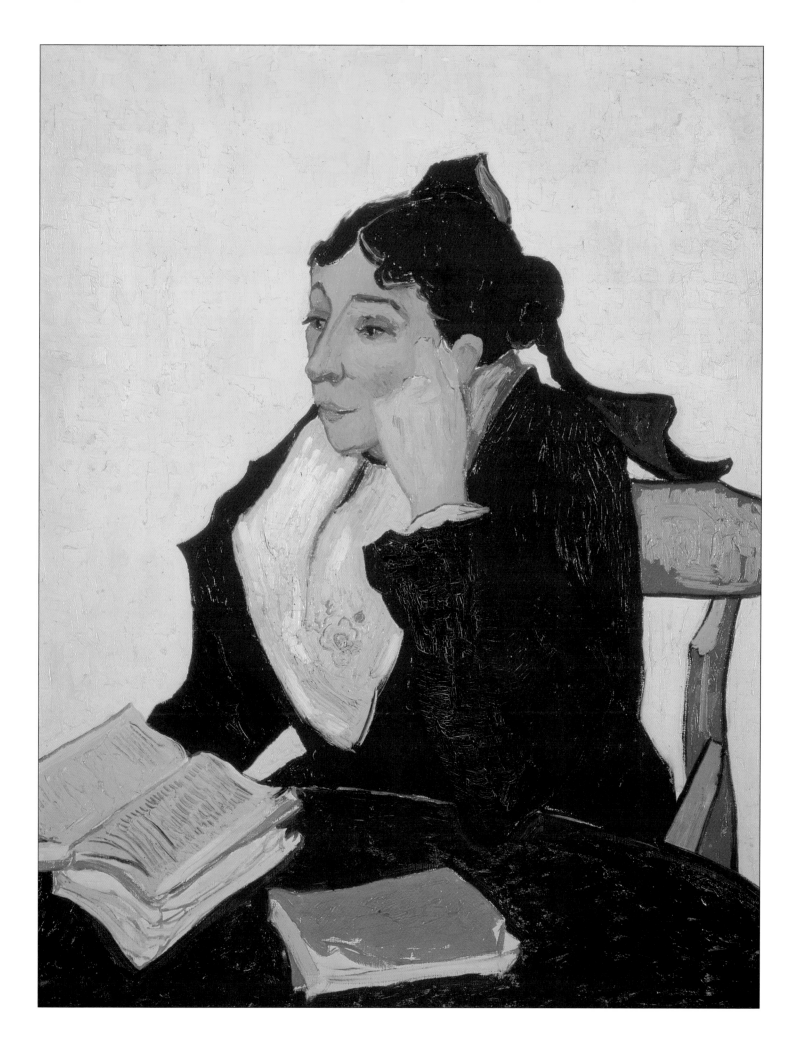

Gauguin decided to return to his 'primitive' haunts in Brittany. He left Paris in February 1888, and it is difficult to believe that Van Gogh's almost simultaneous departure for the south was purely coincidental. Unhappily, they were to meet again.

Paris Blues

Gauguin's decision was probably the final impulse that prompted a run-down, discontented Van Gogh to leave Paris – and perhaps, some of his troubles – behind. The year 1887 was one of roller-coaster emotions. In March his relations with Theo reached crisis-point, to judge by Theo's laments in a letter to his sister Wil: their best-friendship was over, Vincent disliked and despised him, his home life was almost unbearable, Vincent drove everyone away, Theo wished he would go and live by himself. 'But if I were to tell him to leave, it would just give him a reason to stay' – which presumably means that, knowing he was not wanted, Vincent would take a spiteful pleasure in staying put. This lights up a side of his personality that we rarely glimpse, as does Theo's perception that 'It is as if he were two persons: one marvellously gifted, fine and delicate, the other selfish and hard-hearted'. He switched from one person or mood to the other, finding arguments to support each: the impression given is of a torrent of pseudo-reasoning and self-justification raining down on the hapless Theo. In the same letter Theo recognized that his brother was 'his own enemy', making life difficult for himself as well as others, and it was clear that Theo had no serious intention of abandoning him.

Not long afterwards the difficulties mysteriously disappeared and the brothers became closer than ever. The only known explanation, offered by Theo in another letter to Wil, was that 'it did no one any good to go on as we had been doing' – the kind of rational consideration that comes into play after a conflict is resolved, but rarely has much to do with resolving it. One possibility is that Vincent's affair with La Segatori or his 'unseemly' affairs in general may have turned his attention outwards, relieving the tension in the apartment. Another is that the growing seriousness of Theo's attachment to Andries Bonger's sister Johanna may have influenced the attitudes of one or both brothers. Moreover Theo's belief in Vincent's talent was steadily growing stronger and that may well have made him more tolerant of his brother's failings. All these explanations are purely speculative; what seems certain is that the peace made between

the brothers was genuine and, despite occasional tiffs, enduring.

The timing of the improvement is all the more surprising since Theo's return to Holland in the summer of 1887 strengthened his relations with Jo Bonger, making an engagement seem imminent. Vincent knew that marriage would break up the Rue Lepic household and must have feared that the bond between him and Theo would be weakened. He dutifully sent congratulations (which proved premature) in a letter written while Theo was still in Holland, but added a hardly friendly word-picture of his brother as a successful dealer with a big house, following up with the comment that 'It's better to have a gay time [as the imaginary plutocratic Theo would have] than to commit suicide' – which could only be interpreted as a threat or a cry for help. The rest of the letter ranged over his feelings of being burnt-out, having sacrificed love for the sake of art, and yet of being 'enough of a lover not to be a real enthusiast for painting'. It may be of some significance that, in the same letter, he described his still friendly feelings towards Agostina Segatori, who appears to have had an abortion or miscarriage and to have been in serious financial difficulties. As so often, he bemoaned his financial dependence on Theo, adding bitterly that he hoped to make progress so that Theo could show his work without compromising himself. Then 'I will take myself off somewhere down south, to get away from the sight of so many painters who disgust me as men'.

It is possible that too much has been made of this depressing document, since it is one of our few pieces of direct evidence about Van Gogh's feelings during his Paris years. We have no idea what happened when Theo returned and can only infer from letters several months later that good relations were maintained. But it seems likely that Vincent's feeling of having wasted his life was long-lasting, like his disillusion with the painters who disgusted him as men. Although violent and opinionated in so many respects, Van Gogh had tolerantly concluded that there was no single path that all artists must follow; the refusal of pointillists and cloisonnists to acknowledge any merit in each others' works, and the intrigues and back-biting in the cafés, disillusioned him and made his dreams of artistic brotherhood seem like crazy fantasies. A true dreamer, Van Gogh blamed the corrupt city and imagined that everything would be different in a peaceful, sunlit 'studio of the south'. A memoir by his friend Emile Bernard records his visions at their most expansive: 'gigantic exhibitions, philanthropic communities of artists, colonies to be founded in

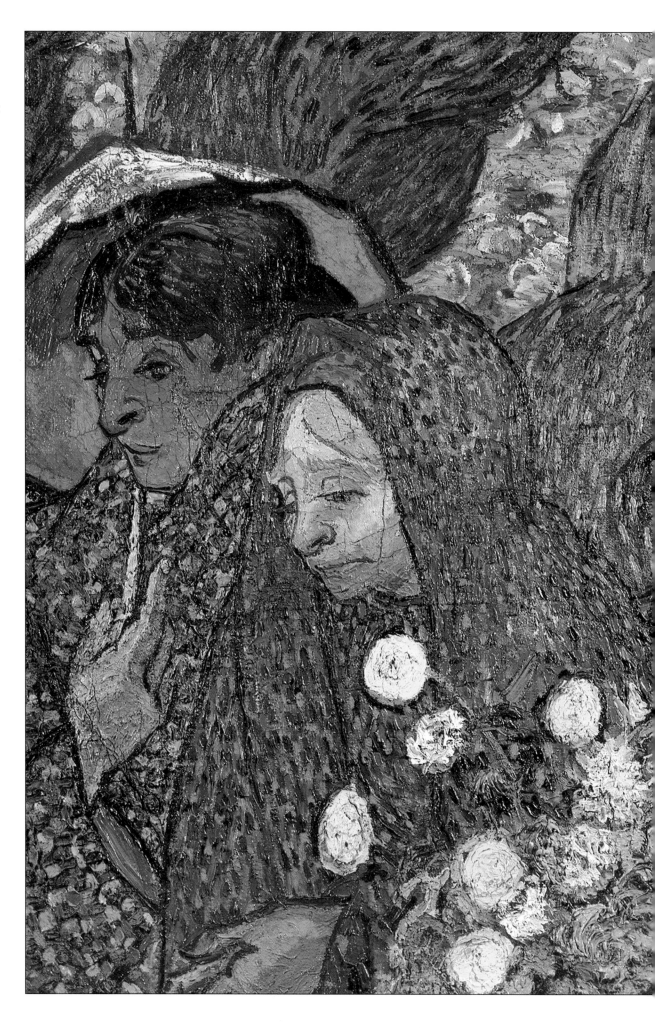

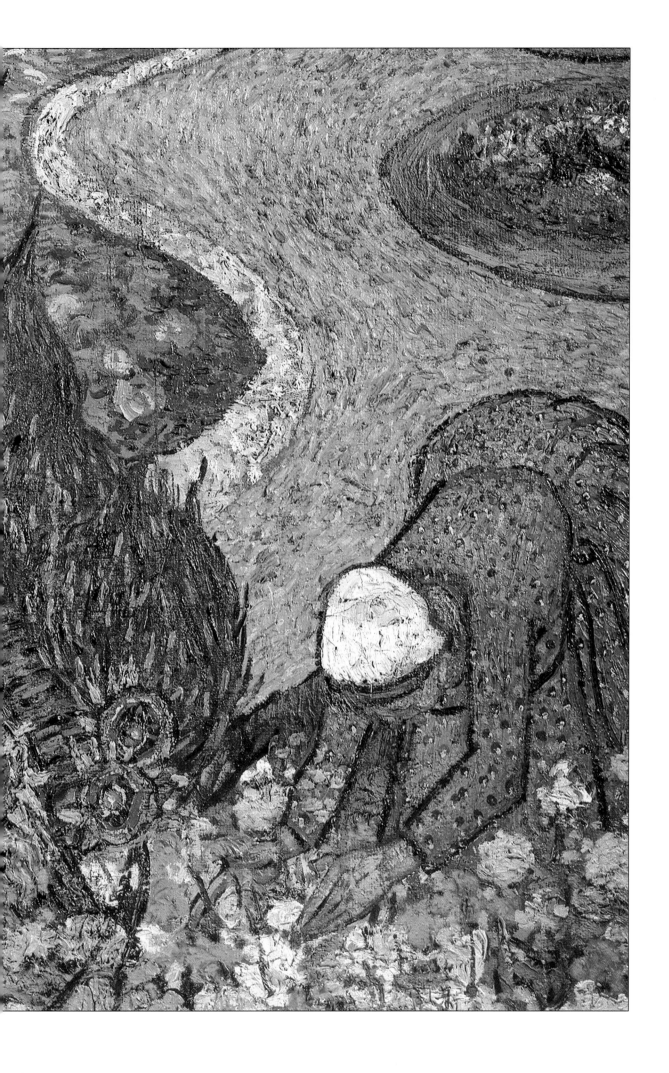

RIGHT: **The Dance Hall at Arles** 1888
MUSÉE D'ORSAY, PARIS

the south, and the conquest of public means of communication to re-educate the masses, who used to understand art in the past'.

With such a confusion of feelings about life, love and art in his mind, it is not surprising that Van Gogh was unsettled. On a more down-to-earth plane, he was deteriorating physically. He had begun to drink heavily, following his friend Toulouse-Lautrec in acquiring a taste for absinthe, a potion made from wormwood and reputedly a slow poison. At this distance in time there is no separating the effects of alcoholism from possible manifestations of his original syphilitic infection, but the fact of his decline is visible in many of the self-portraits, in which Van Gogh is unmistakably drawn and diminished. Theo sent him to doctors, who sensibly recommended abstinence and rest, but the beneficial results seem to have been short-lived. Descriptions of Van Gogh during this period – often, it is true, based on hindsight – suggest that he became increasingly erratic and quarrelsome, so that models refused to pose for him, and he was apt to vent his irritation on people who stopped to watch him working in the open; according to Theo, Vincent was even forbidden by the authorities to paint in the street.

Away to the South

For some or all of these reasons, Van Gogh decided to leave Paris and head south. The self-portraits he painted during the winter of

1887–8 all make him look ravaged and thin-faced, but in the final portrait (page 74), dating from early in the new year, he looks so different that it must surely be interpreted as a conscious change of self-image, fashioned to suit a new phase of his life. Unusually, he shows himself as a painter at work, and although he looks older than his years, he appears to be physically powerful and poised for action.

ABOVE: **The Arena at Arles**
1888
HERMITAGE,
ST. PETERSBURG

The evening before he left, Van Gogh and his friend Emile Bernard arranged Vincent's room in the Rue Lepic in such a way that Theo would still feel that he was present. One of Van Gogh's abiding beliefs was that a room took on the personality of its inhabitant, a belief later exemplified by paintings such as *Vincent's Bedroom* (page 180) and, extended to other objects, by his 'empty chair' paintings (pages 147 and 148). Van Gogh and Bernard nailed Japanese prints to the walls, placed some of Vincent's canvases on easels and piled the rest up, no doubt in the disorderly fashion that had so often irritated Theo. After Vincent had gone, Theo did miss him. If the missing was mingled with relief, he never admitted it when writing again to Wil. 'Now that I am on my own in the apartment it seems decidedly empty. I shall find someone to share with if I can, but it is not easy to replace a man like Vincent. His knowledge and clear view of the world are extraordinary. I am certain that if he lives for a few more years he will make a name for himself...'

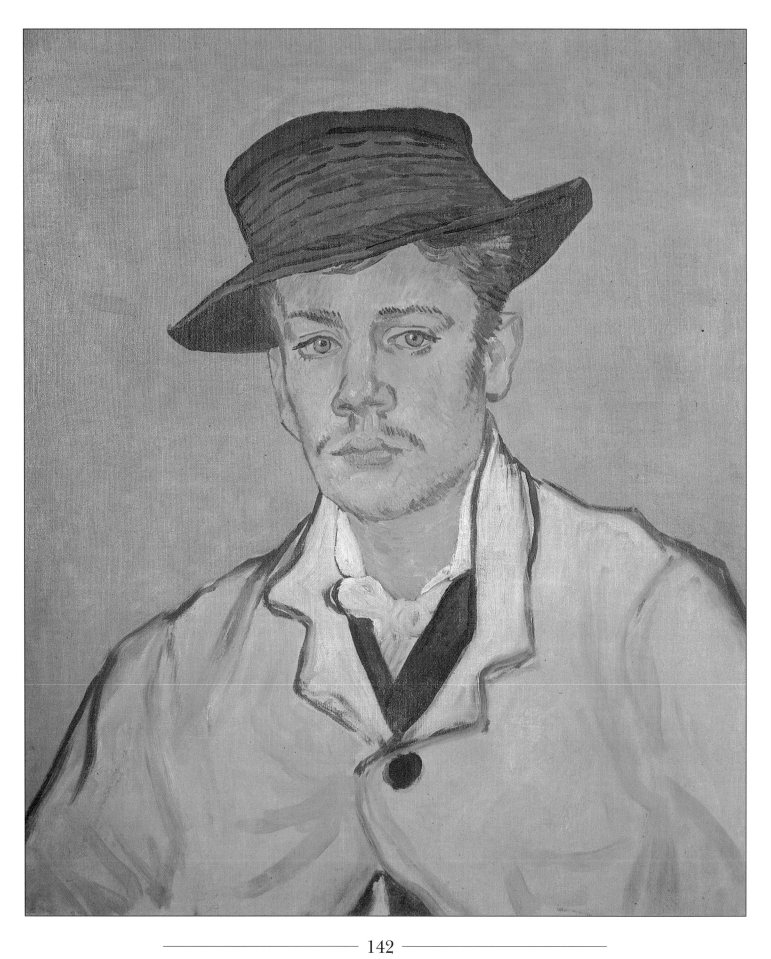

The South

Van Gogh left Paris on about 20 February, 1888. At the end of a long journey by train to Arles, he discovered that the sunny south was covered in winter snow. However, he was in no mood to be discouraged, reflecting that this made the place look even more like a Japanese print, a medium whose masters had exploited the nearly-uniform tones of snow to great effect in their travel scenes. His imagined Japan remained, to an extraordinary extent, Van Gogh's criterion of art and beauty ,and he was now determined to see the Midi – the French South – as its longed-for European counterpart.

Entering the town from the station, he came to an undistinguished café-hotel called the Restaurant Carrel and took one of the rooms to let on the first floor. Unable to work straight away in the open air, he settled in by painting his immediate surroundings, including a still life and the charcuterie (pork butcher's shop) on the opposite side of the street. He also tried to track down a painting by Monticelli rumoured to be in an antiques shop, but it eluded him. Then, despite the unusually late fall of snow, blossoms began to appear on the trees and Van Gogh, like so many northern artists before him, was overwhelmed with joy on

LEFT: **Portrait of Armand Roulin**
1888
FOLKWANG MUSEUM, ESSEN

first experiencing the light and colour of the South. As for the countryside, it was 'as beautiful as Japan', perhaps a not unreasonable comparison in view of the profusion of almond, apple, peach, plum, cherry and apricot blossoms. Van Gogh made them the subject of a dozen brightly cheerful orchard paintings (pages 78-9). In March, while he was working on them, he heard of the death of his old teacher Anton Mauve, whom he had continued to respect in spite of their differences; Mauve had, after all, effectively introduced him to the joys and torments of painting. With this in mind, he inscribed a painting of a peach tree in blossom with the words 'Souvenir de Mauve' (*In Memory of Mauve*, page 80), added his own name and Theo's (later removed for some reason) and sent it to the artist's widow.

Encounters in Arles

At Arles, Van Gogh was in the heart of Provence, a region of France which had retained a distinctive outlook and customs. Arles itself was an historic town, famous for its ancient Roman arena and the Romanesque church of Saint-Trophime. Neither interested Van Gogh greatly, although something about Saint-Trophime, probably the death-and-damnation carving, struck him as chillingly cruel – a 'Chinese nightmare', as he phrased it in the mysterious language of his private Orient. Despite its past, nineteenth-century Arles was a small, sleepy town, disturbed only by the presence of a few hundred Italian immigrant workers and a regiment of Algerian Zouaves in their flamboyant uniforms. Shortly after Van Gogh's arrival two Zouaves were murdered by Italians outside a brothel, and he took advantage of the hullabaloo to slip inside the establishment and have a look round, correctly anticipating that he would have need of its services.

None of this suggested that Arles would offer Van Gogh much congenial company. If there were any enthusiastic amateur artists in the town, they shied away from an eccentric figure who painted such crudely bright, simplified pictures. Over the months that followed, Van Gogh was dependent on the contacts he made with a few artists who were spending a little time in the area. In March there was a Dane, Christian Mourier-Petersen, who was taking his first steps as a painter. Formerly a medical student, he had developed a nervous disorder after taking his examinations and now felt that 'it is doctors who kill people'. Van Gogh dismissed Mourier-Petersen's work as dry, timid and conventional, but felt

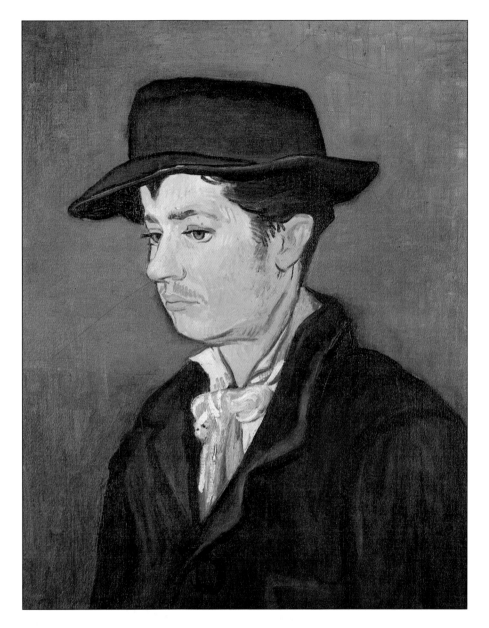

able to take up a tolerant attitude on the grounds that the Dane was as yet a beginner. Indeed, Van Gogh wrote about his friend as though he were a very young man, when in fact there were only five years between them. Their relationship was helped by the fact that Mourier-Petersen, although he had at first thought that Van Gogh was mad, began to look up to him and accept his authority.

For two months, until late May, Dane and Dutchman were close companions. By then Van Gogh had also become acquainted with an American artist named Dodge Macknight, who was a friend of the Australian John Peter Russell. Macknight lived in the nearby village of Fontvieille and came to call. He was reluctant to let Van Gogh see his work, doubtless knowing what Vincent spotted at once: that he had learned enough of the new colour

theories to disable him as a conventional artist, but had not yet become the master of his new knowledge. After mixing with Gauguin, Bernard and others in Paris, Mourier-Petersen and Macknight were disappointing, but they were the best company that Arles had to offer. Van Gogh clung to his dream of 'a studio of the south', hoping that Theo would be able to finance it or that Macknight would turn out to be wealthy; accustomed to spending money on materials and having almost nothing left over, he was always inclined to believe that artists who were less obviously up against it must be rolling in money.

Macknight may have proved to be an artistic and financial disappointment, but his visits lessened Van Gogh's isolation. During the summer the two men saw a good deal of each other and Macknight later remembered Van Gogh as a good companion. Echoing other witnesses, he added that Vincent could be moody and quarrelsome, especially if anyone disagreed with his opinions about artistic matters. In a newspaper interview given many years later, Macknight described Van Gogh's artistic position at this point: Van Gogh, Gauguin and Bernard had all been affected 'by the Impressionist kind of thing and had revolted against it. Instead of working with little dots and dashes of colour, they had formed the habit of using great masses of colour, either pure or blended, according to the need of the case'.

Technique and Expression

This was quite perceptive as a summary of avant-garde trends in the late 1880s, but as far as Van Gogh was concerned it exaggerated his dependence on a single technique: everything he had learned in Paris stayed with him and remained available for use 'according to the need of the case'. At Arles his long apprenticeship came to an end and his painfully acquired skills were deployed as if instinctively. He had made a practice of working rapidly ever since his years in Drenthe, but now his certainty of touch had become extraordinary. As he explained to Theo, the paint flowed as naturally from his brush as sentences from his lips.

This is not to say that Van Gogh was a kind of inspired madman: only that his skills and responses, like a sportsman's, had become second nature to him. (Also like a sportsman, he still had occasional bad days when nothing would go right and all his efforts were fruitless.) His subjects were chosen with deliberation, usually while he was out walking, and he worked out the necessary treatment in

his mind before he attacked the canvas. *The Poet* (page 117) is an instance of a picture described in one of Van Gogh's letters before he had even met the person whose portrait it would become. But he made no use of conventional preliminaries, such as preparatory sketches and oil studies, wielding his loaded brush to 'draw' directly on to the canvas and even squeezing paint straight on to it from the tube.

Working at speed, Van Gogh could preserve the freshness of his sensations – at first visual sensations, later on sensations that can only be described as visual-emotional since they remained anchored in the outside world but were modified under the

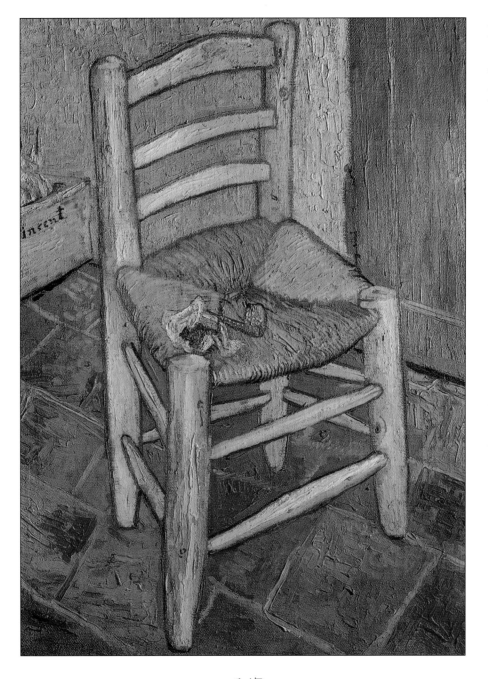

LEFT: **Vincent's Chair** 1888
TATE GALLERY, LONDON

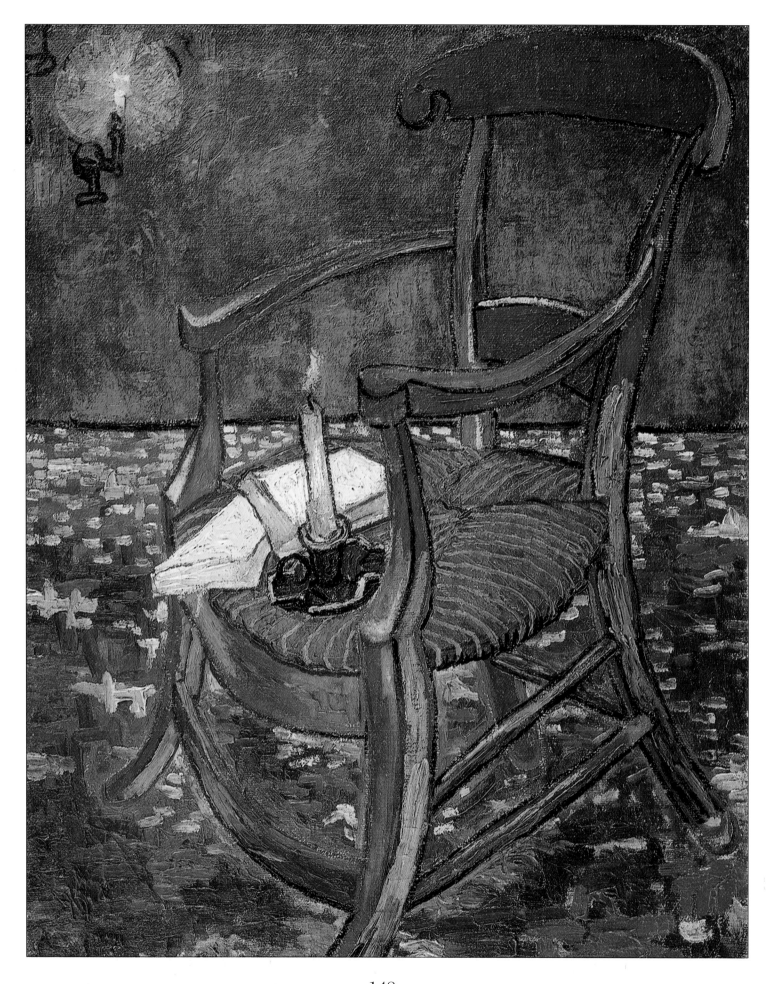

pressure of the painter's emotional responses, which were conveyed by distortions of form and colour. In either mode Van Gogh gave the surface texture of his paintings an importance that represented something new in art. The brushstrokes of the Impressionists were visible and consequently shocking to the academic observer, but generally speaking they did not play an independent role; whereas Van Gogh's parallel or splayed streaks, criss-crossings, blobs and whorls bound the picture together and led the viewer's eye about over the canvas as the artist desired. These devices were so central to Van Gogh's intentions that he imitated the effects in the more stubbornly two-dimensional medium of drawing in ink, which he was often compelled to use when he could not afford to buy paints. With the help of a home-made reed pen (another of his 'Oriental' discoveries), he created masterpieces in which hatching, curls, masses of dots and patterns of moving lines became the counterparts of brushstrokes, giving density and dynamism to straightforward views of fields, parks, roads or ruins. Van Gogh's poverty had at least this beneficial consequence, that it made him master drawing as thoroughly as he had mastered painting. In both arts, his advance to mastery in the South was of an order that could never have been predicted, despite the quality of his Parisian work.

Bridges and Boats

For months Van Gogh tramped all over the countryside around Arles, finding that it offered a wealth of subjects: orchards, farmhouses, wheatfields, canal and river scenes, and spectacular ruins. His paintings of trees in blossom still showed some influence from Impressionism, appropriate to their delicacy, but in the strong sun and hard, brilliant colours of the Midi, Impressionist atmospherics seemed irrelevant; Paul Cézanne had discovered the same thing a few years earlier. Many of Van Gogh's works took on a colourful, hard-edged look, not unlike cloisonnism but sharper and more vital in style. *The Langlois Drawbridge* (pages 82-3), *Boats on the Beach of Saintes-Maries* and *Street in Saintes-Maries* (page 85) are among the paintings in which this tendency is clearest. *The Langlois Drawbridge* also illustrates Van Gogh's fusion of techniques, combining 'hard' main-subject elements (bridge, carriage, washerwoman) with spiky patterned reeds and heavily impasted brown-red earth. The drawbridge was a picturesque feature and it probably attracted Van Gogh all the more because bridges of

the same type spanned the canals of his native Holland; at any rate he painted the subject no fewer than four times.

At the end of May he saw the Mediterranean for the first time at Saintes-Maries-de-la-Mer. This little fishing village was only about 30 kilometres south of Arles and it is surprising that Van Gogh did not visit it sooner since it had been one of Adolphe Monticelli's haunts. However, there was no railway line to Saintes-Maries, so the trip had to be made by coach across the wild Camargue, and Van Gogh timed his departure to coincide with the low-fare pilgrimage season. (Saintes-Maries was said to have been the place from which 'the three Marys' evangelized Provence.) During his five-day stay he completed several paintings and drawings, using them to create further paintings on his return to Arles. Among the pictures inspired by the experience were two versions of *Boats on the Beach*, painted in a straightforward, almost childlike style, as well as *Street in Saintes-Maries* (page 85), a view of the town, a group of cottages and two seascapes. The seascape in the Pushkin Museum (pages 86-7) relegates the fishermen and their brightly coloured boats to the background, emphasizing the heavy waves in the foreground by rendering them with tangible, thickly impasted paint that seems to have a three-dimensional, organic life of its own. Predictably, the Mediterranean impressed Van Gogh profoundly, convincing him that he should stay in the Midi and make his pictures blaze with colour.

During his first few months in Arles Van Gogh seems to have sensed his own rapidly growing powers and to have been fairly content with his lot. He even made good resolutions. Determined to make a fresh start after becoming a near-alcoholic, he cut down his drinking and tried to eat sensibly, although poverty and the cost of paint prevented him from being entirely consistent, and Mourier-Petersen's taste for brandy may also have tempted him to over-indulgence. As a result of his past or current excesses he was troubled by stomach disorders and teeth problems, severe enough in April to keep him from working for a week. Subsequent letters to Emile Bernard suggest that his sexual potency was more or less permanently impaired or, at any rate, that his vitality was not great enough to combine intense work with much sexual activity, unlike (he believed) 'healthy' artists such as Rubens. Naturally it is difficult to be sure what this implied standard entailed or how often Van Gogh saved enough for what he described as 'hygienic practices' in the local brothels.

One reason for his poverty was that life at Arles was proving

RIGHT: **Portrait of Dr Rey** 1889 PUSHKIN MUSEUM, MOSCOW

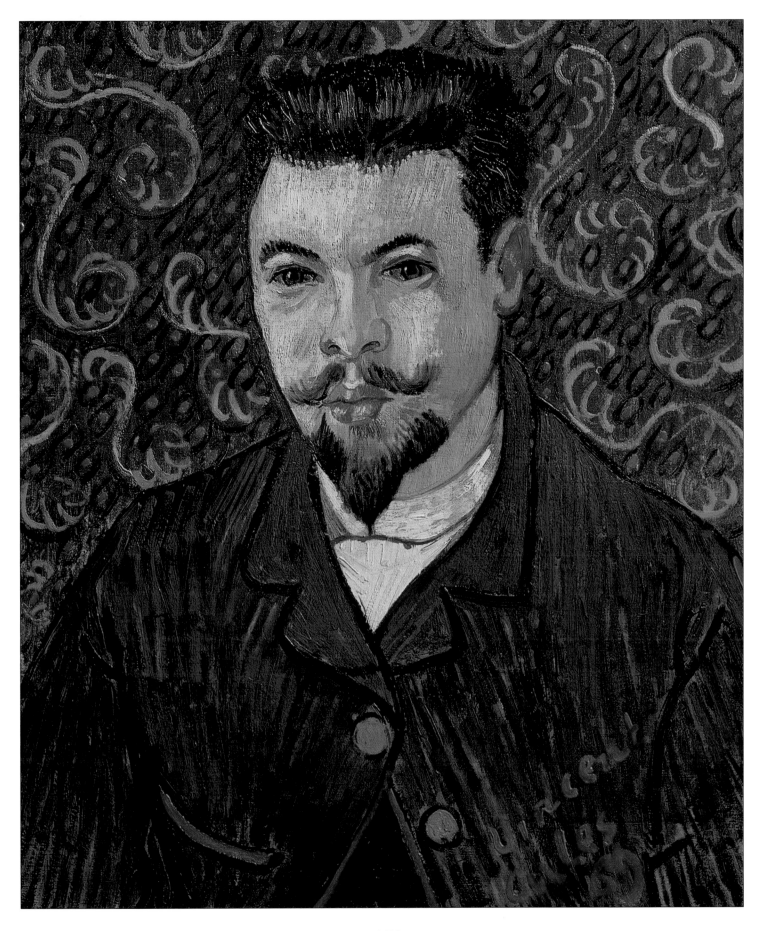

more expensive than it had in Paris, mainly because his room at the Restaurant Carrel was costing him five francs a day. After a time he managed to get the rate knocked down to four francs a day on the grounds that he was a long-term resident, but the proprietor was resentful, the service deteriorated and Van Gogh was meanly treated even during his illness. In May he left in outrage, claiming that he was being overcharged; he subsequently took the matter to court and was eventually awarded a refund of 12 francs. However, the move turned out to be beneficial since his new hosts proved far more helpful Joseph and Marie Ginoux ran the Café de la Gare (Station Café), a seedy but friendly establishment whose downstairs public room stayed open all night and was patronized by any workers, soldiers and drifters who could afford a single drink. Van Gogh was better looked after at the café and liked his new landlords, although he remained jocularly uneasy about the size of his bills. Marie Ginoux sat for both Van Gogh and Gauguin in local costume as 'L'Arlésienne' (*The Woman of Arles*, page 135).

The Café de la Gare was only a few doors from 'the Yellow House', Van Gogh's name for a yellow-painted, semi-derelict building on the Place Lamartine. Shortly before settling at the café he had rented the four-roomed right-hand side of the Yellow House for a modest 15 francs a month, visualizing it as a home and studio for himself and as the future headquarters of the artists' colony he was still determined to found. By taking the Yellow House he had effectively decided to settle in Arles rather than going on to Marseilles, as he had first intended. Over the next four months he remained at the café while the house was made habitable and he struggled to furnish it. The interior was whitewashed, but Van Gogh maintained the theme of yellow by painting a series of pictures to decorate it. Showing sunflowers in a vase, these are now among the best-known of all his works (pages 92, 93). The sunflower – large-formed, spiky, variable in tone – might have been created with Van Gogh specifically in mind. In Paris he had painted superb close-up studies of the heads of sunflowers (page 68-9) as well as a number of predominantly yellow still lifes, including some with scattered, yellow-covered French novels. But the Arles sunflowers were more emphatically studies in yellow – or rather, yellows – of an unprecedented kind. So, too, were the series of wheatfield paintings (pages 252-3), produced under the burning sun of the South, in which the landscape begins to assume a heavy, wavelike character. No doubt remembering all this, Van Gogh himself wrote that he had struck a 'high yellow note' in the summer of 1888.

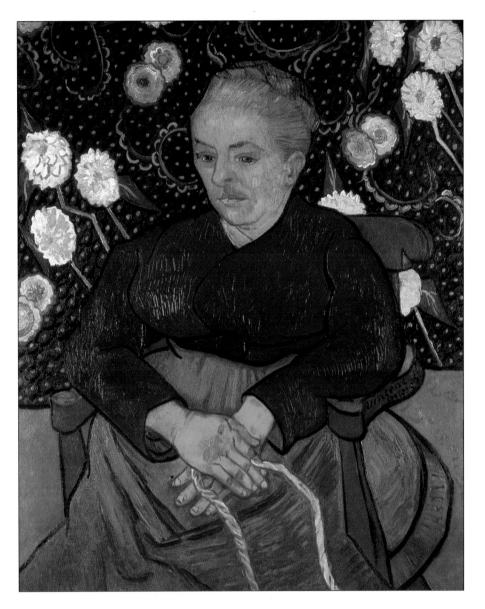

LEFT: **La Berceuse** 1889
PRIVATE COLLECTION

It was rounded off in September with a painting of the Yellow House (page 95), which he was at last able to move into. Apart from the great expanse of intense blue sky, this picture, too, is a masterpiece of yellow-on-yellow. Although it would be rash to assert that Van Gogh had a 'favourite' colour, he certainly saw yellow as the key to the South, instancing his hero Monticelli, who had painted it 'all in yellow, orange and sulphur colours'. Through yellow in particular, Van Gogh began to move towards a concept of 'suggestive colours', expressive rather than merely decorative.

Meanwhile he had started to settle in at Arles and make some friends. One of these was a career officer named Paul-Eugène Milliet who was stationed in the town with the Zouaves. The son of a soldier, Milliet had few interests or ideas outside the army, but his enthusiasm for drawing gave him a point of contact with Van

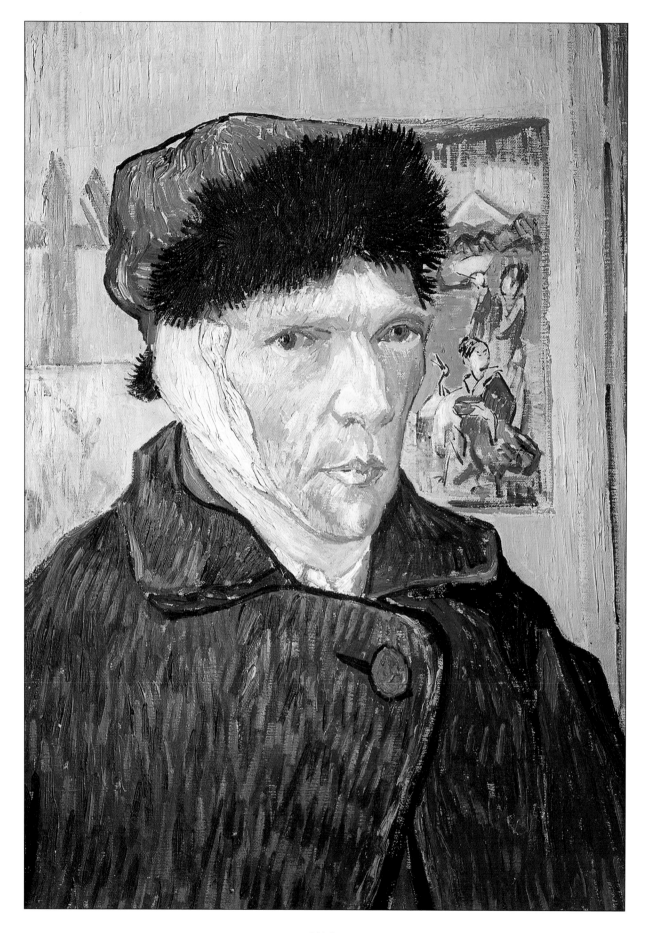

Gogh, who acted as his teacher and took him out sketching to favourite sites such as Montmajour, locally celebrated for its ruinous monastery and brooding fortress set on a great rock. Milliet was prepared to listen to Van Gogh's advice, since he was deeply impressed by his drawing skills. But because these skills were not in evidence in his friend's paintings, Milliet considered them atrocious. When Van Gogh set up his easel, the soldier retreated so that he would not be forced to express an opinion on the work in progress and start a row. It is salutary to remember that while Van Gogh was moving beyond Impressionism, most people, like Milliet, still took their criteria from the pre-Impressionist art of the academies, with its careful 'drawing' and fine detail. Moreover, when a journalist tracked Milliet down in the 1930s, the old man had not changed his opinion, remaining unimpressed by the fact that the portrait of him painted by Van Gogh was in a museum, 'somewhere in Holland, I believe'. He was a reluctant, restless sitter (who should therefore have been grateful for Van Gogh's speed-painting style), and no doubt found Van Gogh's stark primaries – the blue uniform, the blue-and-red cap, the emerald background based on the Zouaves' pseudo-Islamic flag – ridiculously crude. However, he was a good friend and obligingly arranged for Van Gogh to paint one of his rankers, whose uniform was far more picturesque. A half-length portrait in oils, *The Zouave*, treats the subject in near-cloisonnist style, with hard, strong colours; only the face is modelled. By contrast, the larger *Seated Zouave* conveys a stronger sense of the man's personality through his powerful features and expressive hands. Remarkably, he is not diminished by his elaborate uniform of scarlet bagged hat with a tassel, embroidered jacket and pantaloons, even though his legs-akimbo posture spreads the pantaloons like a voluminous skirt, enabling Van Gogh to fill about a quarter of the canvas with a virtuoso rendition of red fabric.

Portraiture now assumed a new importance in Van Gogh's art. Since painting the peasant women of Nuenen he had only occasionally worked from models (except himself). The middle-class and bohemian contacts of the Paris years were apparently not what he sought (even Theo did not merit a portrait) and once he had reached Arles he again took 'ordinary' people as his subjects. One of them was an old gardener, Patience Escalier, formerly a shepherd in the Camargue, whose work-worn features and grey hairs are emphasized in two portraits. In the stronger example (page 97), the gardener's equally worn, blunted hands

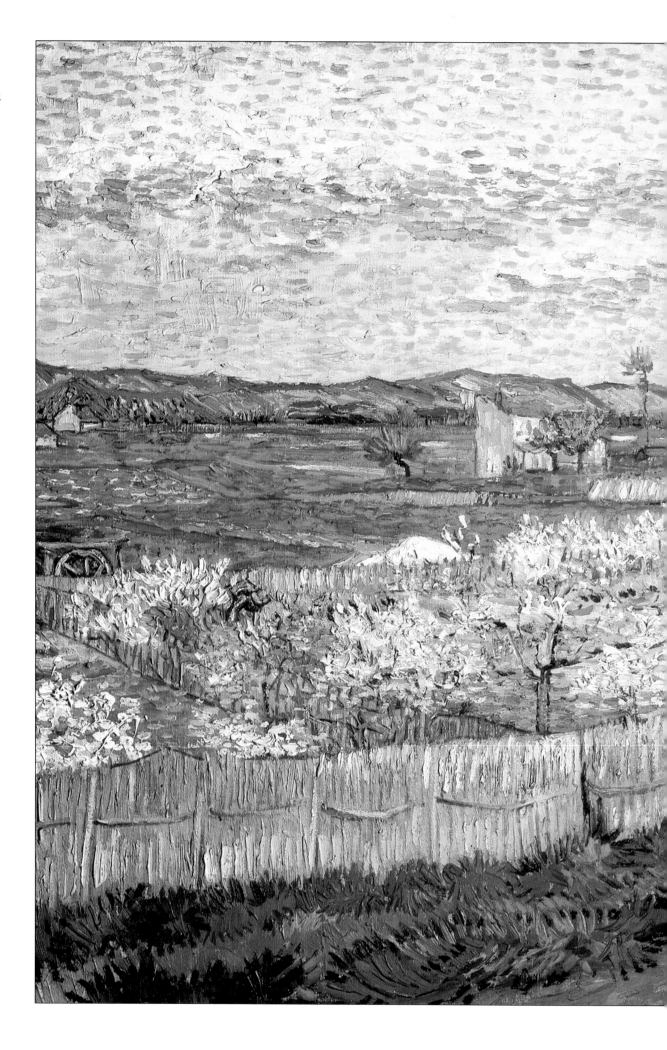

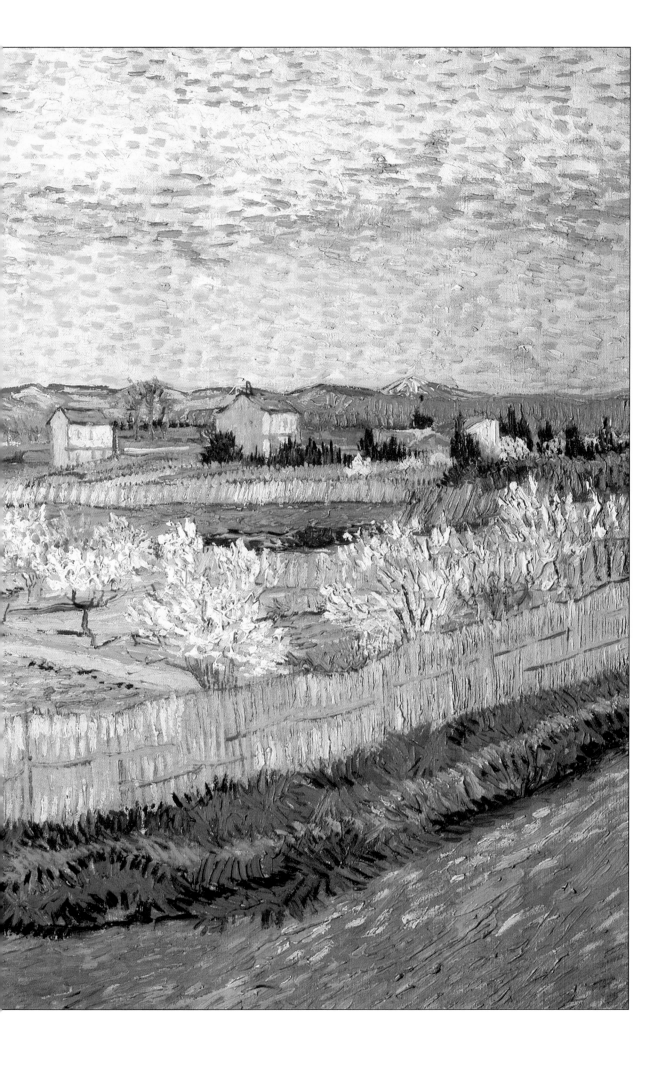

reinforce the apparent 'message', but the brilliant colours and fascinating, flaunted brushwork patterns that model the face undermine any 'social' interpretation. Escalier seems too individual, however much moulded by a hard life, to represent anything but his own rock-like self. A portrait of this kind was, in fact, something new, showing working people in everyday clothes and with their everyday faces, but without (as had previously been done) turning them into representations of a class or moral exemplars.

By contrast, *La Mousmé* (page 99) is the only Van Gogh portrait that captures a certain kind of solemn girlish charm. It was inspired by a recently published novel he had just read, *Madame Chrysanthème* (1888), the work of Pierre Loti, a French writer who specialized in love stories set in foreign places. In this instance the place was Japan (which was no doubt why Van Gogh had read it hot off the press), and he was able to tell Theo that a *mousmé* was a girl in her early teens. In spite of this, there is no specific Japanese influence in the painting unless it is in the way in which the smooth, fine curves of the chair take on an almost abstract quality, its bentwood elements surely exaggerated, surrounding the girl and springing out in a way that makes it hard to believe it is fulfilling its function; but abrupt cropping conceals any deficiencies it may have in that respect. Similarly, the viewer can easily remain unaware of the vast area of the girl's skirt, supporting her neat figure in its striped tunic, and her head with its best-behaviour face. The stripes and her long, exposed arms and hands, follow or balance the lines of the chair. In fact, the unobtrusive formal relationships in *La Mousmé* – the complex of line and movement, the balance between dense patterning and empty areas – show Van Gogh at his most refined and calculating, whatever the speed at which he may have completed the picture.

During the summer of 1888 he met a man who was to be important to him both as a friend and as a portrait subject. Joseph Roulin, a postal worker, was a big, magnificently bearded man of the people, a booming radical who was quite capable of breaking into the strains of the *Marseillaise* in the middle of the street. He became Van Gogh's best friend among the local people and something of a father-figure to him. A surrogate relationship of the kind certainly entered his mind, since he wrote to Theo about Roulin in a revealing fashion, pointedly remarking that he was not quite old enough to be his father (in reality Roulin was only ten years older) and consoling himself with the thought that the older man displayed a gravity and tenderness towards him such as a

veteran soldier might show towards a young one! The military simile is oddly inappropriate (perhaps suggested by Van Gogh's relations with Lieutenant Milliet), since Van Gogh and Roulin were friends on equal terms, meeting most often over drinks in cafés.

Later on the artist would get to know – and paint – the entire Roulin household, but in the summer of 1888 he was mainly concerned with Joseph, whose natural dignity, beard and broad nose made him think of the philosopher Socrates. In two portraits of Roulin from the summer of 1888, the generous patches of red paint on the face may indicate that he had the complexion of a regular tippler. Nevertheless, he is an imposing figure in both, dressed in his working uniform, including his cap, which makes him look like a sea-captain. The paintings are essentially harmonies in blue. In the larger (page 100) the dark-blue-uniformed Roulin is seated with a light blue cushion behind him which is the same colour as the background. As a result, man, chair and table are hardly anchored to the floor, a fact that points up the awkwardness of his pose, his large hands hanging in front of him, apparently poised for action. The chair is presumably the one occupied by La Mousmé, but now it is dwarfed by Roulin's big, authoritative figure.

Waiting for Gauguin

Roulin was a staunch friend and he even had the natural good taste to admire Van Gogh's paintings. But he had a job and a family and could not, in any case, supply companionship of a certain intellectual and emotional quality. Van Gogh fought off loneliness by writing long letters to Theo and by dreaming of his hoped-for 'studio of the south'. All through the spring and summer of 1888 he kept in touch by letter with his friends Gauguin and Bernard. Both had left Paris for Pont-Aven in Brittany, where they developed still further away from naturalism, much as Van Gogh was doing in Arles. However, their work, although still more or less cloisonnist in style, was touched by another literary-artistic tendency that was gaining in influence – Symbolism. This was not a technique so much as a general outlook, exalting mystical attitudes without being very precise about what they were supposed to represent. The effect was to encourage Gauguin and Bernard to paint imaginary and pseudo-religious scenes. Gauguin's *Vision after the Sermon* and *Yellow Christ* were not genuine religious works, but rather

represented the Breton ethos as he imagined it, still caught up in a 'primitive' legend-saturated Christianity. Whatever else they may have been or done, the pictures signalled the emergence of a powerful new decorative impulse in Gauguin, confirming Bernard's belief that his comrade was a genius.

Bernard communicated his conviction to Van Gogh, who was all too ready to share his young friend's hero-worship of Gauguin. At the same time he was uneasy about the notion of painting from memory and imagination, especially when the subject was religious. Although driven by strong emotions, Van Gogh needed to respond to the outside world and was suspicious of any act that was not anchored in some kind of reality, however transformed by the artist's vision. He conveniently forgot that he had attempted a Gethsemane scene shortly before his arrival in Arles, with Jesus in orange and blue and an angel in yellow. It was evidently very much the kind of thing that Gauguin and Bernard were doing, but Van Gogh's vehement reaction to his own impulse was to scrape off every trace of the picture. He had never been indifferent to religion, but he now believed that religious emotion could be expressed only through the artist's relationship with his surroundings. Often, during these months, he wrote of art itself in terms commonly reserved in the nineteenth century for religion, declaring that he wanted his paintings to be consoling, like music. The notion of life as a vale of tears, with religion offering consolation for suffering, does not seem far away, although 'consolation' seems a woefully inadequate description of the actual effect of Van Gogh's paintings on the viewer.

Whatever his reservations about the direction of his friends' painting, Van Gogh was eager to persuade Gauguin to join him. It was Gauguin, still a relative stranger, not his close friend Bernard, whom he urged again and again to come south. Evidently he still craved for an authority figure, a role that the 20-year-old Bernard could hardly hope to play, but for which the powerful, saturnine, 40-year-old Gauguin seemed ideally suited. It is true, however, that Bernard would not have been available for long as a companion, since he was shortly to do his military service. For his own part, Gauguin was friendly but cautious. He was glad of Vincent's help in cultivating Theo's patronage, but not much inclined to leave Pont-Aven in a hurry, despite the extravagant flattery heaped on him by Vincent, who had cast him in the role of director of a southern atelier or, more emotionally, as the head of a monastic order of painters, utterly dedicated to their work and enjoying no

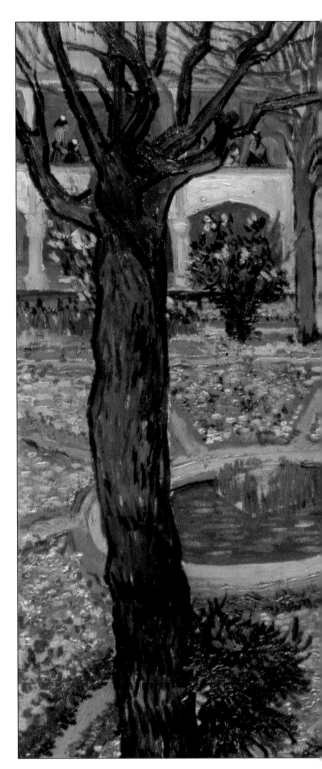

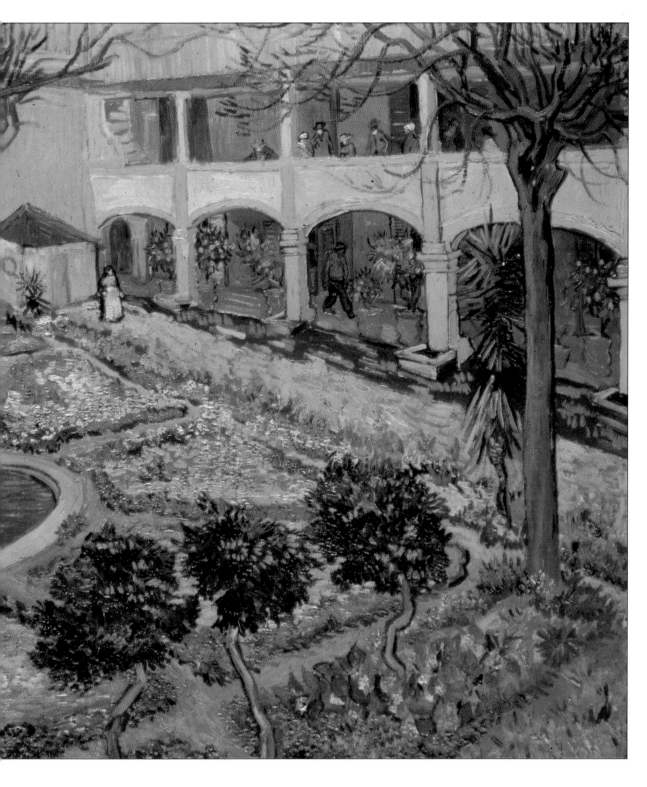

LEFT: **The Garden of the Hospital at Arles** 1889 OSKAR REINHART COLLECTION, WINTERTHUR

luxuries beyond a fortnightly outing for hygienic purposes...

Gauguin's attitude has often been described as calculating, with the implication that he was cold and self-seeking in his relations with Van Gogh. There is undoubtedly some truth in this, but his reluctance to take a leap into the dark was understandable. In fact, if he had been less vain he might have sensed the dangerously

fragile mental state in which Van Gogh burned incense to him. By summer he had agreed to come, but continued to temporize, held back by illness, debts and, perhaps, an obscure instinct against the whole venture. Meanwhile, Gauguin, Van Gogh and Bernard agreed to exchange portraits in a 'Japanese' gesture of fraternity. At the Pont-Aven end, the arrangement was that Gauguin and Bernard would paint each other and send the results to Van Gogh. But Bernard was too overawed by Gauguin to try, and although Gauguin began a portrait of Bernard, he could make no progress with it. Instead, each painted a self-portrait with a little sketch of the other on the wall behind the main figure, and sent it with a dedication to their friend Vincent.

Gauguin's self-portrait (pages 108-9) might have been designed to emphasize his authority, showing him as a powerful presence beside the weak-looking Bernard, sketched in the top right-hand corner. Gauguin's fixed gaze and dangerous expression make him look like a man who may do something violent and decisive at any momen. Or at least that would be a plausible reading of the painting if we had no outside information as to its meaning. To make sure that it said what he wanted it to, Gauguin painted on a title, 'Les Misérables', and sent Van Gogh an explanatory screed. *Les Misérables* ('The Wretched') is the title of a famous nineteenth-century novel by Victor Hugo, dominated by the character Jean Valjean, an escaped convict of immense strength, integrity and humanity who is hounded through several hundred pages. Gauguin explicitly compared himself with Valjean, adding, for good measure, observations on the volcanic lava burning in the painter's soul and the purity of his art, symbolized by the 'childlike' floral background. 'And as for Jean Valjean, oppressed by society, outlawed on account of his love, his strength, is he not a mirror image of the Impressionist today?' This elaborate description, so much less convincing than the wordless painting, shows Gauguin in the process of re-inventing himself, via the myth of the artist-outsider, as the outcast and strong but gentle 'savage' who would eventually flee civilization and take refuge in the South Seas.

Despite Van Gogh's professed admiration for Gauguin, he was unwilling to accept the self-portrait on his friend's own terms. To him, Gauguin looked like a prisoner, 'ill and tormented', and he hinted that Gauguin had painted it rather too much for effect. He even preferred Bernard's self-portrait, an accomplished but much less powerful work than the Gauguin, so much so that it is difficult not to interpret Van Gogh's reaction as an expression of

subconscious rivalry with the abbot-elect of his monastery. He wrote to Theo that he was pleased to have an opportunity of seeing what kind of work his comrades were doing, and quite certain that the self-portrait he was sending to Gauguin held its own beside the others. It is certainly one of Van Gogh's most remarkable productions (page 110). He repaid Gauguin in kind by sending him a written account of the canvas, equating this image of himself with 'an Impressionist in general', a bonze (Buddhist priest) and 'simple worshipper of the Eternal Buddha'. To the outsider Van Gogh's description seems even further off the mark than Gauguin's conception of his own self-portrait. The close-cropped head, fleshless features and rough clothing convey a feeling of suffering rather

BELOW: **Lilacs**
1889
HERMITAGE,
ST. PETERSBURG

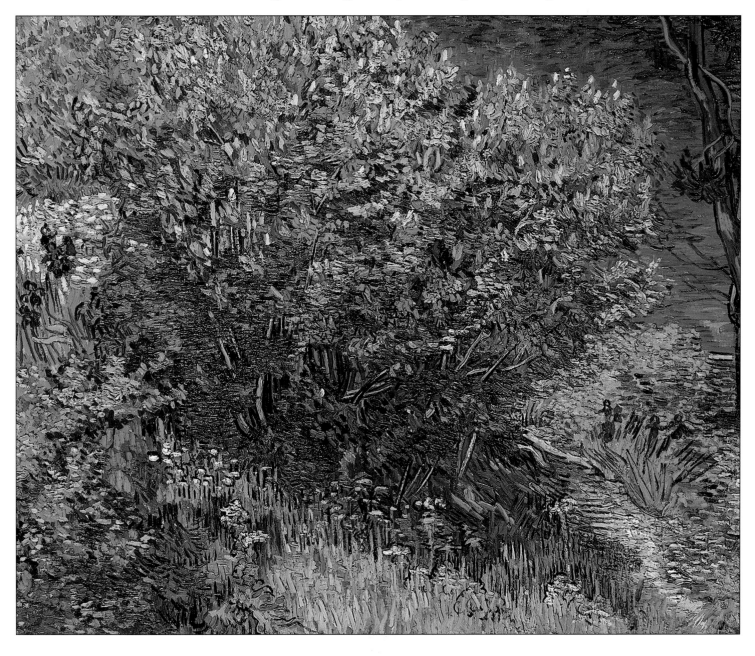

RIGHT: **Irises**
1889
J. PAUL GETTY
MUSEUM,
MALIBU,
CALIFORNIA

RIGHT: **Field with Poppies** 1889 KUNSTHALLE, BREMEN

than worship, intensified by the malachite background and 'whites' of Van Gogh's eyes. This self-image might easily be that of a Siberian exile, painted to illustrate a nineteenth-century Russian novel by Dostoyevsky or Tolstoy (both of whose works were, incidentally, known to Van Gogh). Nevertheless, when Van Gogh compared his own self-portrait with Gauguin's, he found it 'as grave, but less despairing' than his friend's.

By now it was September, and Van Gogh had at last managed to furnish and move into the Yellow House – ready for Gauguin. Gauguin's arrival began to seem imminent, prompted by the stipend of 150 francs a month that Theo had promised to pay him in return for 12 paintings a year. (Theo, but not Vincent, had inherited some money on the death of Uncle Cent and could now afford to support a second painter, even though he had not had any great success in selling the works by Gauguin that he had taken so far.) Van Gogh's response was to live and work harder than ever, fuelled by quantities of coffee and absinthe. He wanted to get as much done as possible to impress Gauguin, but he also felt the need to consolidate his style and methods, so that he could benefit from Gauguin's influence without being overwhelmed by him. Again there is a strong note of subconscious rivalry in Van Gogh's remarks to Theo, at odds with the almost ludicrously worshipful note in his writing to Gauguin himself. In combination with his deprivations and excesses, the nervous

excitement, the admiration and sense of rivalry appear to have made up a deadly psychic cocktail.

Painting the Night

For better or for worse, the 'cocktail' led to the creation of masterpieces in which symbol and emotion again appeared overtly in his work. Van Gogh himself cited the underlying similarity between *The Night Café* (page 112-13) and his most ambitious effort at Nuenen, *The Potato Eaters* (page 20-1). In both the painter has a 'message' and although the message has changed, this indicates an affinity between them that does not exist between these canvases and Van Gogh's Impressionist-derived work in Paris, with its apparently neutral stance towards the world. The lack of commitment to anything beyond the beauty of nature and the enjoyment of the moment in most Impressionist painting probably explains the coolness with which Van Gogh so often wrote of it, even though it had liberated his palette. He preferred to think of himself as the heir of an earlier colourist, the Romantic Eugène Delacroix, and wrote to Theo describing his Paris period as essentially a diversion from his main line of development. In any event, it was true that he was now leaving Impressionism behind. Through the use of 'suggestive colour' – soon he would call it 'arbitrary colour' – he was finding his way towards a new way of infusing painting with the artist's emotions, and thereby pioneering the kind of art we now call Expressionism.

Van Gogh described the origin of *The Night Café* in a jocular passage of a letter to Theo: the landlord of the Café de la Gare had had so much of his money that he had told the fellow it was time to take his revenge by painting it! To do so he stayed up three nights running, producing a watercolour and the now famous canvas. In the picture it is a quarter past midnight and the café has only two customers who are still awake. The rest – a mere three drunks and derelicts in a large public room – are huddled down in sleep or stupor. The only other sign of life is the standing waiter, probably the proprietor, Ginoux. The scene might easily be banal and dispiriting; instead, it is dispiriting but also terrible, like a mystic's account of the dark night of the modern soul. The exaggerated steepness of the perspective pitches the viewer forward into the room, towards the half-curtained private quarters, and also creates a sense of vertigo and distorted vision, familiar from nightmares. Walls and ceiling are painted in a strong, flat red and green – an oppressive combination, as Van Gogh understood perfectly well,

explaining to Theo that he had tried 'to express the terrible passions of humanity by means of red and green'. But perhaps the most sinister features are the lamps, with their large, orange-and-green halos, seeming to hover over the scene like giant insects. The top half of the canvas creates its basic mood, as any viewer can verify by looking at it with one or the other half of the reproduction covered up; the bottom half supplies the 'facts'. The thickly applied paint adds a further dimension of strangeness, buckling the table-tops and robbing the billiard table of its prosaic quality by turning its baize into a swamp-like surface. The final effect is not of some active evil, but of seediness and despair: a place where, as Van Gogh put it, 'one could ruin oneself, where one could go mad and commit crimes'.

Possibly it was the change of hours in painting *The Night Café* that precipitated Van Gogh into working at night in the open air. He had been attracted to night subjects soon after arriving at Arles, but had been reluctant to use what seemed to be the only feasible method, namely working from memory. However, in September he ventured outside and painted on the spot. According to a well-known story, which may even be true, he obtained the light he needed by fixing candles along the top of his easel and in the brim of his hat, laying the foundations of his future reputation in Arles as a lunatic.

The results were deeply satisfying, causing him to declare that the colours of night were even more beautiful than those of the day. By contrast with *The Night Café, Café Terrace at Night* (page 114) is a calm, harmonious picture. Given the significance of starry nights in Van Gogh's work as symbols of eternity, it would not be too much to say that the terrace is 'saved' by the presence of the night sky with its great blossom-like stars. The café was not Ginoux's establishment but a larger nightspot on the Place du Forum. Evidently gas lighting was not necessarily an evil in Van Gogh's eyes, since here the lit-up café forms a cheerful block of yellow that gives life to the entire canvas. In a letter to his sister Wil, Van Gogh boasted that there was no black in the painting but a beautiful combination of blue, violet, green and yellow; and he enthused about working outside at night.

At about the same time he painted the first and now the lesser known of his two 'starry night' pictures, *Starry Night over the River Rhône* (page 115). It seems to have been directly inspired by a walk in which he found night and the river beautiful beyond ordinary happiness or sadness – very much the way in which mystics have

expressed their experiences of the reality beyond reality. In his painting of the Rhône, the stars, like haloed suns, find echoes in the artificial lights along the riverbank with their long, rippled reflections; but the mood is one of harmony, not conflict.

The *Portrait of Eugène Boch*, often called *The Poet* (page 117), is a night painting in a different sense. Boch was a Belgian writer and artist, only a couple of years younger than Van Gogh, who had joined Dodge Macknight at Fontvieille during the summer. Macknight introduced him to Van Gogh, who enjoyed his company and saw in him the quintessence of the poet, apparently because he resembled some image of the great medieval Italian poet, Dante. In a letter to Theo, Van Gogh described a portrait of Boch as he imagined it might be, and indeed as he did go on to paint it, again demonstrating that his art, however spontaneous in execution, was by no means unpremeditated.

ABOVE:

Landscape with Green Corn
1889
NARODNI
GALLERY, PRAGUE

OVERLEAF PAGES 170-1:
Starry Night
1889
MUSEUM OF
MODERN ART,
NEW YORK

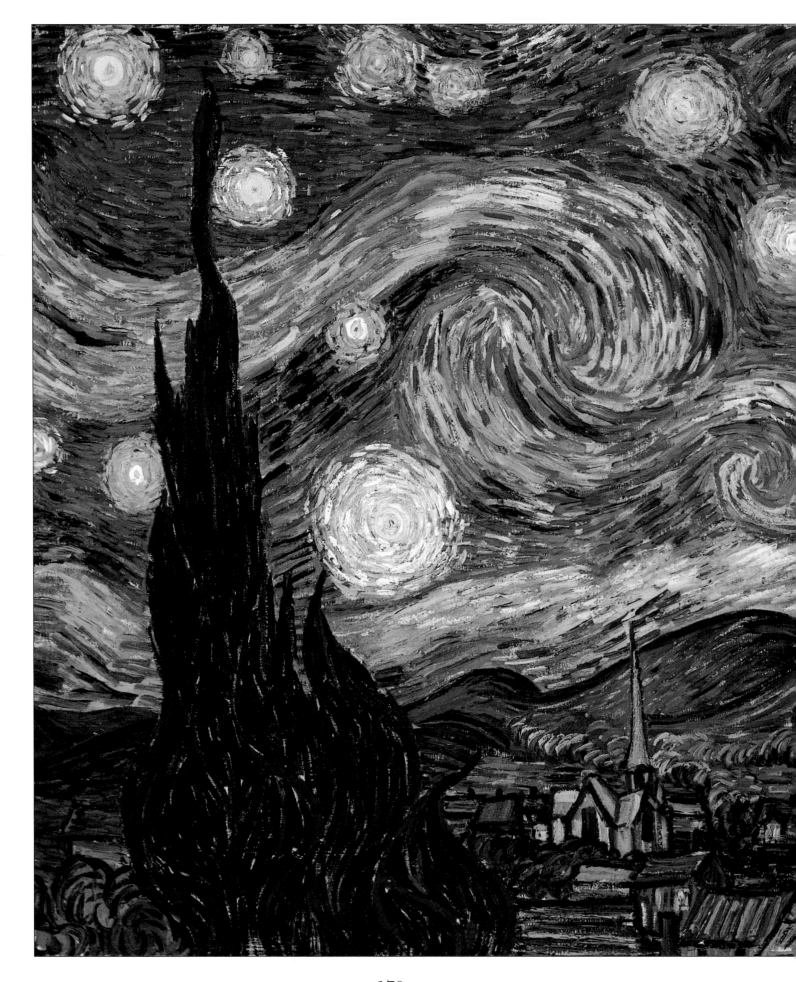

As an example of a modern visionary painting, the portrait is something of a curiosity. Boch is dressed conventionally and, up to a point, is painted naturalistically, although, to judge by a surviving photograph, Van Gogh has narrowed his face, giving it a more strikingly gaunt appearance. His face and figure are primarily a study in yellows and he is posed against what looks like a night sky. All this was according to programme: 'I'll paint him as he is, as faithfully as I can, to begin with', wrote Van Gogh, after which he would become 'the arbitrary colourist', exaggerating the poet's fairness, even using 'orange tones, chromes and pale citron-yellow'. But instead of an ordinary room behind the head Van Gogh proposed to paint infinity, 'the richest, most intense blue that I can contrive'. Barring the star-effects that he introduced in the background, Van Gogh painted Boch's portrait as he had visualized it, creating a strangely benevolent figure (perhaps himself as he would have liked to be) and an original harmony in yellow and blue.

The portraits of Boch and Lieutenant Milliet were partly in the nature of farewells to friends who were soon to leave Arles; Boch went to the Borinage, having been inspired by Van Gogh's descriptions of it, while the Zouaves were due to return to duty in Algeria at the end of October. With the nights beginning to draw in, Gauguin's arrival became even more vital. As if comforting himself with images of domesticity, Van Gogh painted *The Yellow House* (page 95) and the quietly cheerful *Vincent's Bedroom*. The yellows and browns of the bedroom furniture warm the sparsely furnished room with its tiled floor; this is the South, and the shutters are partly closed to keep out the heat of the day. No doubt this was an image of the comfortable monasticism that Van Gogh proposed to share with Gauguin. He always felt that rooms and personal possessions took on something of their user's personality, and the following year, in very different circumstances, he made two copies of *Vincent's Bedroom* (one shown on page 180), as though trying to recapture the mood that inspired it.

Meanwhile he continued to find new subjects, including the public gardens on the Place Lamartine, of which he made a number of pleasant, unpretentious paintings in Impressionist style (pages 118-9, 123). In his mind the little park became associated with poets such as Dante and Petrarch, and he made no bones about writing to Gauguin comparing him, as the 'new' poet, with these revered 'old' ones. The park became *The Poet's Garden* (page 120-1), of which he made a set of four paintings with which to decorate Gauguin's room in the Yellow House.

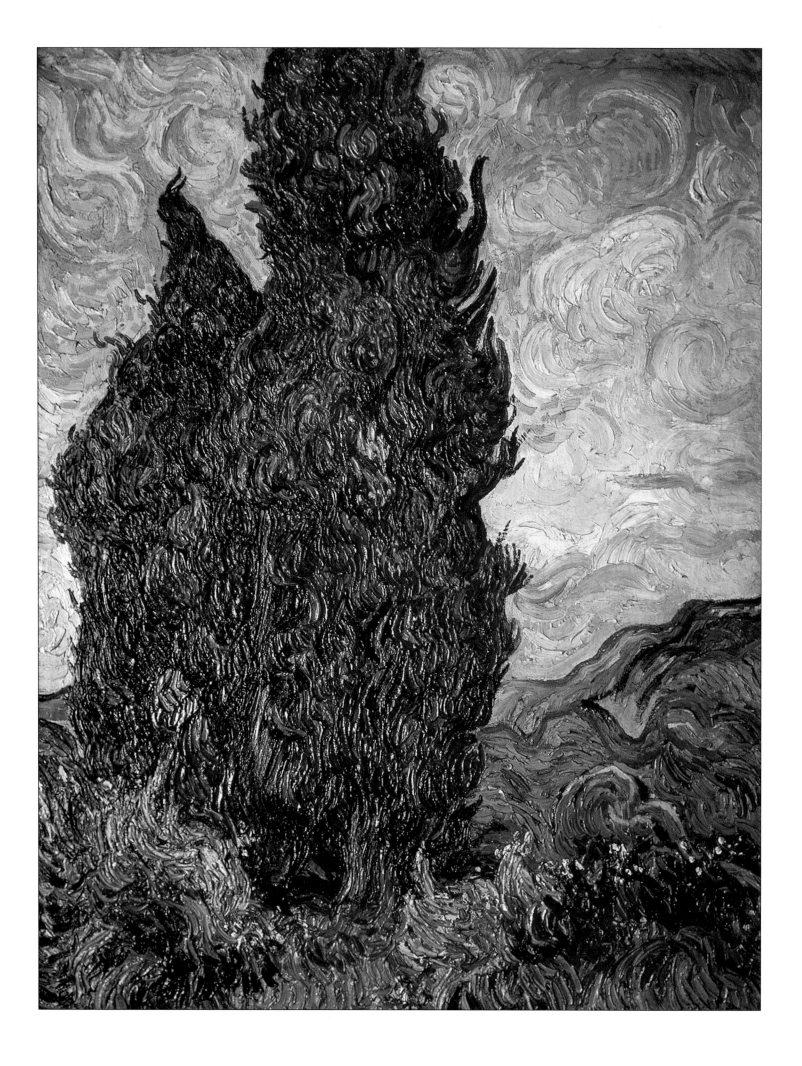

Breakdown at Arles

inally, Gauguin came. He made the long journey from Brittany to Provence, arriving at Arles in the small hours of 23 October, 1888. Exhausted, he went into the Café de la Gare, where the proprietor recognized him from Van Gogh's detailed description of his long-awaited comrade: 'You're his pal!' Directed to the Yellow House, Gauguin waited until it was light and then knocked Vincent up.

The events of the following two months can be partly reconstructed from letters written at the time by Van Gogh and Gauguin, but the only coherent narrative was composed 15 years later by Gauguin shortly before his death. Productions such as his *Avant et Après* ('Before and After') often include mistakes caused by lapses of memory and emotional distortions, but Gauguin's writing smacks of insincerity too. Understandably he is anxious to show himself in a good light and to minimize his responsibility for the final catastrophe. However, he goes so much further, displaying himself on every occasion as the wise and strong friend, the mature artist putting his younger colleague right, that few readers have ever been convinced by his version of the relationship. *Avant*

LEFT: **Cypresses**
1889
METROPOLITAN
MUSEUM OF ART,
NEW YORK

et Après is indispensable, but it is also highly suspect and to be used with caution or even scepticism.

Living Together

For a few weeks everything seems to have gone well. Van Gogh was delighted by Gauguin's arrival and pathetically anxious to please. The weather was still reasonable and the two artists were able to make expeditions beyond the town, often painting the same subject. One example was Les Alyscamps, an ancient burial ground lined with poplars and Roman tombs, that now served Arlesians as a pleasant walk. Of Van Gogh's four paintings of the subject, two are in his own direct manner (as page 131), but the others are in a style clearly influenced by Gauguin's pink-red tones and smooth-surfaced, semi-cloisonnist style. Another common subject was *The Red Vineyard* (page 132-3), which, despite Gauguin's obvious influence, has a vigour and colouristic strength that is distinctly Van Gogh's.

Apparently the dominant artist, Gauguin also took over the management of the Yellow House, less in his role as the abbot of an artistic fraternity than as an ex-sailor who could not abide disorder. *Vincent's Bedroom* evidently expressed an ideal of order that the hectic, messy Van Gogh could not sustain on his own. Gauguin cleaned up, put their common funds (provided by Theo) into a money-box, worked out a budget and sent out Van Gogh to do the shopping; apart from one inedible soup made by Van Gogh, Gauguin did the cooking. In a revealing comment, Gauguin wrote that he didn't know how Vincent made up his soup – presumably the same way he mixed his colours! Since this was written in 1903, it obviously represents a long-standing and deep-seated hostility towards the free, heavily impasted painting style from which he had hoped to wean Van Gogh.

The influence was not all in one direction, a fact that Gauguin forgot to mention in *Avant et Après*. He was impressed enough by Van Gogh's *Night Café* to paint a red-green café scene of his own, with Madame Ginoux seated at a table in the foreground resting her head on her hand. In turn, Van Gogh was so taken with Gauguin's preparatory drawing of the café proprietress that, months later, in a hospital, he used it as the basis for several paintings. More immediately he made the same woman the subject of two paintings entitled *L'Arlésienne* (*The Woman of Arles*, page 135). Her pose is the same as that of the woman in Gauguin's *Night Café at Arles*, although she is seen from a

RIGHT:
Self-portrait
1889
Musée d'Orsay,
Paris

174

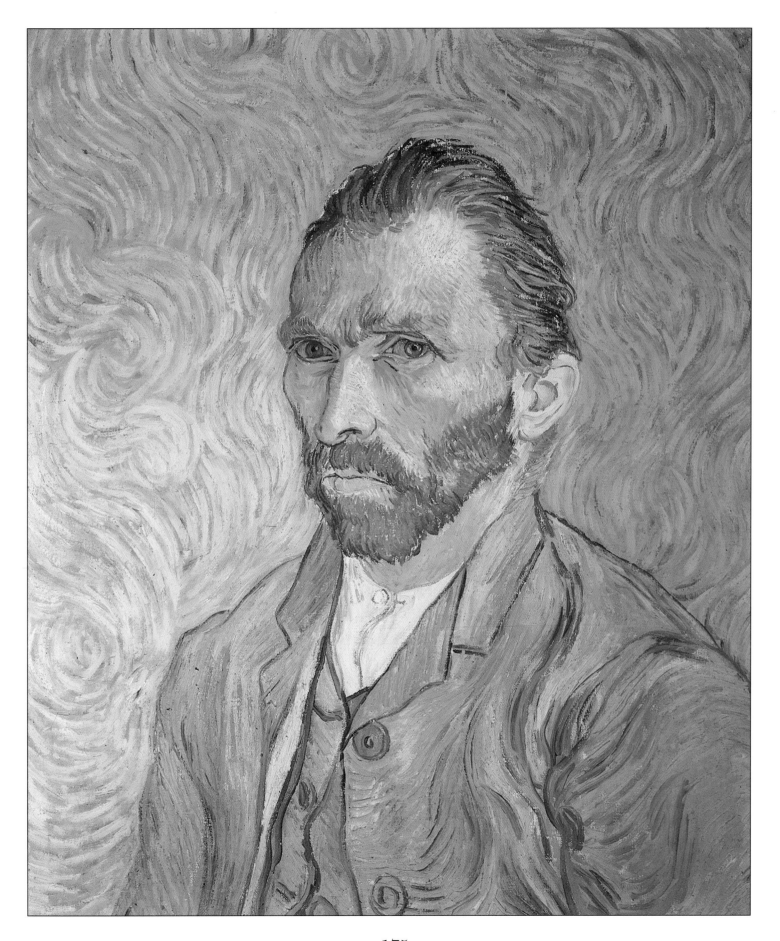

different angle – apparently for the very good reason that the two artists were painting her simultaneously. In one version of *L'Arlésienne* (probably the earlier) she sits at a table with her umbrella and gloves in front of her, while in the second (page 135) they are replaced by books; the background is a brilliant yellow. *L'Arlésienne* was a familiar title in France; in using it Van Gogh made a deliberate reference to the popular play of that name by Alphonse Daudet and the now better-known incidental music composed by Bizet. Consequently the word 'Arlésienne' evoked the independent spirit and beauty of the original heroine. Madame Ginoux's origins are made plain by the Arlesian folk costume that she wears, but her pensiveness could be taken to imply that she is reading or dreaming over the story rather than posing as a character in it.

Memories and Portraits

Such café paintings were produced as winter set in and the prospect of working out in the open became increasingly unpleasant. In these circumstances Gauguin's advocacy of painting from memory and imagination began to seem more attractive, as did his conscious striving to create a sense of mystery: 'Gauguin gives me the courage to imagine things,' Van Gogh told his brother, 'and certainly things from the imagination take on a more mysterious character'. *Memory of the Garden at Etten* (pages 138-9) represents his most whole-hearted attempt to please Gauguin, despite distinctly non-Synthetist speckles of bright colour ('Memories of Neo-Impressionism'?). The picture is a masterpiece of its kind, taking the decorative intensity and airlessness of cloisonnism to an extreme and turning the canvas into a jewelled Symbolist icon. In describing it to his sister Wil, Van Gogh compared his use of colour with notes of music: both could express feelings by the way in which they were arranged, without reference to any outside reality (an anticipation of the rationale of abstract painting). He went on to explain that the serpentine lines, so typical of cloisonnism, did not represent the garden as it appeared in reality but as it might look in a dream. In a burst of even more intense mystification, he implied that the women out walking might or might not be Wil and their mother, irrespective of their lack of 'the slightest, most everyday and unimportant resemblances'.

In all of this Van Gogh appears to be trying to speak with the voice of Gauguin, and rather overdoing it in an attempt to carry a

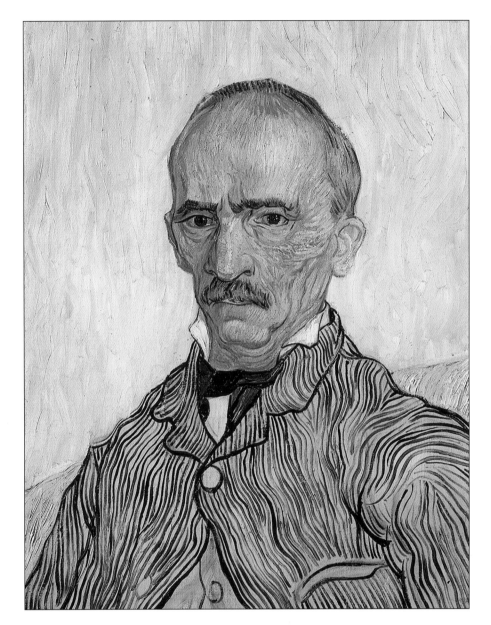

conviction that he did not really feel. The same might be said about *Memory of the Garden at Etten*; as so often, Gauguin painted a closely similar subject, *Old Women of Arles*, which achieves its 'mysteriousness' with simpler forms and larger areas of pure colour. Van Gogh must have had an almost immediate revulsion against his experiment with Synthetism and Symbolism, for he painted nothing else remotely like *Memory of the Garden at Etten*. Some other pictures from November and December 1888 must have been painted from memory, for example two versions of *The Sower*, with a huge sun on the horizon. But in these Van Gogh returned to his own vein, so that the intensity of the colour and the working of the paint conveyed a sense of an experience deeper and more convincing than the result of his self-conscious

RIGHT: **Field of Wheat with Cypresses** 1889 NATIONAL GALLERY, LONDON

ABOVE: **Vincent's Bedroom at Arles** 1889 MUSÉE D'ORSAY, PARIS

quest for mysteriousness. He also retained an interest in cloisonnism, especially as developed by Emile Bernard. Gauguin had brought with him to Arles a picture by Bernard, *Breton Women*, in which the artist took still further the cloisonnist simplification and elimination of detail. Van Gogh made a watercolour copy of the painting, and used a similarly bold technique in *The Dance Hall at Arles* (page 140); but where in Gauguin's and Bernard's works the fluently outlined areas of colour created a contemplative atmosphere, Van Gogh somehow marshalled them so that they generated a surge of vitality and movement. At about the same time he painted in a looser style *The Arena at Arles* (page 141), recalling the impression that had been made on him earlier in the year by the throng of spectators at the local bullfight.

At about the same time, Van Gogh was painting a series of portraits that owed little or nothing to Gauguin's arrival. Most of these were of members of the Roulin family and, since Van Gogh had now become friendly with them all, were probably done in their home; Roulin's wife Augustine is certainly shown in a domestic setting, alone (but with pots filled with new shoots visible through the window) or proudly holding up her new baby, Marcelle. Van Gogh also painted three little portraits of the all too convincingly pudding-like Marcelle and of the schoolboy Camille, but put more sad poetry into his images of the oldest brother, Armand (pages 142, 145); in the version in which he is wearing a yellow jacket, he might easily be a film actor.

Such indoor portraits were a natural response to winter. But the Roulins' company was probably also a relief from Gauguin's, as the season forced the two artists even closer together. After a day spent in each other's company in the Yellow House, they went to the café together, drank together and visited the brothel together. Living in near-isolation in a provincial town in winter might have strained any friendship. Before very long Van Gogh seems to have become a little disillusioned with his friend, as was almost inevitable after the way in which he had exaggerated his perfections. Although he never specified what Gauguin had said or done, Van Gogh was evidently shocked by his pose of cynicism and his self-seeking attitude. Another, less idealistic person might have reflected that becoming a professional painter in middle age and working in an innovative, unorthodox style such as Gauguin's were hardly signs of ruthless careerism; and that, for all his eye-on-the-main-chance attitude, Gauguin had ended up no better off than Van Gogh himself. Much of his arrogance and bravado was a self-protective pose, like the wisdom and strength he projected in his autobiographical writings. Even his meticulous budgeting was mostly make-believe, since an impulsive raid on the money box and a brief spree would set everything at sixes and sevens, just as it had been when Van Gogh had lived by himself.

Gauguin's arrival almost certainly intensified the unconscious rivalry that Van Gogh had felt towards him in the summer. He was influenced, although not overwhelmed, by Gauguin's art and ideas, but he could only be jealous of Gauguin's success in other spheres. Soon after Gauguin's arrival, Van Gogh wrote to Bernard describing his friend as 'a virgin creature with savage instincts. With Gauguin blood and sex prevail over ambition.' Gauguin certainly appeared to have a way with women, and his appetite was

probably greater than Van Gogh's – something that may have seemed more important when they were together than it had when Van Gogh was writing philosophically to Bernard about his declining sexual powers. Gauguin may also have had a more down-to-earth attitude towards prostitutes that is likely to have shocked Van Gogh, with his fellow-feeling for all outcasts. A sense of rivalry between the two may also have been created by their connection with Theo. Despite his generous heart, Van Gogh must have been cast down when, in November, Theo held a small exhibition of Gauguin's work and even made a few sales. In the event it did not prove to be a breakthrough for Gauguin, but at the time it must have seemed otherwise, making Vincent miserably aware that he had so far failed to make even the slenderest of reputations.

It should also be said that many relationships hold up under disillusionment and jealousy, so we cannot be sure that any of the considerations outlined above were of decisive significance in the crisis that occurred between Gauguin and Van Gogh. Even the sequence of events is uncertain. In their letters to Theo, both Van Gogh and Gauguin wrote in rather bland terms until late in December, which may mean that things were alright – or alternatively that they were playing down their difficulties.

Tension in the Yellow House

It is hard to know how and when they started to get on each other's nerves. They may well have been on good terms until mid-December, except for one important matter that weighed on Van Gogh's mind: Gauguin's lack of commitment to Arles, to the studio of the South, to Vincent. By comparison with Brittany, Arles was a rather ordinary place, with all its romance locked away in the too-distant past. Although Gauguin held Van Gogh spellbound with his tales of the sea and foreign climes, his obvious longing to get away to the tropics was distressing. At moments Van Gogh even made himself believe that he, too, would head further south, but in his heart he knew that that was not what he wanted or needed. His anxiety was probably exaggerated, if only because Gauguin lacked the resources to sail away and had every reason to spend at least the winter months in the Yellow House, where he could live and work without financial worries, subsidized by Theo van Gogh. Writing to Theo in mid-November, he visualized staying in the Midi for more like a year, as Vincent hoped.

But it was just his mounting anxiety that caused Van Gogh

to act in ways that upset Gauguin and made him restless. Van Gogh was sometimes raucous, at other times sullen. Eventually Gauguin – if his own account is to be believed – began to wake in his bed at night and find his friend standing over him. A grave 'What's the matter, Vincent?' would send him wordlessly to his own bed and a deep sleep, presumably relieved to find that Gauguin had not fled in the night. If this really happened, or at any rate happened more than once, Gauguin must also have

BELOW: **Head of an Angel** (after Rembrandt) 1889
PRIVATE COLLECTION

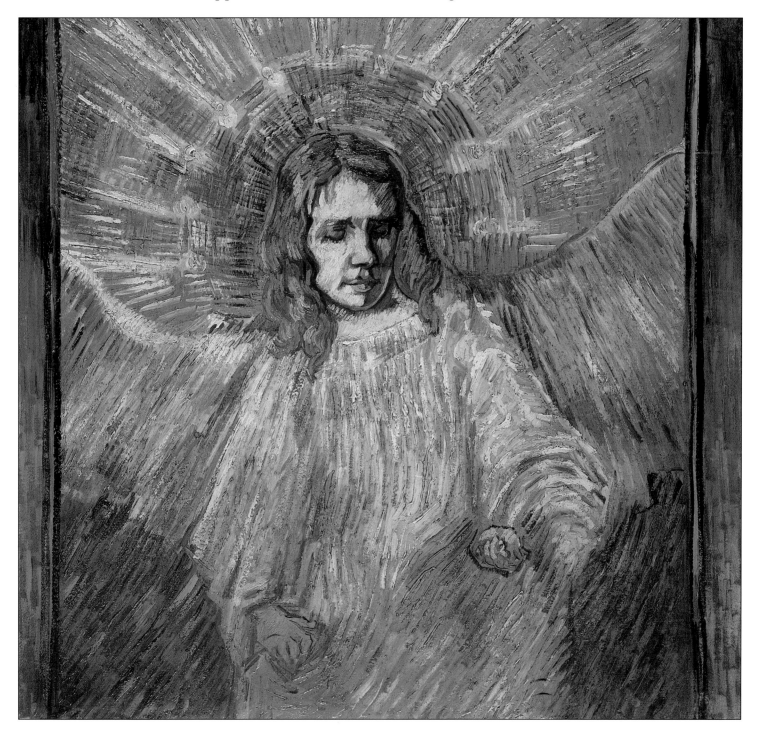

wondered just what Van Gogh would have done if he had not woken up. Such incidents inevitably prompted Gauguin to talk of leaving, so that Van Gogh's anxieties were confirmed and strengthened, making him behave more erratically and alienate Gauguin still more, in a familiar spiral of agitation and tension.

Their arguments about art also became heated. We may imagine that Van Gogh shed his originally deferential attitude and – or – that Gauguin no longer held back from condemning Van Gogh's vehement brushwork. On 13 December they were still friendly enough to take a trip to Montpellier, 60 kilometres to the west, where the town museum (the Musée Fabre) housed a superb collection accumulated by a wealthy connoisseur named Alfred Bruyas. Afterwards they discussed what they had seen and ended by ranging over the history of painting. Gauguin praised Raphael, Ingres and, among his contemporaries, Degas; Van Gogh declared his preference for Delacroix, Daubigny, Théodore Rousseau and Daumier. In reality each man was praising the tradition to which he belonged. Gauguin, despite his liking for primitive and exotic subjects, was a Classicist, cerebral in his approach to painting and drawn to the use of cool and controlled line, whereas Van Gogh was essentially a Romantic in his devotion to spontaneity, feeling and colour. If Van Gogh and Gauguin failed to realize the futility of such a debate, it can only have been because some element of personal struggle was also involved. Gauguin described their differences of taste in an irritable letter to Bernard, indicating that he was thoroughly fed up with Arles. Van Gogh wrote in more ominous terms to Theo: his arguments on such subjects with Gauguin were *electric*, and they emerged from them exhausted, like spent batteries.

Even at this point Gauguin may not have realized that Van Gogh was heading for a breakdown. Several incidents occurred in a matter of a week or ten days during December, but they cannot be arranged into a certain sequence. Gauguin completed a portrait of Van Gogh, showing him at his easel painting sunflowers; these were the works by him that Gauguin most admired. He is seen from above, at an unusual angle which may have been adopted as a homage to Vincent's beloved Japanese prints, but which gives the picture a disturbingly vertiginous quality. Combined with Gauguin's version of Vincent – long-jawed, with a curiously veiled expression – it justified Van Gogh's reaction to it: 'It's me, yes, but me gone mad.' He had always been angry at any suggestion from others that he was mentally unstable (whatever he might say about himself), so Gauguin's canvas almost certainly upset him.

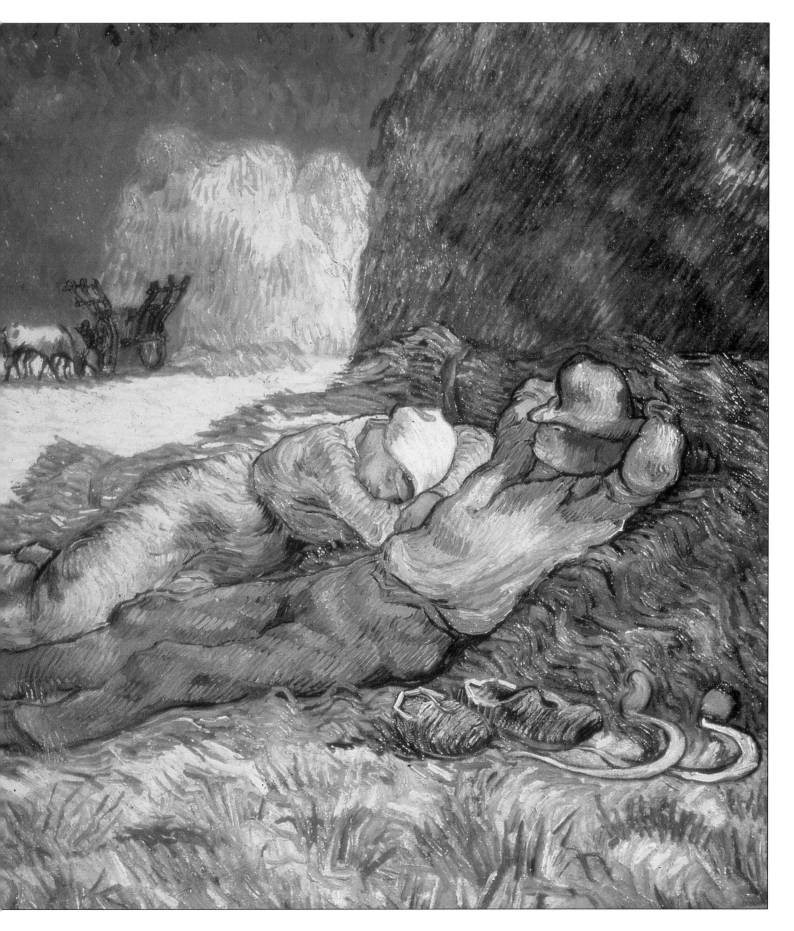

According to Gauguin, this triggered an incident the same evening for which we have only Gauguin's word; but his account is understated enough to carry some conviction. He and Vincent went to the café, but when they had been served their drinks Van Gogh suddenly flung a glass of absinthe at him. Gauguin managed to dodge it and, taking Van Gogh in his arms, carried him back to the Yellow House and put him to bed. He fell asleep within seconds and did not wake again until morning. He had only a vague memory of what had happened, and when he apologized Gauguin 'gladly forgave him' but feared that, if such a thing recurred, he might lose control of himself and strangle Vincent; so he had better go. At any rate this is what he claimed he said, 15 years later. The implication that he was the master of every situation is typical of Gauguin's writings about himself, but it is true that he was bigger and more powerful than Van Gogh and perhaps had no inkling yet that the little Dutchman might prove dangerous.

In the circumstances Gauguin felt that he should write to Theo and announce his intention to return to the north. His narrative in *Avant et Après* suggests that his final confrontation with Van Gogh occurred on the same day, but it seems likely that in writing the story he ran several time-separated incidents together for dramatic effect. He did write to Theo, tactfully indicating that, despite his respect for Vincent, they were incompatible; but in the event he was persuaded to stay on. For all his egoism, Gauguin did have a certain affection for Van Gogh, although it was usually expressed in self-flattering terms. In a letter to a friend he wrote that he was in an awkward position at Arles: 'I owe a great deal to van Gogh [that is, Theo] and to Vincent, and in spite of some discord I cannot be angry with an excellent fellow who is sick, who suffers, and who asks for me.' He would stay, but his departure would always be a possibility.

But that was a large part of the trouble: Van Gogh lacked the secure companionship he needed, and he was much sicker than Gauguin imagined. His fears were expressed in two famous paintings, *Vincent's Chair* (page 147) and *Gauguin's Chair* (page 148). Once more he associated objects with their owners' personalities. The significance of empty chairs in particular had a long history. During his London years he had been greatly moved by engravings of Luke Fildes' *The Empty Chair*, which showed Charles Dickens' study at Gad's Hill, unoccupied after the great novelist's death. Later, after his father had visited him at The Hague, Vincent had burst into tears at the sight of the chair that the

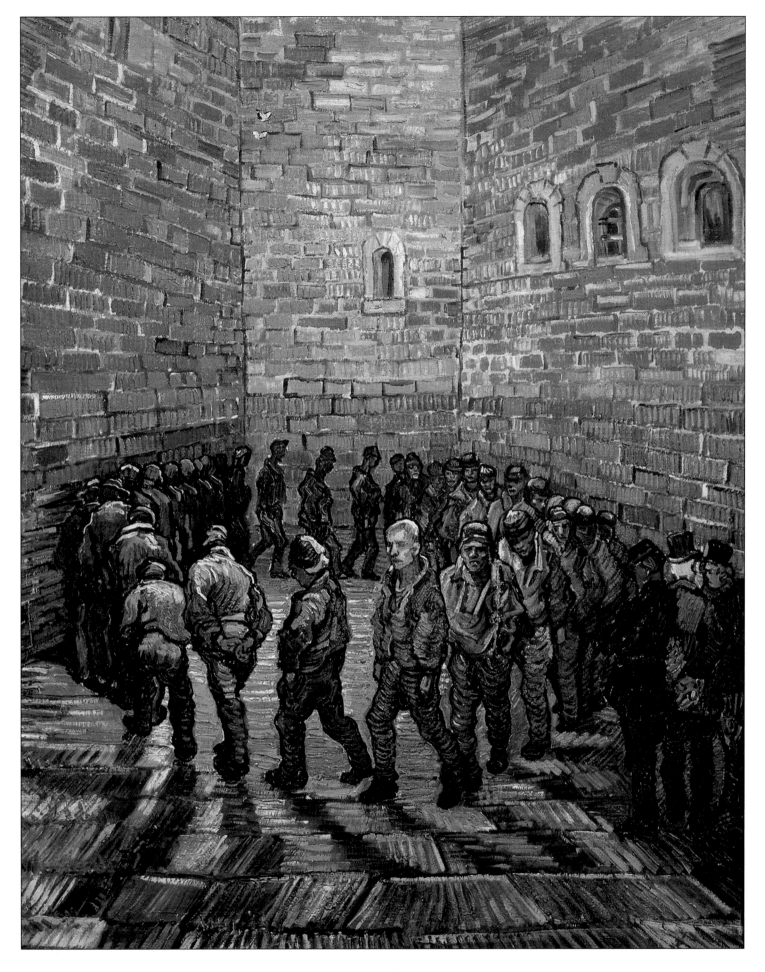

pastor had sat in. Applying this imagery to his relationship with Gauguin is an indication of how important that relationship was to Van Gogh; but the treatment also demonstrates the ambiguity of his attitude to his housemate. *Vincent's Chair* is a 'noble' yellow, simple, foursquare and friendly, with his pipe and tobacco lying on the wicker seat. *Gauguin's Chair* has a more oppressive atmosphere, combining reddish-brown and green in a sinister way reminiscent of *The Night Café*. The glaring gas lamp intensifies the mood, making it clear that this is a night-piece. The chair itself is elaborate, with curved arms and an upholstered seat on which Van Gogh has painted two books and a lighted candle. The books seem about to slip on to the floor, while the candle, however its symbolism is interpreted (phallic, guiding-light, mourning), gives rise to distinctly uneasy sensations. There may also be an element of wish-fulfilment in the pairing of these pictures: an ignorant viewer might easily suppose that Vincent was the sunlit-stable member of the household, by contrast with a dark, unstable Gauguin.

The Razor's Edge

It was now almost Christmas, a painful rather than joyful season for a lonely man like Van Gogh, and one that had been associated before with crises in his life. Gauguin was restless again. Vincent wrote to Theo telling him as much and, sounding very judicious, stated some of the pros and cons from Gauguin's own point of view. Vincent himself awaited his decision with serenity – he said. Possibly it was at this time that he asked Gauguin whether he intended to leave and, when Gauguin said yes, tore a strip from a newspaper with the macabre printed sentence 'The murderer had fled'.

On the evening of 23 December, Gauguin went out for a walk. Hearing footsteps behind him, he turned and found himself face to face with Van Gogh. In both accounts given by Gauguin an altercation followed, but there was a vital difference between them. According to the later version, Van Gogh held an open razor and made a run at Gauguin, only to be stopped in his tracks by a 'powerful look', after which he stumbled away. Did Gauguin discreetly suppress the open-razor incident in his contemporary account of that night, or was the razor a touch of melodrama added to magnify Gauguin's heroism and enthral the newspaper readers for whom *Avant et Après* was originally written in 1903? Normally we should have little hesitation in dismissing the later, self-glorifying version as a bit of embroidery – if we did not know of a near-identical

incident, involving Van Gogh and a doctor (page 197), which occurred three months later. So Gauguin's story may well be true.

Whatever the exact details, the confrontation was obviously a traumatic one. Gauguin felt unwilling to return to the Yellow House that night and booked into a hotel. Despite his tough façade, he was deeply upset and found it hard to settle to sleep. Next morning, Christmas Eve, he found a crowd round the house and a police commissioner on the scene who as good as accused him of murdering Van Gogh. This is the part of Gauguin's story that is hardest to believe, for he claims that it was he who approached Van Gogh's body and demonstrated (to a presumably dumbfounded police force) that he was still alive! A number of bloodstained towels scattered on the floor downstairs testified to

LEFT: **The Garden of St Paul's Asylum** 1889 PRIVATE COLLECTION

Van Gogh's efforts to staunch a wound. Gauguin relates that he whispered to the commissioner, 'Be so kind, Monsieur, as to wake this man with great care and, if he asks for me, tell him that I have left for Paris. The sight of me could be fatal to him.' The speech is a fine literary flourish, designed to obscure the fact that Gauguin distanced himself from the catastrophe as soon as possible – not that one can blame him much. He sent a telegram to Theo, urging him to come at once, and waited for his arrival.

The police are unlikely to have suspected Gauguin of assault or murder, since they had been called in much earlier by the girls in one of the brothels, whose evidence must have made them almost certain that Van Gogh's wound was self-administered. The local Sunday newspaper, the *Forum Républicain*, gave a brief account

of the affair on 30 December: 'Last Sunday, at 11.30 in the evening, Vincent Vaugogh [!], a painter of Dutch nationality, presented himself at maison de tolérance no. 1 [licensed brothel no. 1]. He asked for a woman named Rachel, and gave her... his ear, saying "Look after this object carefully". Then he disappeared. Informed of this deed, which could only be that of a poor lunatic, the police went to his home the following morning and found him lying in bed and showing almost no signs of life. The unhappy man was immediately admitted to the hospital.'

Hospital

Van Gogh had evidently returned to the Yellow House after his confrontation with Gauguin, hacked off a piece of his ear with a razor, wrapped it in newspaper, and then walked to the brothel and presented it to the unfortunate Rachel, who understandably fainted when the contents of the newspaper were revealed. Van Gogh's memory of the entire episode was vague, so there is no way of knowing what his motives and intentions were. His malady in general and his self-mutilation in particular have been diagnosed in many different ways (most often as epilepsy or schizophrenia aggravated by malnutrition and alcoholism), but no consensus has been reached on the basis of available evidence.

Theo rushed to Arles, arriving on the 24th, but there was little he could do for the still-unconscious Vincent. He did manage to contact a Protestant pastor, Frédéric Salles, who agreed to help and to report regularly to Theo. In fact, Salles' letters are an important source for Van Gogh's history over the months that followed.

At the public hospital Van Gogh was well cared for by a young doctor named Félix Rey. Although he had lost a good deal of blood, having cut away the lower part of his ear, his physical recovery was quite rapid. But when he became articulate his talk was incoherent and interspersed with religious ramblings that presumably represented memories of old hopes and fears linked with his family background. His postal-worker friend Joseph Roulin visited him on the 26th and came away with the impression that Van Gogh was irreparably 'lost'.But he was actually making quite rapid progress. After a week or so he was rational and able to write letters, and by 7 January he appeared to have recovered completely. Escorted by Roulin, he was allowed to go back to the Yellow House, where he began to work again.

One of his early subjects was Dr Rey (page 151), whom he

painted against a dense background of arabesques, little lozenges and dots. Rey was understanding as a physician, but Van Gogh's painting baffled him. Unable to comprehend why he should be shown with red tints in his hair and green lights on his face, he allowed his mother to stack the canvas out of sight. Years later, when Van Gogh had become famous, it was recovered from the Reys' chicken coop, where it had come in useful to cover up a hole.

In similar style, over a three-month period Van Gogh painted no less than five versions of *La Berceuse*, which might be freely translated as 'The Hand that Rocks the Cradle'. That is exactly what Madame Roulin is doing in the picture, although the only sign of the existence of baby Marcelle or her cradle is the cord that the mother pulls to keep the cradle in motion. Madame Roulin's pose is identical in four out of the five portraits, but there is one (page 153) in which her right hand lies on the left, instead of the other way round as in the rest. The colour scheme of her costume varies from painting to painting, but the greatest changes occur in the treatment of the background, where not only the colours but the actual flowers are widely different (and, in some cases, belong to imaginary species). Similarly dense, decorative backgrounds also appear in three pictures of Joseph Roulin that are otherwise near-copies of his head-and-shoulders portrait of 1888 – except that Roulin's beard has become divided into rounded masses of curls, apparently in sympathy with the arabesque background.

This small group of paintings stands apart from the rest of Van Gogh's work. There is nothing quite like them, earlier or later, although the decorative backgrounds do signal an ongoing impulse to fill the entire canvas with activity. This would later become visible again, for example, in the frequent transformation of the sky into a swirling, seething element. Except as a first manifestation of this impulse, the decorative backgrounds have no demonstrable significance, although it is difficult not to imagine that their rather oppressive effect was linked to Van Gogh's personal situation.

However, his images of himself during the same period offer far more direct accounts of his condition. Two self-portraits show him with a large bandage covering his mutilated ear. In one he wears his fur hat and greatcoat, smokes a pipe and looks straight at us with sorrowful stoicism; the background is bare of decoration, consisting of two shades of red. The other self-portrait (page 154) has a stronger sense of personal collapse. Still dressed in fur cap and coat, Van Gogh stares in an unfocused way, as if he can

neither think nor see. The consoling pipe is absent, but the art for which he has sacrificed so much appears in the form of a Japanese print on the wall and an easel behind him with an indecipherable canvas on it.

Persecutions, Real and Imagined

For three weeks Van Gogh appeared to have made a full recovery. He even reproached Gauguin, in an otherwise friendly letter, for bringing Theo from Paris, as though his self-mutilation had been an accident, not worth making a fuss about. Incidentally, Van Gogh remained on excellent terms with Gauguin, expressing remorse for the trouble he had caused his friend, and evidently convinced that the catastrophe at Arles had not been Gauguin's fault.

Then, early in February, Van Gogh had a new breakdown, suffering from insomnia, hallucinations and a persecution complex which caused him to refuse to eat in the belief that someone was trying to poison him. On 7 February, after his cleaning woman reported his strange behaviour, police again took him to the hospital.

No one can say what brought on this second crisis, but two events in January certainly intensified his anxieties. Theo's relationship with Jo Bonger, which appeared to have foundered, was suddenly renewed, and Vincent received news of their engagement. Although genuinely pleased for his brother, he must inevitably have felt his solitude even more keenly, as well as worrying about the practical consequences for himself. His isolation became more complete when he learned that Joseph Roulin was to leave Arles for a new job in the postal service at Marseilles. He now had no close friends in the town and, as events were to show, without the interest in him taken by Dr Rey and Pastor Salles, he might have found himself treated as a crazy Dutch derelict with no great call on Arlesian sympathies or resources.

Again he made a rapid recovery, but this time the hospital authorities responded to it more cautiously. In mid-February he was allowed to go back to the Yellow House during the day, but he had to return to the hospital to spend the night. This attempt at a solution was not given a fair trial, since Van Gogh's neighbours were by this time determined to rid themselves of the 'madman' in their midst. A petition signed by 30 people was presented to the mayor, demanding that Van Gogh should be sent back to his family or confined to an asylum. The police investigated, interviewed

witnesses and concluded that Van Gogh, although not dangerous, might become so; and they took action accordingly.

The police report makes depressing reading. Its conclusions were based on the evidence submitted by five witnesses. Even a cursory look at their testimonies makes it obvious that their general-sounding statements were all based on a single incident in which Van Gogh was said to have 'touched women' and made obscene remarks in a grocer's shop; the only woman who claimed to have been touched asserted that Van Gogh had seized her by the waist and lifted her into the air. Two of the witnesses had nothing at all to say except that they agreed with the testimony of the rest. Van Gogh was not called upon to explain his behaviour or rebut the charges. The irresistible conclusion must be that the mayor and the police were content to pacify local opinion, without too close an examination of its reasonableness, at the expense of an outsider.

ABOVE: **The Mulberry Tree** 1889 NORTON SIMON COLLECTION, PASADENA

Salles, who was not likely to take a lax view of such matters, felt that even these not very serious charges were exaggerated. He condemned the action of the police, who on 28 February again took Van Gogh to the hospital and insisted on his confinement in an isolation cell. Dr Rey and his colleagues must have agreed with Salles, for restrictions on Van Gogh were soon eased; but there was no doubt that he had been incarcerated, an experience that simply aggravated the strain he was under.

When he was somewhat better, and again in contact with Salles, he protested that he had done no one any harm and would have remained calmer if the police had protected him. This was the other side of the story: after his release in February, children had pursued him when he went out to paint, throwing bits of vegetables at him, and both children and adults had climbed the walls of the Yellow House to spy on him, as though he were a strange animal. Fortunate in the quality of the treatment he received at the hospital in Arles, Van Gogh was less lucky in the primitive reactions he elicited from the Arlesians. It sounds very much as though the people of the Place Lamartine had first tormented him (or, at best, looked on while he was tormented) and then felt themselves threatened when he rounded on them.

As usual, Van Gogh quickly improved and was able to talk and write lucidly about his condition. Never far from his thoughts was the conviction that he had sacrificed himself to art and that the sacrifice had been a necessary one. In March, Rey reproached him for not eating enough during his time at Arles and keeping himself going on coffee and alcohol. Van Gogh reported this to Theo, commenting 'I admit all that, but all the same it is true that to attain the high yellow note that I reached last summer, I had to be pretty well tuned up.'

On 23 March Van Gogh received a visit from Signac, who took him out, asserted his rights against the police and forced open the Yellow House, where a large number of masterpieces such as The Night Café were still stacked away. While they were looking over the canvases and discussing art Van Gogh seemed quite normal; but the expedition had overtaxed him and he suddenly seized a bottle of turpentine and tried to drink it. It was clear that any excitement (even pleasurable excitement) was liable to bring on an attack of some kind. Van Gogh became reconciled to quitting the Yellow House for good, but was reluctant to take up Rey's suggestion that he should move into cheap rooms in a different part of town where he was not known. Rey was no doubt trying to rehabilitate him, but in

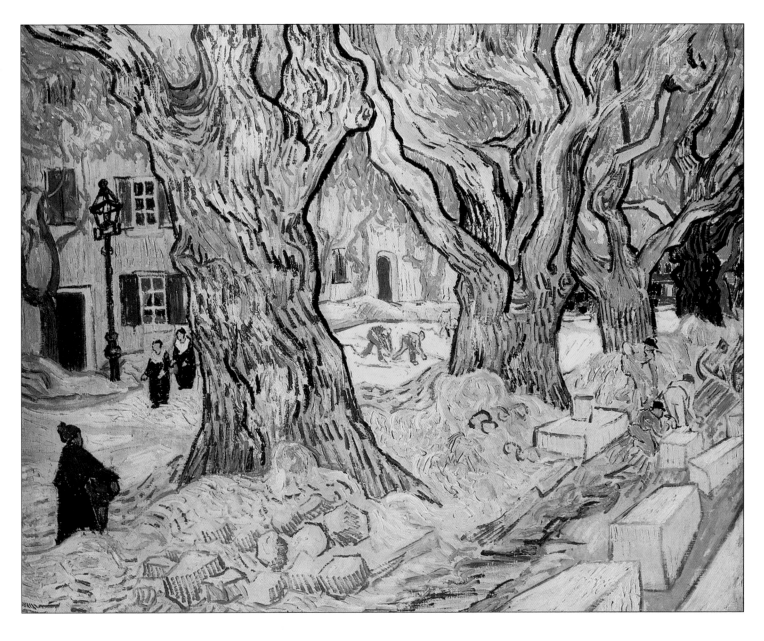

retrospect Van Gogh may have made the right decision, since everything that happened to him subsequently suggested that he needed constant monitoring and a worry-free routine.

Rey's treatment was astonishingly liberal and, by his own testimony, even risky. Van Gogh was allowed access to the doctor's quarters in the hospital and one day entered when Rey was shaving. After blandly asking Rey what he was doing, he offered to give him a shave and then, his expression suddenly dangerous, tried to seize the razor. Rey's stern response – he told him to clear off right away – was enough to subdue Van Gogh and send him hastily back to his room. Rey's razor story has much in common with Gauguin's, and the similarity between Rey's stern command and Gauguin's 'powerful look' makes it much easier than it might otherwise be to

ABOVE: **The Roadmenders**
1889
PHILLIPS
COLLECTION,
WASHINGTON, DC

believe Gauguin's version of events in Arles. For whatever reason, this was Van Gogh's last attempt to injure anyone else. Henceforth, when he was gripped by murderous impulses, they were turned against himself.

During his periods of freedom Van Gogh had continued to paint, producing still lifes of fish and shellfish, and copies of his sunflower canvases, as well as the portraits noted earlier. In April he painted the three new versions of Joseph Roulin's portrait, and then, when he was allowed to venture out again, executed a number of springtime views of the park and the countryside beyond Arles. In some he focused on a small patch of field or flower bank, excluding the horizon to give an all-green or all-yellow effect. Others are longer views, such as Orchard in Blossom with View of Arles, done with massed spikes and curls, full of movemen,t of a kind that reappear in many of his later works, and the more idiosyncratic La Crau with Peach Trees in Blossom (pages 156-7), with its all-over dappling. Both are far removed from the lighter mood of his blossom paintings of the year before.

At the same time he had started to paint his immediate surroundings – the first of many institutional pictures by Van Gogh that have few nineteenth-century parallels. In Ward in the Hospital at Arles, we see the fever ward in deep perspective, with the floor running like a road between the lines of beds on either side from the stove in the foreground to the crucifix on the end wall; drooping patients huddle round the stove while nursing nuns scurry about. The low wooden ceiling helps to make the picture a little cheerless, but it gives the impression of being truthful rather than hostile. All the same, when a grateful Van Gogh tried to present it to a member of staff, a comedy followed in which one after another tried to palm it off on a colleague. The 'victim' who eventually agreed to take it was later (and inevitably) rumoured to have sold it for an enviably large sum. Even finer is The Garden of the Hospital at Arles (pages 160-1), with its crowding, lack of horizon, almost unbearably intense colours, and patients like the audience in a gallery waiting for something to happen.

April was a month for decisions. Theo married his Jo in Amsterdam and brought her to live with him in Paris. It was not a moment for Vincent to show up, even in good condition; and as Theo well knew, the noise, confusion and competing excitements offered by the capital had damaged his brother's health before and would now quite certainly produce even more disastrous consequences. Fortunately Van Gogh himself realized this. He

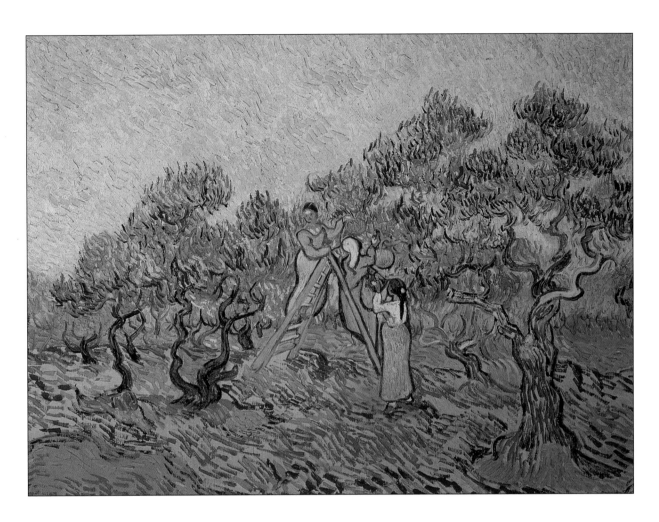

ABOVE: **Olive Picking** 1889
NATIONAL
GALLERY OF ART,
WASHINGTON, DC

told Salles that he accepted that he couldn't look after himself or control himself: 'I feel quite different from what I used to be.' He had had no more attacks, but he often felt faint and knew that, at the least, he needed a long, quiet period of recuperation. Salles passed the information on to Theo, telling him that for this reason they had abandoned the idea of finding Vincent somewhere to live. Since Vincent had expressed the wish to be admitted to an institution where he would be looked after, Salles had taken the initiative and obtained particulars of a private asylum at St Rémy, some 27 kilometres north of Arles.

The scheme was adopted, although there were moments when Van Gogh feared that he might not be allowed to paint at St Rémy and fantasized about joining the French Foreign Legion – he was, he believed, physically, if not mentally, sound – for a five-year stint. On 8 May he made the move (to St Rémy, not a desert outpost), accompanied by Salles. The admirable pastor reported to Theo that Vincent had remained perfectly calm during the journey and had himself explained his case to the director, 'like a man who is fully conscious of his position'.

St Rémy

The asylum of St-Paul-de-Mausole was situated a kilometre or so outside the town of St Rémy, in countryside no doubt chosen to afford maximum peace and quiet for the occupants. The earliest of these had been Augustinian monks who had set up a small house and chapel there during the Middle Ages. Taken over by the state during the French Revolution, the property had been sold and in 1806 the Augustinian buildings had formed the nucleus of the asylum. Successive enlargements had turned it into a substantial establishment with separate wings for male and female patients. A brochure issued a few years before Van Gogh's arrival made St Paul's sound like a model institution, with advanced treatment and many amenities, including billiards rooms, books and journals, and top-quality food.

By 1889, however, the place seems to have fallen on evil days. Either falling numbers of patients had led to declining standards, or vice versa. The entire asylum had a run-down air. There were only ten male patients, and as a result some 30 rooms were vacant in the men's wing. The common room, used when the weather kept everybody in, was, Van Gogh noted, like a third-class waiting

OVERLEAF PAGES 206-7:

Memories of the North 1890
RIJKSMUSEUM
KRÖLLER-MÜLLER,
OTTERLO

room, an impression strengthened by the behaviour of some inmates, who wore travelling outfits and sported canes as though about to board a train or coach for some imaginary destination. The rooms, too, were depressing, with their iron-barred windows and shabby furniture. The food seems to have been abundant but stale and monotonous – mainly lentils and other pulses which, Van Gogh hints, caused explosions and evacuations that served to give interest to the long, idle hours. The books and journals, if they had ever existed outside the pages of the brochure, had vanished. Treatment was minimal, being confined to hydrotherapy – that is, extended immersion in one of the baths lining a long room in the asylum.

In some ways Van Gogh benefited from the ill-success of St Paul's. Theo, who was paying, had booked him in as a third-class patient, which in a thriving institution would have consigned him to a dormitory shared with others. But with so much space to spare, he was allocated a bedroom of his own and allowed to use another vacant room as his studio. Accustomed to an austere way of life, he seemed untroubled by the gloom of the place and even took some comfort from the knowledge that he was not alone in suffering from hallucinations. The cries he heard at night and his encounters with a young man who could make only inarticulate noises helped him to realize that there were others who endured far more than he did. Moreover, he was a privileged, self-admitted patient, staying at St Paul's mainly for a rest rather than restraint.

The asylum director was an ex-naval doctor named Théophile Peyron. On the day after Van Gogh's admission he wrote up his notes on the new patient, presumably based mainly on what Vincent had told him. At any rate, after recording the new patient's derangement, hallucinations and self-mutilation, he added a pathetic sentence that sounds too unprofessional to have been his own: 'Today he [Van Gogh] appears to have regained his reason, but he feels neither the strength nor the courage to live at liberty.' Peyron, like Rey, made a provisional diagnosis that Van Gogh's malady was epilepsy, occurring at long intervals. Once formed, the hypothesis seemed to be confirmed by examples from his mother's family provided by Van Gogh himself. By the time he wrote to Theo van Gogh on 26 May, Peyron was sufficiently confident to hazard the opinion that the attacks were probably epileptic. If this was so, Vincent's hopes for a complete recovery would be dashed and the outlook was serious. From Peyron's point of view, the fact that the patient would have to be under observation for a long time entailed a welcome addition to the hospital's income,

but there is no reason to doubt the sincerity of his diagnosis.

At first Van Gogh spent all his time in his room and had to be encouraged even to venture into the hospital grounds. Once there, he began to draw for long periods, his activity making a favourable impression by comparison with the idleness of the other inmates (whose lack of occupation was, however, partly the fault of the poor amenities at St Paul's: not everybody can, or wants to, draw).

Mystic, Magical Paintings

He also began to paint pictures of the garden and detailed, close-up studies of plants and bushes, among them *Lilacs* (page 163) and the celebrated *Irises* (pages 164-5). Apart from their sheer loveliness, these canvases are notable for their slightly disconcerting 'close-up' quality, which gives the viewer the sensation of standing a little too near them, and for the angle at which they are shown, virtually excluding the sky. Like so much of Van Gogh's work, these can be interpreted in psychological or purely aesthetic terms. Excluding the sky creates an unusual picture with an all-over, strong surface design, but it may also have represented for Van Gogh a comforting sense of being enclosed and protected, anticipating the unease that he sometimes felt later on under the open sky.

By the end of May he appeared to be 'entirely tranquil' and was allowed to go out into the countryside, accompanied by an orderly, usually a young man named Georges Poulet. Throughout June he created magnificent landscapes – to use a term that has a rather feeble air when applied to these tremendous, life-charged wheatfields, olive groves and cypresses, painted with the violent undulating lines that have become the most widely known feature of his late style. Having appeared briefly in some of the wheatfield paintings of 1888, they now broke loose in full force. Fusing the elements of the scene into a dynamic whole, Van Gogh's brush-strokes move all over the canvas: they run, heave, curl, swirl and flare, transforming everyday reality into a vision of a universe in which every particle is filled with life. This was most striking in his treatment of cypresses, trees that had often appeared in paintings, associated with death through their dark, solemn presence. In Van Gogh's hands (for example, page 172) they become fully alive, burning with a sinister black-green flame.

All in all, there is a striking affinity between the experiences conveyed by Van Gogh's paintings – especially those of his final

years – and the accounts of visionary states and moments of illumination given in many classics of mysticism. Although all works of art, even the most 'photographic', are ultimately subjective responses to a stimulus of some kind, Van Gogh's, more than most, bear the imprint of his mind and imagination. The most famous of all these works from June 1889 is *Starry Night* (page 170-1), an indisputably visionary painting in which a huge moon, radiant stars or suns and swirling, wave-like nebulae fill the night sky. A cypress and the entire landscape tremble and move in sympathy; only the little village remains solid and stolid in the turbulent vastness of the universe.

This is not at all the same as saying that Van Gogh's paintings

ABOVE: **Meadow with Butterflies** 1890 NATIONAL GALLERY, LONDON

were linked with his mental difficulties in the direct sense that they were the work of 'an inspired madman'. On the contrary, they were generally produced when he was well, and it was precisely when he experienced an attack that he was devastated and then reduced to a torpor, both conditions in which he was incapable of working. On the other hand, the mystic and the madman were the same person (or, to put it another way, the same brain produced masterpieces and aberrant actions), so it would be presumptuous to dismiss possible links between the visions and the vastations, which also existed in famous contemporaries such as the philosopher Nietzsche and the dramatist Strindberg. Recent writers on Van Gogh have understandably striven to combat any idea that his are 'the works of a madman', but in doing so they have tended to play down the well-documented connection in some hypersensitive individuals between creative intensity and mental fragility. Most artists and poets stay more or less sane, but a long tradition, celebrated by poets and great wits, brackets the poet with the lunatic and the lover (Shakespeare) and declares that 'Great wits are e'er to madness near allied' (Dryden).

Although Van Gogh remained 'tranquil' all through June, he was still easily upset, reacting unfavourably to unfamiliar faces and places in sleepy St Rémy: 'I fell ill from the mere sight of people and things'. But about a month afterwards he made an uneventful trip to Arles, accompanied by the senior orderly, Superintendent Trabuc, in order to collect some of his paintings. Then, on 10 July, his hopes of a smooth recovery were shattered by a terrible attack, during which he suffered hallucinations and tried to kill himself by swallowing quantities of paint.

There may have been a psychological element in these breakdowns, which sometimes occurred not long after news of Theo that was not altogether welcome. (However, like all other attempted explanations of Van Gogh's affliction, this one certainly does not cover all cases.) Theo's engagement and marriage occurred during Vincent's first wave of breakdowns in Arles, although he seems not to have heard of the engagement early enough for it to have influenced the crisis with Gauguin. In July 1889 the news from Theo was Jo's announcement of her pregnancy. As usual, Vincent was consciously pleased, but it would also have been quite natural for him to feel less important to Theo and a hopeless failure by comparison with his bread-winning, family-man brother. He was also aware that he must be more of a burden now that Theo had two other people to support. He wrote to him in a rather

RIGHT: **Road with Cypress and Star** 1890 RIJKSMUSEUM KRÖLLER-MÜLLER, OTTERLO

RIGHT:
**Landscape at
Auvers after the
Rain** 1890
PUSHKIN
MUSEUM,
MOSCOW

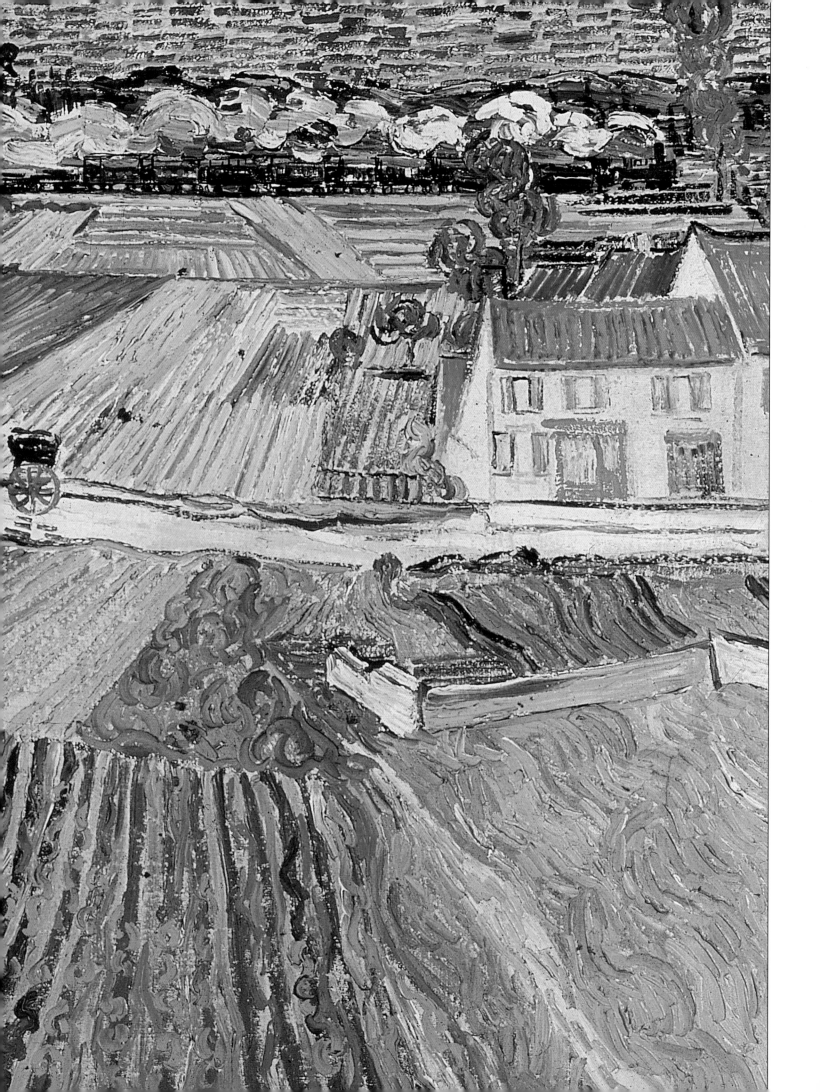

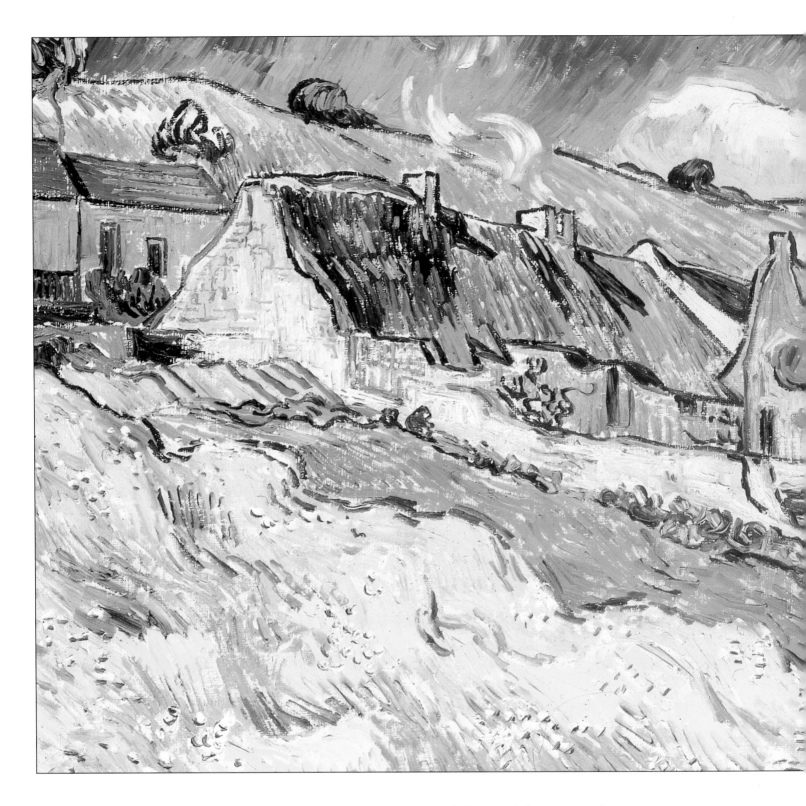

garbled fashion that suggests his fear of the straight answer he
might receive to a straight question: if Theo found himself
faced with heavy responsibilities, well, they shouldn't worry
much about each other (in other words, Vincent would
survive somehow). Coincidentally or otherwise, Van Gogh's attack
occurred only a few days afterwards.

After his suicide attempt Van Gogh was forbidden access to paints, a natural decision on the part of the director, but one that left him miserably unemployed and probably delayed his recovery. In the latter part of August he wrote to Theo, confessing that he was still in a bad way, 'in complete *dérangement*, the same, or perhaps worse than in Arles'; and in a rare lapse from stoicism, he described the prospect of future attacks in a single word: *abominable*. From now on he would have to work as and when he could, creating as much as possible, with the threat of some final, irreversible seizure always hanging over him.

Associating his misfortune with Provence and its roasting sun, he began to long for the north, but he realized that for the moment there was no question of his living in Pont-Aven (as Theo had suggested), let alone Paris, unless it were in yet another asylum.

The Final Portraits

After a few weeks he was allowed to paint again and he began to work with his usual passion – but indoors. His attack had occurred while he was in the countryside, and from this time he was nervous of working in the open, feeling particularly vulnerable under a big sky. Until September he would not even venture into the asylum grounds. The results of his self-confinement were a series of portraits and many remarkable copies. As so often, he was his own model, picturing himself in widely different styles and moods that it is tempting and perhaps legitimate to relate to his personal circumstances – although Van Gogh was certainly aware of the parallel between his own persistent self-portrayal and that of the greatest Dutch master, Rembrandt. Like Van Gogh, Rembrandt recorded the ravages of time and suffering on his features, but he also showed himself in what can only be described as fancy dress, as king or cavalier. Van Gogh, too, may sometimes have gone in for a certain amount of play-acting, perhaps in the Parisian portraits in which he looked a man-about-town and almost certainly in one of the self-portraits painted in September 1888. In this he is the blue-smocked painter, clean and clear of gaze, grasping his palette and brushes. It has been plausibly suggested that this almost glamorous image, begun as soon as Van Gogh was allowed to resume normal activity, was painted in order to impress Dr Peyron with his status and convince him that the artist was to be trusted again. Yet the strangest of all the self-portraits, in which an almost brutish, blood-red-flecked Van Gogh looks out at us through a

green-yellow miasma, belongs to the same period and might easily be taken as a portrait of madness. By contrast, a blue-on-blue self-portrait now in the Musée d'Orsay (page 175) is harsher-featured and, despite the hallucinatory swirling lines of the background, filled with an apparently hard-headed, almost aggressive determination. Curiously, having completed his thirty-seventh known self-portrait in September 1889, Van Gogh painted no more of them during the remaining ten months of his life. Since these ten months represented about a tenth of his career as a painter, the absence of any self-image would appear to be a symptom of some important psychological or artistic shift of outlook; yet nothing momentous of the sort seems to have occurred during the autumn of 1889.

During his indoor period Van Gogh also painted the *Portrait of Trabuc* (page 177). He admired the superintendent, finding 'something military about him', and suggested that, although sprung from the common people, he had the air of a Spanish grandee. Trabuc had worked in a hospital in Marseilles during the cholera epidemic and had, as Van Gogh observed, 'seen an unbelievable amount of suffering and death'. Perhaps for that reason, Van Gogh created a (for him) unusually naturalistic portrait of the old man, fallen-faced but strong-centred, with a hint of kindliness beneath his show of authority. The sprightly linear patterning of his jacket seems to belong to another kind of picture, yet it also discreetly echoes the lines on his face. Remarkably, the two styles co-exist and fuse without the slightest incongruity.

Trabuc lived with his wife, on almost instant call, in a house close to the asylum. Van Gogh also painted Madame Trabuc, a dark, large-nosed, elderly woman, not unlike some of the Dutch peasant subjects who had sat for him at Nuenen. The portrait was believed to have been destroyed during World War II, and it was only in 1995 that it reappeared in St Petersburg, in a show devoted to paintings carried off by Soviet 'trophy brigades' from defeated Germany. At least three other Van Gogh canvases have also seen the light again after fifty years of oblivion.

It is not certain whether the Trabuc portraits are the originals or copies. Often Van Gogh presented portraits to people who liked him well enough but accepted his works with embarrassment and later destroyed them, deliberately or through neglect; possibly the Trabucs did just that. Fortunately Van Gogh had a habit of copying his own works, and this has ensured the survival of one or more versions of many canvases from his years in France. After his first breakdown he no longer attacked his canvases with the same

frantic energy. Copying seems to have relaxed him and to have given him the opportunity to create variations on a theme, like a musician. He made two new versions (including that on page 180) of *Vincent's Bedroom* in September 1889, and two new versions of *Field of Wheat with Cypresses* (pages 178-9).

Creative Copying

He also returned to his earlier practice of copying other artists' works. Apart from the fact that it could be done indoors, copying was a way of learning, and although he was now a great master (without fully recognizing the fact), Van Gogh's urge to learn remained very strong. It was now supplemented by a motive of prime importance, given his mental condition: 'I find that it teaches me a lot and – this is the main thing – sometimes soothes me.'

There were additional reasons, both practical and artistic. In the asylum, where live models were not readily available, copying enabled Van Gogh to keep up his figure painting, which he still considered the most important part of his work. Now he had also come to realize that, for him, copying had a creative aspect which he likened to the interpretation of music by an instrumentalist; he thought of his brush as held between his fingers like the bow of a violinist. Since he was painting from black-and-white prints, he had to improvise the colours he employed in his 'copies' (although he tried to remember – but also to 'interpret' – them if he had seen the original pictures). Moreover, the drawing in many of the prints was rather stiff, effectively forcing him to use his own living line.

Van Gogh saw himself as 'translating into another language' the works of other artists, and consequently widening their potential audience; but most people who now look at them are content to regard his copies as authentic Van Goghs, while finding a certain added interest in comparing them with the originals. During September he made two copies of Delacroix's *Pietà* and one copy of a Rembrandt *Angel* (page 183). Most striking of all was his return to Jean-François Millet, the great peasant painter. Although he had never renounced him, Van Gogh had shown less interest in 'Father Millet' after he had left Holland and apparently turned away from concern for toilers and social conditions. His renewed enthusiasm was probably linked with his longing for the North and his roots; at times he even spoke of abandoning the bright palette he had taken over from the Impressionists and going back to harmonies based on greys. But this was not in fact how, as a copyist,

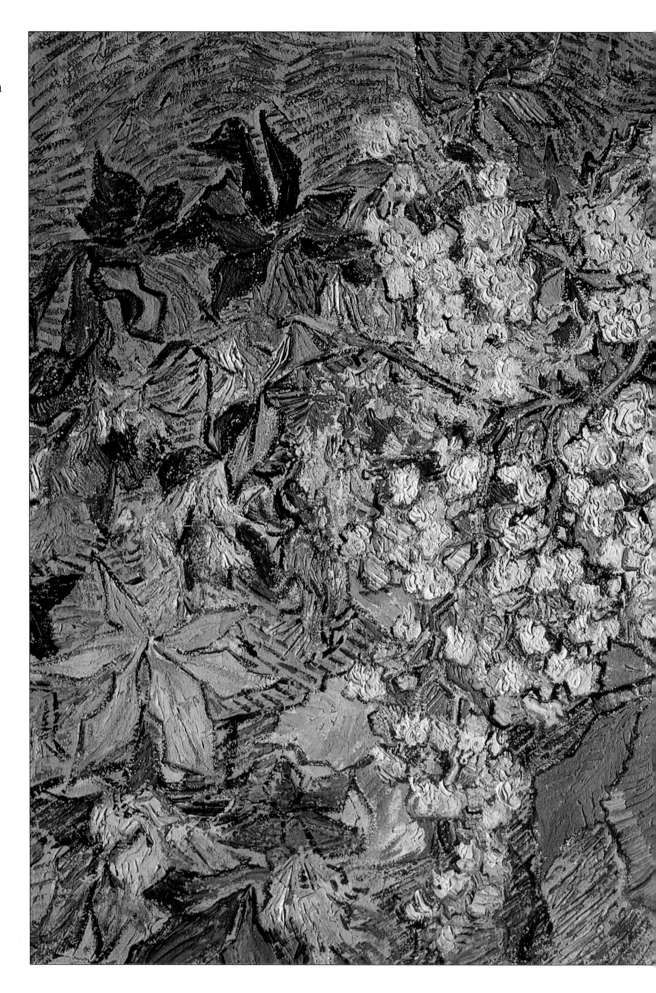

RIGHT: **A Branch of Chestnut Blossom** 1890
BÜHRLE COLLECTION, ZURICH

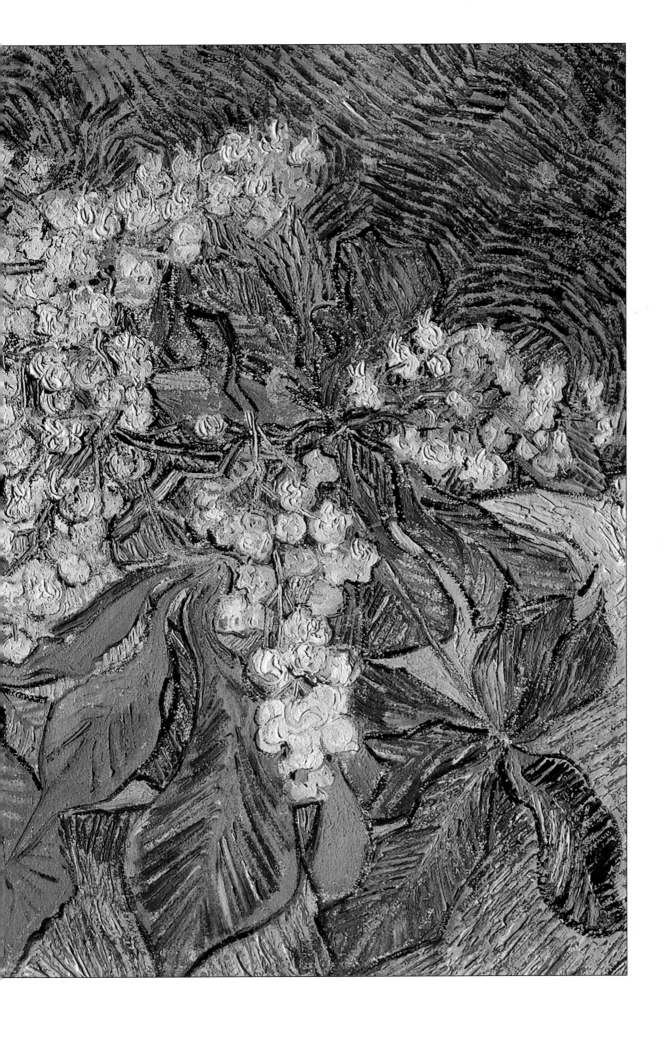

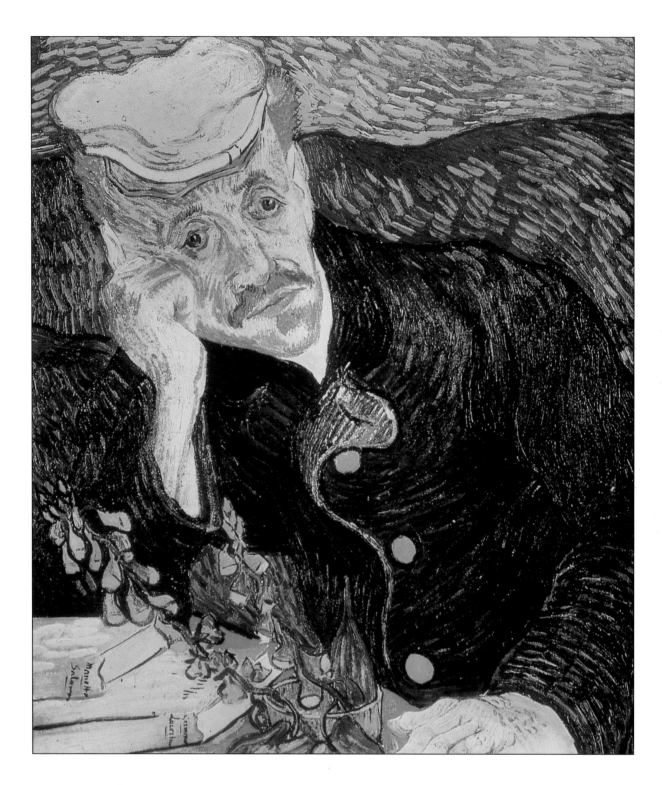

ABOVE: **Portrait of Dr Gachet** 1890 PRIVATE COLLECTION

he interpreted Millet, whose field- and craft-workers now shone forth predominantly in blues and yellows. Van Gogh copied many single figures from a series of engravings, 'Labours of the Field', and later did a few large copies such as *Noon* (pages 184-5), in which, unusually, his vigorous and varied brushstrokes create a sense of relaxation rather than agitation. The man has kicked off

his shoes and he and his companion are at ease in a way that is arguably unique in Van Gogh's work. The sickles, side by side, parallel and comment upon the sleeping couple.

Copying remained an important activity all through Van Gogh's stay at St Paul's. Millet was his favourite by far, becoming the direct source for some 20 pictures, and inspiring other scenes such as paintings of the fields that Van Gogh could see through the bars of his windows, which he humanized by adding Millet-style figures working the land. As if recalling his religious-social phase in the Borinage, he painted versions of Rembrandt's *Raising of Lazarus*, Delacroix's *The Good Samaritan*, and Doré's *Exercise Yard at Newgate Gaol* (page 187). These also concerned matters that touched him even more directly: sickness, assistance to the afflicted and confinement. Gustave Doré (1832–83), much admired in his day as a painter, is now mainly remembered as a graphic artist. Although French, he became particularly well-known in Britain, even opening his own gallery in London. He alternated between extremes of grotesque fantasy and the social realism that Van Gogh valued. He had known the most famous collection of Doré's prints, *London* (1872), since at least 1877, when he had written to Theo from Dordrecht, recommending it to him. At the time he mentioned the Thames wharves, the Underground and similar sights, rather than the scene that now caught his attention, in which prisoners march in a circle round the exercise yard, deprived of freedom even within its narrow confines. The painting is less gloomy than Doré's original, not only because of its 'translation' into colour but also because Van Gogh has interjected a certain vitality into it that raises it above mere gloom; being the work of a great artist, it is not 'depressing' but tragic. *Exercise Yard at Newgate Gaol* has always been seen as an image of Van Gogh's own situation – not in the literal sense that he was confined against his will in St Paul's (which was not the case), but that he and the other inmates were restrained, directed and punished, moving but getting no further forward, at the behest of unknown forces.

The Threat of Success

Despite his years with Goupil's, Van Gogh had never tried to have a 'career' in any seriously self-promotional sense of the word. Theo, who might have taken over that side of his brother's life, was positively inhibited by his position as an employee of Boussod and Valadon and by his reputation as an advocate and patron of new

kinds of art, who ought not appear to be favouring his own kin. All he could do was to make occasional efforts to interest other dealers in Vincent's work.

Although appreciation was consequently slow in coming, Van Gogh was not the complete failure that legend has made him out to be. In 1889–90 his art began to be praised and written about fairly often, albeit only in avant-garde circles. Because he died in July 1890, this seems pitifully little; but looked at in a different time context – that of his mere eight years of ac tivity as a painter – it was better than might have been expected for a supposedly misunderstood genius.

Van Gogh's public début (apart from café showings) was at the Salon des Indépendants in March 1888, shortly after his departure for Arles. Three works were sent in by Theo in the face of his brother's professed indifference; but the artist was interested enough to insist yet again that he should be known as Vincent and not Van Gogh. Being shown was not in itself a triumph, since the Indépendants was a 'free' exhibiting society (that is, without a selection jury), open to any artist on payment of the appropriate fee. No more was seen of Van Gogh's paintings in Paris until the Indépendants show in September of the following year, when the artist had just about recovered from one of his breakdowns. Because of limited space, a maximum of two paintings was allowed to each exhibitor. Van Gogh showed two masterpieces, *Irises* (page 164-5) and *Starry Night over the River Rhône* (page 115), and although Theo complained that *Starry Night* had been badly hung, it is clear that they attracted a good deal of attention.

Two Belgians, the art critic Octave Maus and the painter Theo van Rysselberghe, had visited the exhibition. They also found their way to Père Tanguy's shop, where they were able to see the many canvases by Van Gogh that were stored there. Their favourable reaction was important, since both were deeply involved with Les Vingt (The Twenty), a Brussels exhibiting society which had established an international reputation for its shows of contemporary art. Maus, as secretary of Les Vingt, invited Van Gogh to contribute to the January 1890 exhibition and Vincent was sufficiently impressed to send in six canvases taking up a little more than the allotted space: two sunflower paintings (pages 92, 93), a *Flowering Orchard* done at Arles, *The Red Vineyard* (pages 132-3) and the recently completed, incandescent *Wheatfield at Sunrise*.

Appearing alongside works by Cézanne, Toulouse-Lautrec, Renoir and Sisley, Van Gogh's paintings still attracted a good deal

RIGHT: **Portrait of Dr Gachet** 1890 MUSÉE D'ORSAY, PARIS

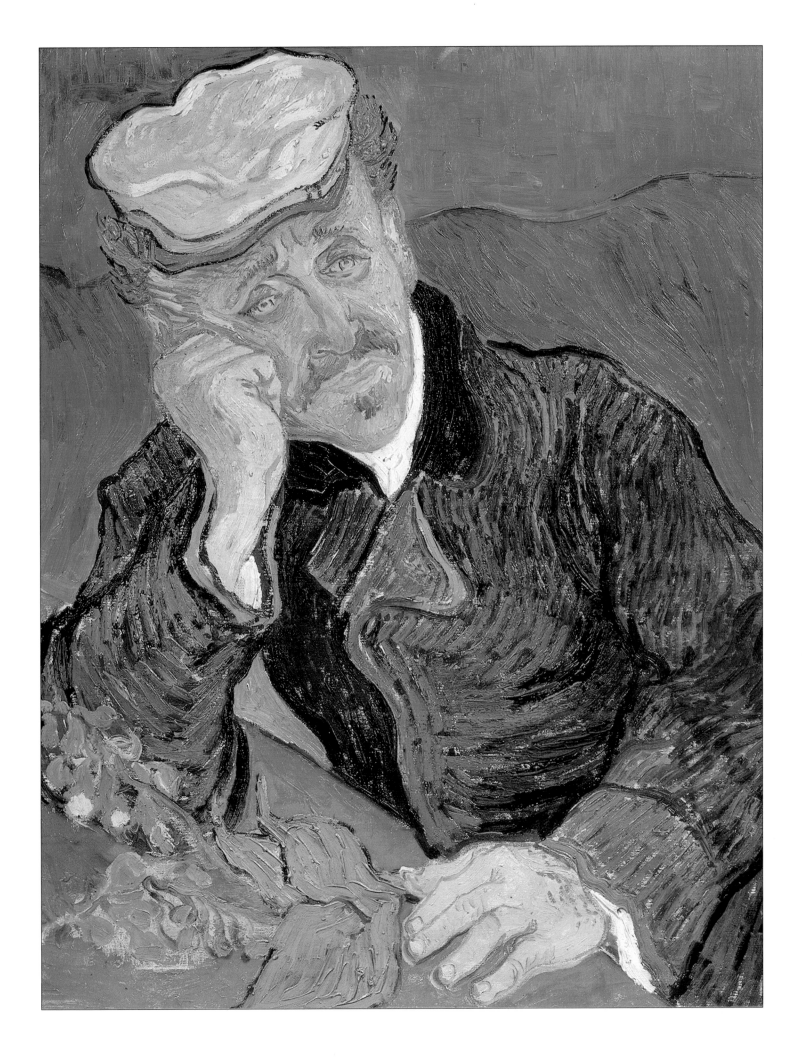

of notice. Not all of it was favourable – for any of the artists mentioned – but one of his submissions, believed to be *The Red Vineyard* (pages 132-3), was bought for 400 francs by the painter Anna Boch, older sister of Van Gogh's friend 'the Poet', Eugène Boch (page 117). This was not, as has often been said, the only painting by Van Gogh to be sold during his lifetime, but it was probably the only one disposed of through 'accepted' art institutions, and almost certainly the only one for which he received a price that did more than cover the cost of the materials used.

Les Vingt was not an exclusively avant-garde show, and one painter did object violently to Van Gogh's work. At a banquet held just before opening day, the Belgian painter Henri de Groux spoke so insultingly of Van Gogh that Lautrec challenged him to a duel and Signac declared that, if Lautrec were killed, he would take his place opposite de Groux. According to Maus, reminiscing (embellishing?) almost 20 years later, seconds were appointed, despite the fact that neither Lautrec nor de Groux were in the kind of physical shape suggested by such a readiness to fight. Maus records that, with considerable difficulty, he managed to persuade de Groux to retract his offensive remarks and so avoid bloodshed.

Theo van Gogh was sufficiently heartened by the response to Vincent's work to predict that he would live to know success. But to judge by his reactions to articles about him, Vincent himself found the prospect unsettling. Indeed, writing to his mother and his sister Wil in April 1890, he declared that 'success is about the worst thing that can happen'. Understandably concerned for his own mental stability, he overlooked the relief that his personal and financial independence would afford Theo and his family.

The first writer to appreciate Van Gogh's work was a fellow Dutchman, the artist and critic J.J. Isaacson, who was at this time sending regular journalistic 'Letters from Paris' to a newspaper at home. In the elevated prose of the time (elevated but, in this instance, accurate enough) he hailed Vincent as 'a unique pioneer' who had revealed the life pulsing through all things. Isaacson's quite brief reference in August 1889 seemed to Van Gogh 'exaggerated' and he discouraged the critic from writing anything further about him.

He was even more alarmed by Albert Aurier's 'The Isolated Ones' (*Les Isolés: Vincent van Gogh*), the first substantial consideration of his style and personality as an artist. Aurier was a young man of 24, still trying to make his way as a writer, but he had

RIGHT: **Roses and Anemones** 1890 MUSÉE D'ORSAY, PARIS

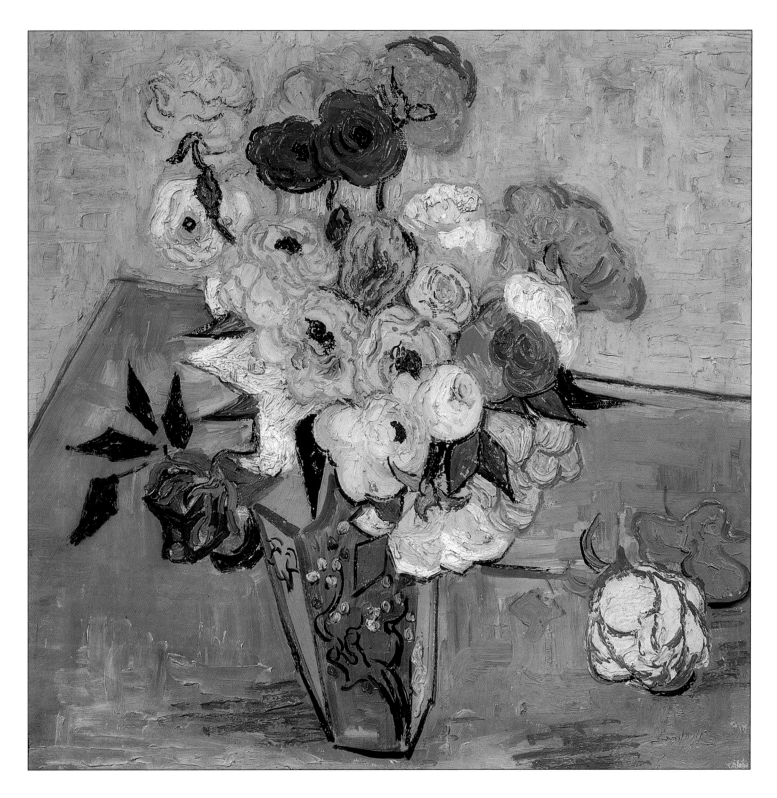

a fine feeling for art. Writing a little earlier in his own short-lived review, *Le Moderniste,* he had already managed to pick out, as the key spots in the Paris art world, Tanguy's shop and 'Van Gogh's' – that is, the branch of Boussod and Valadon run by Theo. He named as the artists to look for in these places Van Gogh, Cézanne, Bernard, Guillaumin, Degas, Pissarro, Gauguin; remarkably, not a

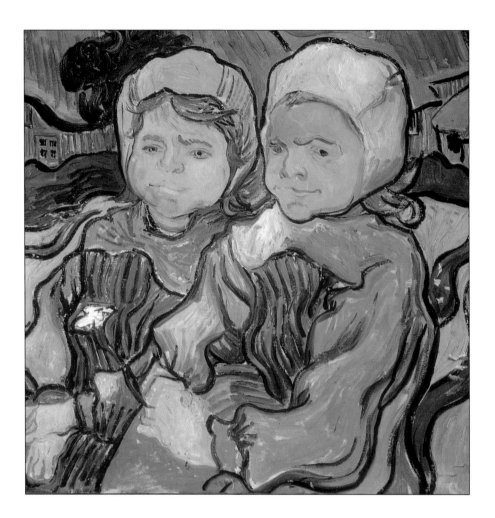

single name now regarded as second-rate figures in his list of worthwhile contemporaries.

Les Isolés was published in a leading Parisian periodical, the *Mercure de France*, in January 1890. It also appeared in Brussels in time for Les Vingt and must have done a good deal to concentrate attention on Van Gogh's contributions to the exhibition. Aurier's prose is imperial purple: 'Beneath skies that sometimes dazzle like faceted sapphires or turquoises, that are sometimes moulded from infernal, hot, noxious and blinding sulphurs...' Purple, and extended: several hundred words more are required to complete Aurier's description of the impression left on the retina by Van Gogh's work.

However, Aurier's literary style was acceptable in its day and he did manage to put over the kind of impact made by Van Gogh's paintings on a keen sensibility, effectively claiming a high place for his art. Aurier had been in touch with Emile Bernard, and his article shows an awareness of Van Gogh's utopian ideas and his dreams of reaching out to ordinary people with his work. Rightly divining the symbolic intentions behind certain recurrent figures by

Van Gogh, such as sowers (pages 106-7, 126-7), Aurier, with rather less justification, assigned the whole of his work to the Symbolist school of which the writer himself was a member. Most surprising (since his informant, Bernard, must have known better) Aurier interpreted Van Gogh's simplifications and the passionate attack of his painting style as evidence of 'the naive truthfulness of his art' and his 'almost childlike sincerity'. In reality, of course, anything that Aurier may have taken to be naive or childlike was the result of a long process of development, passionately carried through but quite deliberate.

In spite of such qualifications, Aurier's article did Van Gogh a great service in publicizing his work. But, as with Isaacson, the artist's response was not so much modest as puzzlingly self-effacing. Writing to Aurier himself, Van Gogh declared that the critic's words reproduced the canvases but were better than them! Aurier's remarks would have been more appropriate if he had written about Monticelli or Gauguin; he, Vincent, held only a secondary place. He reiterated his secondary status, and his inferiority to Gauguin, when writing to Theo. While these statements were not exactly insincere, Van Gogh's shrinking away was clearly prompted by more than humility or underestimation of his own powers. Apart from anything else, he gave different reasons to different people. He told his mother that he disliked being defined as an 'isolated one', since he was sustained by the thought that he was part of a common effort. To his sister Wil, having described Aurier's article as a picture of what his work should have been, he hinted that he was afraid it would stir up jealousies and back-biting on the part of other painters. At the same time he was proud enough of Aurier's piece to suggest that Theo send copies of the article to Alexander Reid in Glasgow, Tersteeg at The Hague and his Uncle Cornelius in Amsterdam. Although he implied that his motives were commercial, these three, and especially Tersteeg and Uncle Cor, were figures from his past whom he might well have wished to show that he had amounted to something after all.

With Theo to keep him up to the mark, Vincent sent no less than ten canvases to the next Indépendants in March 1890. As a result, while he was still at St Paul's asylum he received a number of would-be-encouraging letters and Theo wrote to say that a good many people had asked him, without any prompting, about Vincent's work. Monet sent complimentary remarks via Theo, while Vincent's old friend Pissarro declared that his exhibits had scored a real success. Gauguin wrote directly to Vincent along the

OVERLEAF PAGES 228-9:

Thatched Cottages at Cordeville 1890
MUSÉE D'ORSAY, PARIS

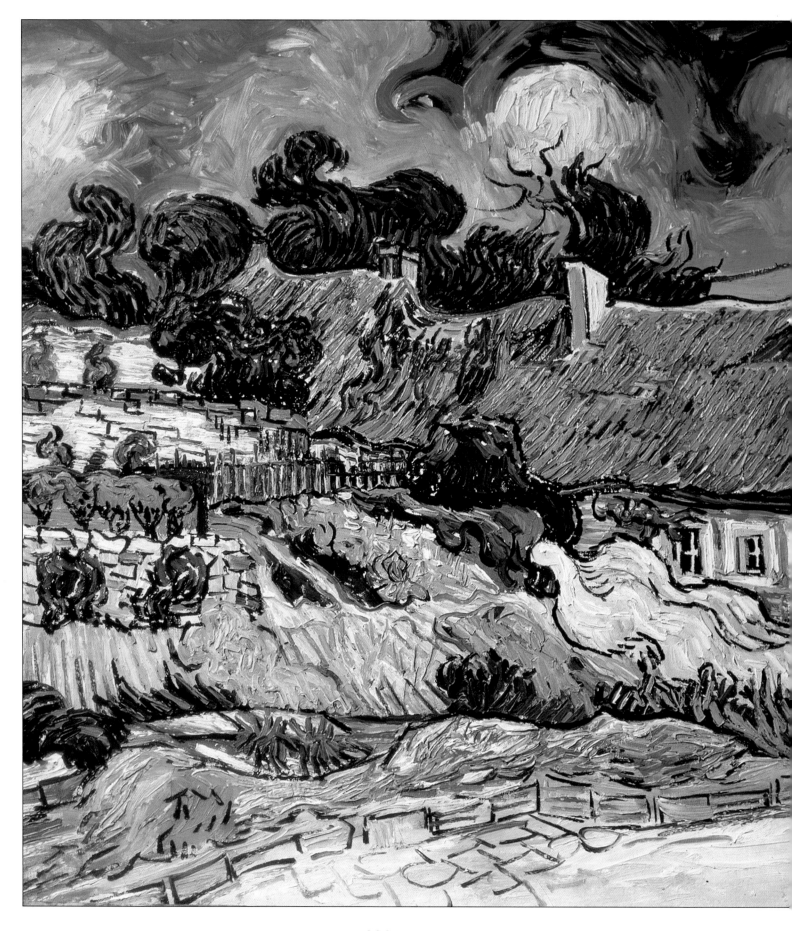

same lines, suggesting that they exchange pictures and asserting that, in the entire Indépendants show, Vincent was 'the only one who thinks'. A number of critics, taking their cue from Isaacson and Aurier, also wrote notices, friendly or otherwise, of his work.

Van Gogh's attitude remained uncomfortably negative. Late in April he asked Aurier to write nothing more about him, since he was too overwhelmed by sorrow to face publicity. He told Theo that, while the act of painting distracted him (presumably from his afflictions), discussions of his work pained him. Perhaps most candidly, he wrote to his mother and sister that when he heard his work was having some success and read Aurier's article praising him, he feared that he would be punished for it: such was a painter's life. He offered no further explanation, and we can only speculate on the nature of the 'punishment' in Van Gogh's mind. Evidently the prospect of success – that is, of change, people, debate – made him feel exposed and vulnerable, whereas obscurity and failure were quiet, undemanding states and he knew how to cope with them. Experience had taught him that there were, on occasion, dangers for him even in visiting an unfamiliar little town, so his reaction to the 'threat' of praise and publicity may well have been soundly based.

Pictures from an Institution

Van Gogh's conviction of his secondary place and his generally negative tone were also influenced by the growing weight of evidence that his 'rest cure' at St Paul's was not working. He was critical of his treatment, which consisted of nothing more than twice-weekly sessions in which he was immersed for a couple of hours. This was in fact Peyron's all-purpose treatment for the otherwise neglected inmates, whose idleness helped to make St Paul's such a desolate place. As Van Gogh was sane for most of the time, the absence of any occupation beyond his work was in itself a source of low spirits, although he had recovered some of his old enthusiasm for reading and was making his way through a set of Shakespeare's history plays (in English) that Theo had sent him. His complaints of terrible fits of depression seemed to be ignored; since he was not having a new attack he was pronounced as being in good health. Not surprisingly, he began to write seriously to Theo about the possibility of returning to the Paris area. Theo sounded out the fatherly old Impressionist, Camille Pissarro, who might well have been persuaded to take Vincent into his home;

but Pissarro's wife, who had borne poverty and painters for all too many years, refused to consider the idea. Probably at Pissarro's suggestion, the name of Dr Gachet, a caring physician who might take charge of him, was mentioned for the first time in October, although the idea bore fruit later on.

Meanwhile Van Gogh had made his usual rapid recovery from his summer crisis, although he dared to venture out only several weeks later. Even in October much of his work was done in the grounds of St Paul's, and the asylum itself, virtually ignored in his earlier paintings, made an appearance in a number of his canvases. In *Trees in the Grounds of St Paul's* (page 188), the trees in the foreground are reminiscent of jungle lianas, shutting out the sky but also screening and dominating the asylum; the tiny human figures look forlorn and helpless. In a closer view of the asylum (page 191), the faceless man and the twisted, apparently billowing tree create an uneasy impression that is typical of these pictures. During the same period Van Gogh also painted two interiors, in one of which the corridor seems frighteningly long, like a series of compartments that, once entered, would go on for ever. There is also, uniquely, a portrait of a fellow patient, an elderly man with twisted face and staring eyes; two strange smears of paint give him a horned look, not so much threatening as painful in its unfocused wildness.

Van Gogh's passionate convictions about art surged up again in November, when he heard from his young friend Emile Bernard. Working at Pont-Aven, Bernard had been influenced by the atmosphere of Breton religious piety, which reinforced his inclination to create an imaginative rather than a realistic art. He sent Van Gogh photographs of two paintings that provoked an explosive reply: *Christ in the Garden of Olives* was a nightmare, *Christ Carrying His Cross* appalling and spurious. Van Gogh admitted that, under Gauguin's influence, he had produced some 'abstractions' at Arles, but warned Bernard that, for all its charm, it was a dead end. By 'abstractions' Van Gogh seems to have meant paintings done from memory, since he mentions his own *Berceuse* (page 153) and *Woman Reading a Novel* as examples. In other words, pattern-making was no substitute for observed reality – even though the artist would not then reproduce that reality in literal fashion, but would try to express the essential truth about it. However, Van Gogh was also irritated by the religious subjects painted by Bernard and Gauguin, perhaps feeling (as was certainly true of Gauguin) that there was an element of pose in such a choice. It

may also be significant that he often expressed his annoyance with the nuns at St Paul's and the atmosphere of 'superstition' – probably the kind of rustic piety that Gauguin and Bernard found exciting in its primitivism, whereas Van Gogh's Dutch Protestant origins inclined him to feel very differently. He told Theo that there was no question of his painting Biblical scenes, which he considered 'dreaming' instead of thinking; evidently his copies of Biblical paintings by Delacroix and Rembrandt did not count, although it is difficult to see why not. But Van Gogh's reaction to Bernard's letter was not merely an outburst of intolerant rhetoric: believing that lack of observation had spoiled his friend's rendition of the scene, he rushed out into the grounds and began to paint an olive grove. He had tackled the subject before, but now produced a series that exploited the gnarled, expressive qualities of the trees to the full (pages 198-9). A little later, in rather different mood, he painted a number of olive-picking scenes (for example, page 201).

On the Move Again

By November Van Gogh was willing to risk a trip to Arles, meeting the Ginoux family and Pastor Salles, and spending two days without obvious ill-effects in a town which might easily have brought back some of his most devastating memories. He remained well in December, writing a letter to his mother and sister on the 23rd before going outside to paint despite the cold. But while he was working he had another attack. As he had pointed out in his letter, the 23rd was the first anniversary of his breakdown and self-mutilation and the memories reawakened by writing of it may have triggered the new visitation. In any case, Christmas, with its religious and familial associations, was always a tense time for him (each new misfortune making it worse) and the prospect of spending the festive season among fellow sufferers in the institutional dreariness of St Paul's would have strained a more robust mind.

We shall never know exactly what triggered Van Gogh's attacks, any more than the sluggish Dr Peyron did. The only hypotheses he seemed able to form were that Van Gogh reacted badly to any but the most peaceful environments, or alternatively, as Peyron had initially supposed that painting made him overwrought and suicidal. The uneventful visit to Arles seemed to disprove the first theory and as Van Gogh's December attack was accompanied by a new, surely symbolic, paint-swallowing attempt to kill

himself, Peyron concluded that the second theory was right after all. Not long afterwards, however, Van Gogh made another attempt, without great artistic undertones, when he seized the kerosene used to fill the lamps and attempted to drink it. And a few weeks later, when he seemed fully recovered, he experienced a new seizure after visiting Madame Ginoux at Arles. Evidently no single factor could account for his affliction, including his possibly ambiguous attitude towards Theo's activities. After his recovery he learned that on 31 January Jo had given birth to a boy, named Vincent Willem Van Gogh in his honour. Whatever his subconscious reactions, he celebrated the event by painting a branch covered with almond blossoms for little Vincent.

There was no relapse after the announcement, unless an all-too-convenient 'delayed-action' reaction is proposed to account for the catastrophe that occurred about three weeks later. During February, Van Gogh had made several copies (one is on page 204) of a drawing by Gauguin which showed Madame Ginoux seated at a table and resting her head on her hand. Gauguin had made the drawing as a preparatory sketch for his *Night Café*, a canvas inspired by Vincent's painting, so the copies represent a further cross-fertilization in the work of the two artists. Van Gogh's interest in Madame Ginoux was strengthened by the fact that she was herself prostrated with some kind of nervous illness, and on 22 February, 1890, he again set off to visit her at Arles, carrying one of his *L'Arlésienne* copies. He never reached the Café de la Gare, went missing overnight and, when discovered and brought back from Arles, could give no coherent account of where he had been and what he had done; the portrait had disappeared in the course of his wanderings.

The most daunting features of this attack were that it was the third within a few weeks and that, for the first time, Van Gogh failed to make a rapid recovery. Over the following two months he was ill almost all the time, surfacing briefly to draw and paint from memory, within the safety of the walls, *Memories of the North* (page 206-7). As late as 24 April he wrote a despairing letter to Theo indicating that he was not in pain but felt 'stupefied', hinting at fears that he might have to be placed under restraint for his own good and then, abruptly, suggesting that he might after all recover if he were 'in the country for a time'. Read in conjunction with his many references to the North and his longing to meet Jo and baby Vincent, this could only mean the countryside around Paris. Since his condition at St Paul's was obviously deteriorating, Theo agreed that the

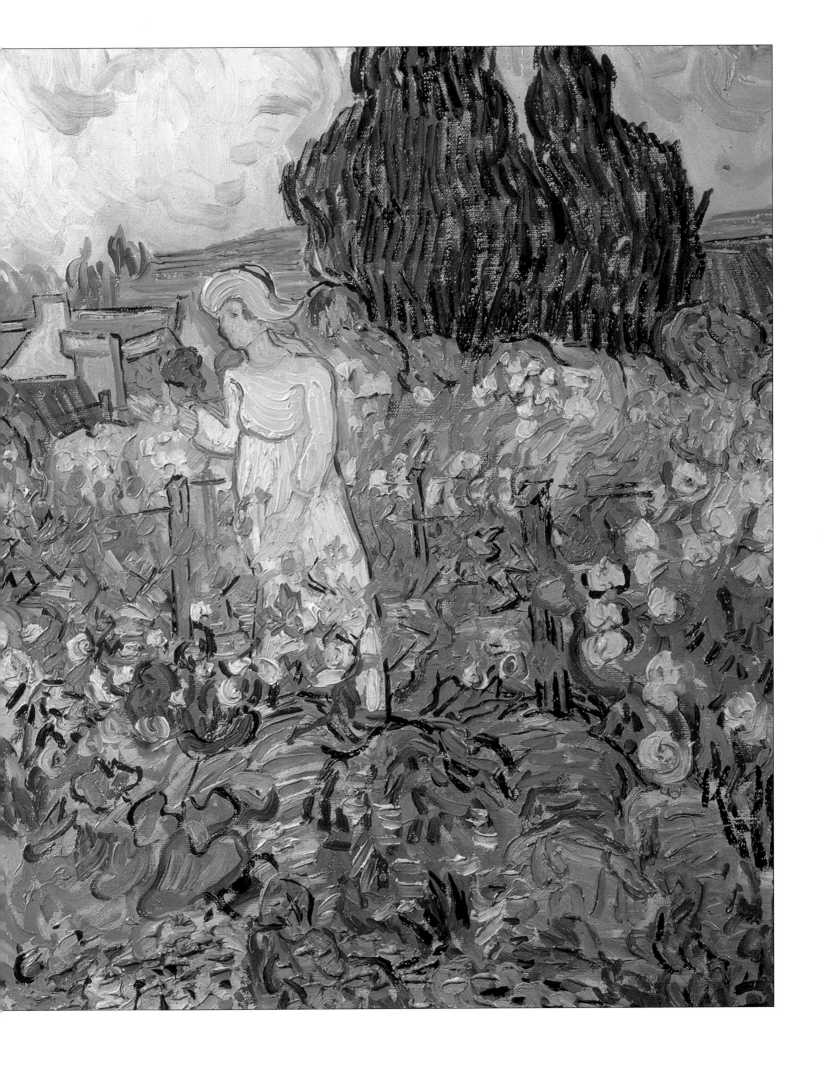

PREVIOUS PAGES
232-3:
**Marguerite
Gachet in the
Garden** 1890
MUSÉE D'ORSAY,
PARIS

change was worth trying and began to make arrangements.

While he did so, Van Gogh plunged back into work. Now that he was about to go, he re-experienced the revelation of colour and felt a terrible sorrow at parting with the Midi. During his final weeks at St Paul's he painted some small peasant studies that were undoubtedly 'memories of the North', but also bright pictures of the grounds (including *Meadow with Butterflies*, page 209), a series of wonderful flower paintings, and two copies that must surely have had a symbolic link with his imminent escape from the asylum, *The Good Samaritan*, after Delacroix, and *The Raising of Lazarus*, after Rembrandt. There were also landscapes comparable with those painted almost a year earlier, in June 1889, among them the overwhelming *Road with Cypress and Star* (page 211).

No escort could be found to take Van Gogh to Paris. After some delays, his own view prevailed: he could safely travel alone, since his attacks occurred after periods of remission such as the one he was living through. His medical record for 1890 hardly bore this out, but Theo allowed himself to be persuaded and Vincent left St Paul's on 16 May. On reaching Tarascon, from which he could travel by rail, he cabled Theo to say that he would catch the overnight train and arrive at the Gare de Lyon in Paris at ten o'clock the next morning. As he had predicted, the journey passed without incident.

Dr Peyron allowed Van Gogh to leave, and to leave by himself, without protest. It would have been more responsible to have admitted that his patient was getting worse, ought not to travel alone and needed close supervision at all times. But then close supervision was something that Van Gogh had not had during his time at the asylum; the fact that he was self-committed, and that the asylum was a private concern that benefited from his custom, had no doubt weakened the director's resistance to those dangerous trips to Arles. Now Peyron wound up the case with a contradictory entry in the asylum register which betrays a highly unprofessional confusion. In one column he summarized the history of Van Gogh's seizures, adding that the patient had decided to move to the north of France in the hope that the climate would alleviate his condition. In the second column Peyron wrote a single, untruthful word: 'Cured'.

RIGHT: **Peasant
Woman against
Background of
Wheat** 1890
PRIVATE
COLLECTION

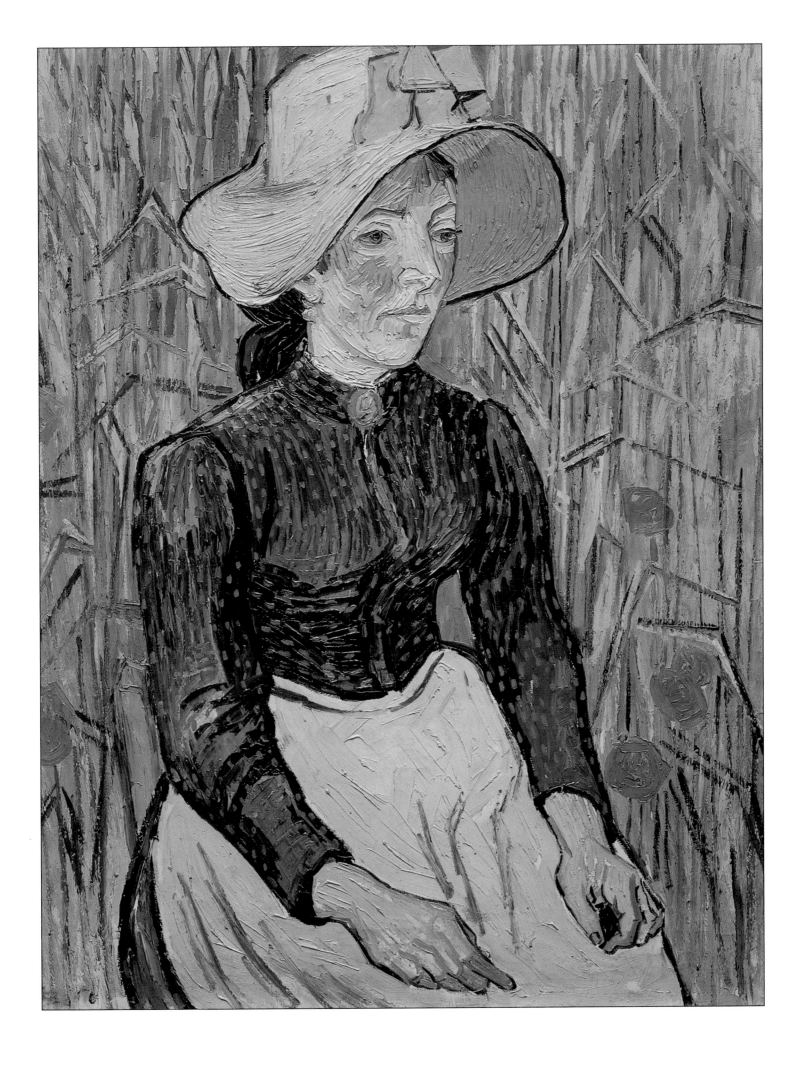

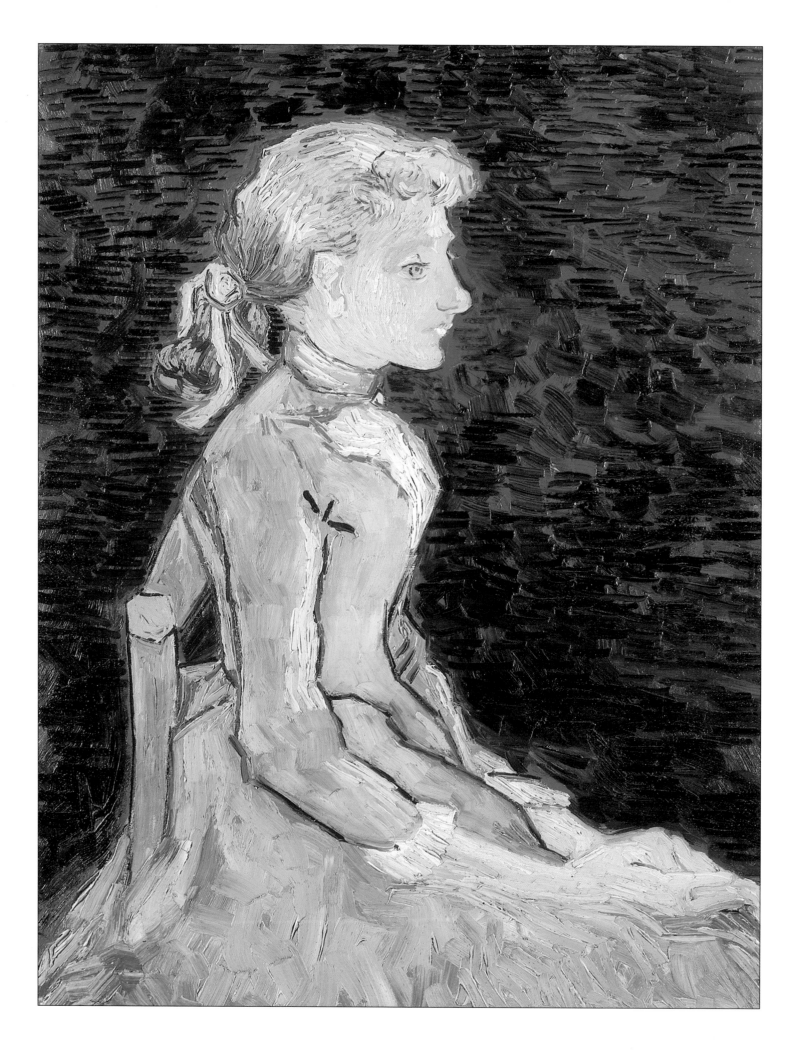

The Final Months

On 17 May, 1890, a Saturday, Van Gogh arrived in Paris. Theo met him at the station and brought him back to the apartment he now shared with Jo and the baby in the Cité Pigalle, not far from the Rue Laval where he had once lived with Vincent. Meeting him for the first time, Jo was struck by how strong and healthy Vincent seemed. Theo had been intermittently ill and actually looked the frailer of the two; in fact he had never been strong and was nothing like so physically robust as his brother. But it soon became apparent that Vincent's nervous system could not tolerate much bustle and novelty. In the first couple of days he met Jo and baby Vincent, dropped into Tanguy's to look at his stored pictures and visited an art exhibition; by Monday he felt the need to get away somewhere quieter.

LEFT: **Portrait of Adeline Ravoux** 1890 PRIVATE COLLECTION

Dr Gachet

Fortunately it was all arranged. He was to live at Auvers-sur-Oise, a pleasant little spot outside Paris. There he would be under the

general supervision of Dr Paul Gachet, the physician recommended by Pissarro some months before, but would live independently in lodgings. On the Monday night or Tuesday morning Van Gogh boarded the train for Auvers, and on his arrival introduced himself to the doctor. A widower of 61, Gachet was a well-respected but rather eccentric figure who was himself subject to bouts of dark depression. Van Gogh somehow divined this, for almost his first reaction was to tell Theo that he believed the doctor to be nearly as sick – perhaps even as sick – as he, Vincent, was. No doubt, he added, Gachet's work sustained him.

This continued to be Van Gogh's opinion, but he rapidly became fond of Gachet and responded to his fatherly interest even though this meant that twice a week he had to endure being treated to long, multi-course lunches for which neither he nor the doctor had the digestive capacity. Part of Gachet's appeal was his genuine passion for art. An amateur of some skill, he had understood the importance of Impressionism at an early date and had built up a wonderful collection of paintings by Pissarro, Cézanne, Renoir and other artists. He was even 'advanced' enough to appreciate Van Gogh's hero Monticelli and, as it soon appeared, the work of Van Gogh himself.

However, the immediate priority was to get Van Gogh settled. Gachet led him to a comfortable inn, but when the painter discovered that it charged six francs a day, he rebelled. After a search he found a café with an upstairs room for which he agreed to pay three-and-a-half francs. He had made a good choice for, although his lodgings were not up to much, the landlord, M. Ravoux, was amiable and Vincent soon fell in with two artists, a Dutchman and a Cuban, who patronized the café; the Dutchman, Anton Hirschig, actually settled in another of the rooms. Van Gogh's medical history was unknown here and, although his new friends were not greatly gifted, they accepted him for what he was and their presence alleviated the loneliness that had so often oppressed him.

This was not entirely a matter of luck, since Auvers was well known to artists, having the double advantage of fine scenery and nearness to Paris. It had already been painted by a number of distinguished figures, including the landscapist Charles-François Daubigny (1817–78), who had settled and built a house in the village, and Van Gogh's great but still unrecognized contemporary, Paul Cézanne (1839–1906). The place, or his return to the North, certainly inspired Van Gogh, who began to work with furious energy,

RIGHT: **Church at Auvers** 1890 NATIONAL MUSEUM OF WALES, CARDIFF

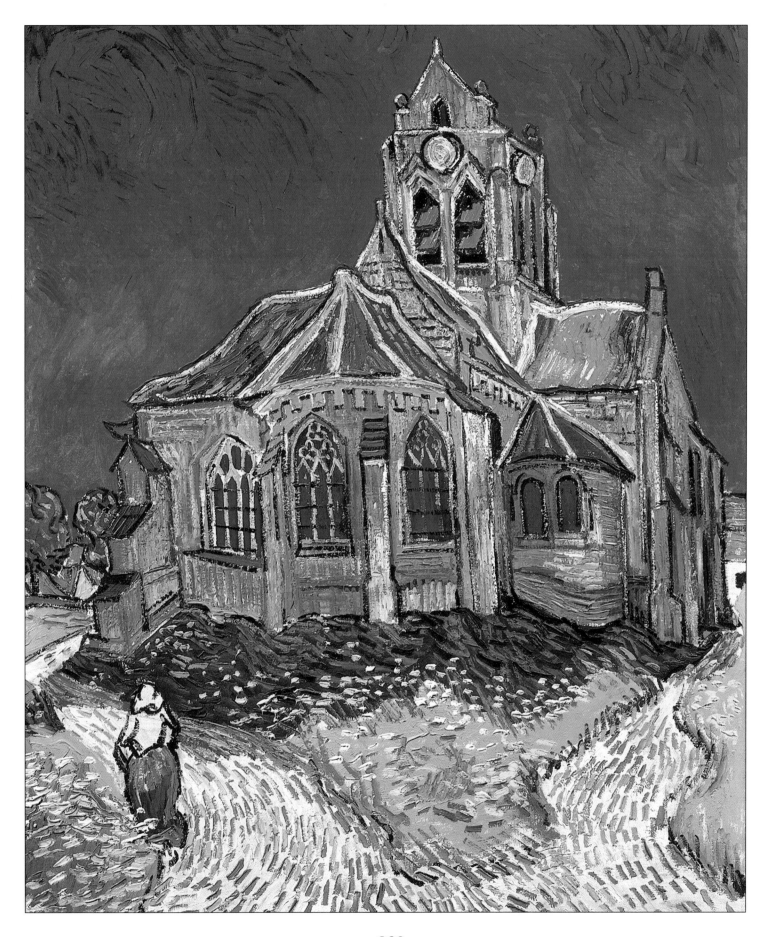

rising each morning at five, painting all day with a short break for lunch at the café, returning for dinner and going to bed by nine o'clock. During his 70 days at Auvers he completed over 80 canvases, the great majority being views of the village or the surrounding countryside. In these, a tendency to use darker colours, visible in some of his later paintings at St Paul's, disappeared. The style in which he worked and the handling of the paint were very varied, ranging from the decorative to the wildly expressive. In view of these apparent forays in different directions, it has often been suggested that Van Gogh was hesitating on the verge of some new artistic advance. The suggestion is plausible although, of course, finally unprovable; and it might be argued with equal force that he was now so much the master of his brush that he could make effective use of elements from any of the '-isms' of his time, turning from one to the other in virtuoso fashion or even making versions of the same subject with widely different technical resources.

This is most apparent in his portraits of Dr Gachet (pages 220, 223), by common consent among the finest of all his paintings. In a letter to Gauguin, Van Gogh famously asserted that he had given Gachet 'the sorrowful expression of our time'. The doctor is shown sitting at a table, leaning his head on his hand; Van Gogh seems to have thought of the pose, also used in *L'Arlésienne* (pages 135, 204), as essentially one of mental distress. In a letter to Theo he described Gachet as 'absolutely *fanatical*' in his admiration of the portrait and, since it was earmarked for Theo, insistent that Van Gogh should paint a second version. He did so, and both pictures show Gachet in an unconventional costume of his own devising, with a light cap and blue frock-coat. He is posed against a background whose undulating horizontal division was originally intended to represent a line of hills, although they became too conventionalized to be recognizable as such.

In the first version (page 220) the background is alive with brushmarks that seem to be swarming round the physician. The table-top is covered with a pattern and carries a glass with foxgloves and two yellow-backed novels by the Goncourt brothers, *Manette Salomon* and *Germinie Lacerteux*. The Goncourts, pioneer realists, were among the contemporary writers whom Van Gogh most revered. The novels seen in the painting were probably their best-known works, so their inclusion may not have any symbolic intention. A special significance could be claimed for *Manette Salomon*, a study of life among artists, pointedly contrasting the gifted and the ungifted, the facile and the true artist, but *Germinie*

PREVIOUS PAGES
240-1:
**Thatched
Cottages at
Auvers** 1890
KUNSTHAUS,
ZURICH

Lacerteux, the story of a 'faithful servant' who leads a secret life of debauch, has no obvious application to the lives and works of either Van Gogh or Dr Gachet. The second version of the portrait (page 223) is much simplified, confining the element of agitation to the figure of Gachet himself. The background is a rich but almost plain blue and the books and glass have vanished, leaving the foxgloves lying flat on an all-red table-top. Overall it is much closer than the first version to the Synthetism of Gauguin and Bernard, but it retains the greater tension characteristic of Van Gogh and, typically, refuses to sacrifice the distinctive humanity of Gachet to cloisonnist pattern-making. Two Little Girls (page 226) is even more cloisonnist, providing another example of the stylistic variety of Van Gogh's work during this period.

Van Gogh made a third portrait of Gachet in a medium he had never used before. Gachet was an enthusiast for etching, a form of print-making that involves drawing with a pointed tool on a resin-covered copper plate. Wherever the tool has penetrated, the plate is exposed, so that when it is covered with acid, the design is bitten into the plate, which can then be inked and used to make numerous prints. Gachet had interested Cézanne in the process for a time, but his most important convert was Pissarro, whose etchings form a distinguished part of his work. Van Gogh made only the one portrait of Gachet, who is shown hatless, as a more homely, grizzled, pipe-smoking figure than he appears in the paintings. Van Gogh had plans for a series of etchings, but either lost interest or never lived to carry them out.

Among other portraits painted during the summer was an eye-dazzlingly impasted canvas of Gachet's daughter Marguerite playing the piano. In lighter vein, she also appears as the figure in a painting of her father's wild, lush garden (page 232-3). A further contrast is offered by the weather-beaten peasant girl (page 235), like a softened version of Van Gogh's Nuenen portraits, and the refined profile and long arms and hands of Adeline Ravoux (page 236), the 12-year-old daughter of his landlord.

The Pressures Mount

Like Jo van Gogh, Dr Gachet had found Vincent looking fit and well. This seemed to confirm the opinion he had put forward even before meeting the artist – that there was nothing fundamentally wrong with him that rest and quiet would not cure. Influenced by homeopathy, Gachet was strongly inclined towards 'natural'

treatments, which on occasion produced better results than drugs and surgical intervention. But they also carried with them a risk that, if misdiagnosed, progressive or dangerous conditions would be, in effect, neglected. In view of Vincent's medical history, including his suicide attempts, Gachet's original opinion was culpably over-optimistic – assuming, of course, that his informant, Theo, had been completely candid about the case. In the event, Gachet's 'supervision' of Van Gogh amounted to little more than occasional socializing, and for three days in every week the doctor was away from Auvers, working at his Paris clinic. Since none of

ABOVE: **Cows**
(after Jordaens)
1890
MUSÉE DES
BEAUX-ARTS,
LILLE

Van Gogh's new acquaintances at the inn was aware of his past, they were not on the alert for any change in his behaviour, so he was, for better or worse, out in the world on his own.

At first the treatment (or non-treatment) seemed to have worked. Early in June, Theo reported cheerfully to his sister Wil that, although Vincent had had all his remaining teeth removed, he had never looked healthier. A few days later, on 8 June, Theo and Jo visited Auvers, lunching with Vincent at Dr Gachet's; where Vincent played the indulgent uncle with his four-month-old namesake, parading all the local animals for the child's entertainment.

This was, on the surface, a happy day, but Vincent's continuing inner sadness appeared in the letter he wrote soon afterwards to his mother and sister . In it he expresses his sense of isolation, writing that he has only been able to make out his loved ones, or to understand the whys and wherefores of partings, 'through a glass, darkly', an apt Biblical phrase (I Corinthians 13) that had haunted him for years. Painting was a consolation, but the painter's canvas 'children' were no substitute for the real thing.

The connections between the life and the work of an artist are often oblique. Sometimes, arguably, such a connection is tenuous or non-existent, for example when the artist is creating within an established tradition or producing abstract patterns. This is obviously not the case with Van Gogh and despite the stylistic variety of his work at Auvers, there are elements in his paintings that seem to speak directly from psyche to psyche. Particularly striking is the way in which the undulating lines of his landscapes are no longer confined to nature but are even found on the buildings of Auvers, so that their roofs appear to sag and slip (pages 228-9, 240-1). Interestingly, in the St Rémy paintings this occurs in only one of Van Gogh's *Memories of the North* canvases and in the buildings copied from it in *Road with Cypress and Star* (page 211).

We can be sure that this did not represent an idiosyncrasy of the local thatching, as it is one of the most extraordinary features of *Church at Auvers* (page 239), a mighty, mind-staggering work of which the ostensible subject is the modest little parish church. In the absence of other information, there is little point in attempting a symbolic interpretation of the picture as signifying the collapse of the Church or, because of the fork in the road, alternative paths of salvation. But the picture itself offers a different kind of evidence – a sense of inner unease and dislocation caused by heaving lines that should be straight, by rubbery masonry buckling under the pressure of a relentless sky, and by snaky paths and

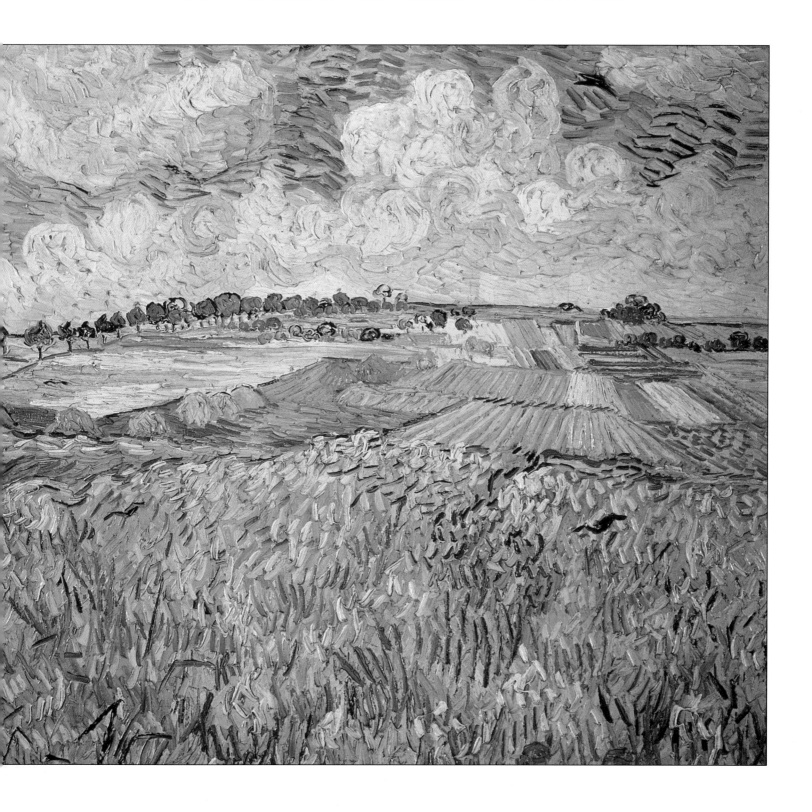

heaving waves of greenery breaking against the church walls. This is not the art of a madman, but to regard it as somehow purely a matter of aesthetic development, removed from Van Gogh's personality and experiences, would be perverse. This is visionary art of the most terrible and enthralling kind.

By early July, the pressures on Van Gogh were building up

ABOVE: **Plain near Auvers** 1890 NEUE PINAKOTHEK, MUNICH

ABOVE: **Rain at Auvers** 1890
NATIONAL MUSEUM OF WALES, CARDIFF

again. Theo sent him a letter in which, for once, he made much of his own worries. He and Jo had been deeply concerned about little Vincent's health, although the doctor had assured Jo that they were not going to lose him. Theo was again thinking of leaving Boussod and Valadon and setting up on his own. Vincent visited them in Paris, probably on 6 July, and found them preoccupied and gloomy. The critic Aurier and the painter Toulouse-Lautrec turned up, lightening the atmosphere, but the strain told on Vincent, and he returned early to Auvers without waiting for the arrival of another friend, Armand Guillaumin. His next letter to Theo and Jo was a little incoherent but showed that he was worried by their troubles, reproaching himself for being a burden and fearful that Theo's financial difficulties might force him to forego painting. Understandably he felt that 'the prospect grows darker, I see no happy future at all'.

In fact Vincent had misunderstood the gravity of the financial

situation and Jo wrote to reassure him. He found her letter 'like a gospel', a deliverance after his life had seemed to be 'threatened at the very root'. Although his tone was scarcely cheerful, he went on to describe the three big canvases he had recently painted: 'They are vast fields of wheat under troubled skies, and I did not need to go out of my way to try to express sadness and extreme loneliness.' However, as if to throw future commentators into confusion, he added that the pictures expressed 'the health and forces of renewal that I see in the countryside'. Such 'big canvases' were a new departure, double-square-sized at roughly 100 x 50 centimetres. They were probably adopted in order to capture the panoramic views of the plain from above Auvers, as in the stunning *Rain at Auvers* (pages 246-7), *Farms near Auvers* (page 250-1) and *Wheatfield with Crows* (page 252-3); but Van Gogh also employed the format for other subjects, including the delightful *Daubigny's Garden* and a large, strange, near-abstract study of tree trunks and roots. In this and other formats he returned again and again to the plains with their wide fields of wheat and large skies. Although it would not be true to say that the majority of these canvases are overtly disturbing, their number recalls Van Gogh's overwork in the fields outside Arles during the punishing summer of 1888, and their skies inevitably remind us of the great exposed spaces of which he had so often been fearful after periods of sickness.

On 15 July Theo wrote to say that he and Jo were taking the baby to Holland during their vacation and would therefore not be able to see Vincent then. Van Gogh had known that this was a possibility and had argued strongly that Auvers would be cheaper as well as healthier for little Vincent. Presumably Theo failed to sense any hint of disturbance in Vincent's vehemence. This is strange, although no stranger than the way in which, a fortnight earlier, he had burdened Vincent with his family and financial worries. Either Theo's relationship was more psychologically subtle (love-hate) than has generally been supposed, prompting him to make 'mistakes' that undermined Vincent's stability, or he simply failed to grasp that his brother's illness might not be purely physical (a 'fit'), but might possibly be triggered by worries and fears.

This is still an open question. Although it seems highly likely that psychological pressures were involved, it is just possible that they were irrelevant and that the breakdowns would have occurred even if Van Gogh had been leading the most untroubled of lives. Since his attacks at St Rémy could not be linked with any single activity or situation, they may have been triggered by some

combination of factors or, alternatively, they may have owed nothing at all to outside influences.

In other words, we cannot be sure that Van Gogh's breakdown at Auvers had anything to do with the strains caused by his relations with Theo and his family, although such a connection is very plausible. As a matter of fact, we cannot be sure that he *did* have a breakdown at Auvers. He saw his landlord and fellow painters at the inn, but none of them noticed anything out of the ordinary about him, let alone signs of hallucination or terror. Years later, Gachet's son declared that Van Gogh had turned up at the doctor's house and quarrelled violently with him because he considered a painting by his friend Guillaumin inadequately framed; and that, on a second occasion, seeing that the framing had still not been done, he again broke into a rage, slinking away when Gachet ordered him out of the house. The story is unsubstantiated and, if true, casts a curious light on Dr Gachet, who is pictured as getting rid of Van Gogh without making any attempt to help an obviously unhinged man or to contact Theo.

It seems more reasonable to believe that Van Gogh, even if low-spirited, behaved relatively normally until the day on which he decided to end his life. On the 23rd, receiving a letter and 50 francs from Theo, who had come back early from Holland, Vincent penned a rather fraught reply, thought better of it and wrote a new version, mostly concerned with paint supplies and a description of *Daubigny's Garden*.

Making an End

After this, nothing is known about his mental condition, and even a narrative of what happened must be brief if it is to be authentic, since almost all the details that have accumulated are highly suspect. Most of these were recalled – or dreamed up – many years later by local people whose accounts are confusing and contradictory. We do not even know which of his paintings was the last on which he worked; the tradition that names the ominous-looking *Wheatfield with Crows* (page 252-3) is based on its appropriateness rather than any shred of evidence.

What we do know is that, on Sunday 27 July, Van Gogh left the Ravoux café after lunch with his painting gear. At some point, out of sight of other people, he took out a revolver (no one knows where he got it from) and shot himself in the body, probably just below the chest. He returned to the inn, presumably concealing

his wound, and went up to his room. When one of the Ravoux family went up to see him, he was lying on his bed. The local physician, Dr Mazery, was called in, and Dr Gachet arrived shortly afterwards. Finding that Van Gogh had lost relatively little blood, they dressed the wound but made no attempt to recover the bullet or call a hospital; unless they were grossly negligent (and it has been suggested that Gachet's dislike of surgery may have influenced his judgement), their decision must have been based on the conviction that the bullet was lodged too deep in the body to recover. Van Gogh asked whether he could smoke and Gachet filled and lit his pipe for him. But when Gachet asked for Theo's private address, Vincent refused to divulge it; and since Boussod and Valadon was closed on Sundays, nothing further could be done that day.

Next morning Anton Hirshig took a message to Boussod's and when he heard the news, Theo left at once for Auvers. As Vincent was calm and conscious, Theo at first believed he might recover, but as the day went on he began to sink. Theo remained by his bedside and the brothers conversed sporadically in Dutch. Towards the end Vincent remarked, 'The sorrow will last forever'. He died in Theo's arms on 29 July, 1890, at about one o'clock in the morning. Dr Gachet made a drawing of Vincent's head as he lay on his deathbed.

The funeral was held the very next day, despite the refusal of the local priest to provide a hearse for a suicide; one had to be hired from a nearby town. A downstairs room in the Ravoux's café served for the lying in. It was hung with Van Gogh's paintings and decked with yellow flowers brought by the mourners, who included Père Tanguy, Emile Bernard, Lucien Pissarro, Andries Bonger, Charles Laval and Dr Gachet. Van Gogh was buried in the cemetery above the town, close to the wheatfields. There was no religious ceremony and, with Theo utterly distraught, Dr Gachet said a few words of farewell, although he, too, was half-overcome with emotion. Vincent, he said, 'was an honest man and a great artist; he had only two aims: humanity and art. It was art, which he cherished above everything, that will make his name live.'

Later on, looking through Vincent's possessions, Theo found an unfinished letter in his jacket pocket. It was the first draft that he had decided not to send on 23 July, and so contained messages that he had decided to leave unspoken. Coming when it did, the letter must have seemed to Theo like his brother speaking to him from beyond the grave. Once more Vincent affirmed that Theo was 'more than a simple dealer in Corots' but had his part 'in the

OVERLEAF PAGES 250-1: **Farms near Auvers** 1890 TATE GALLERY, LONDON

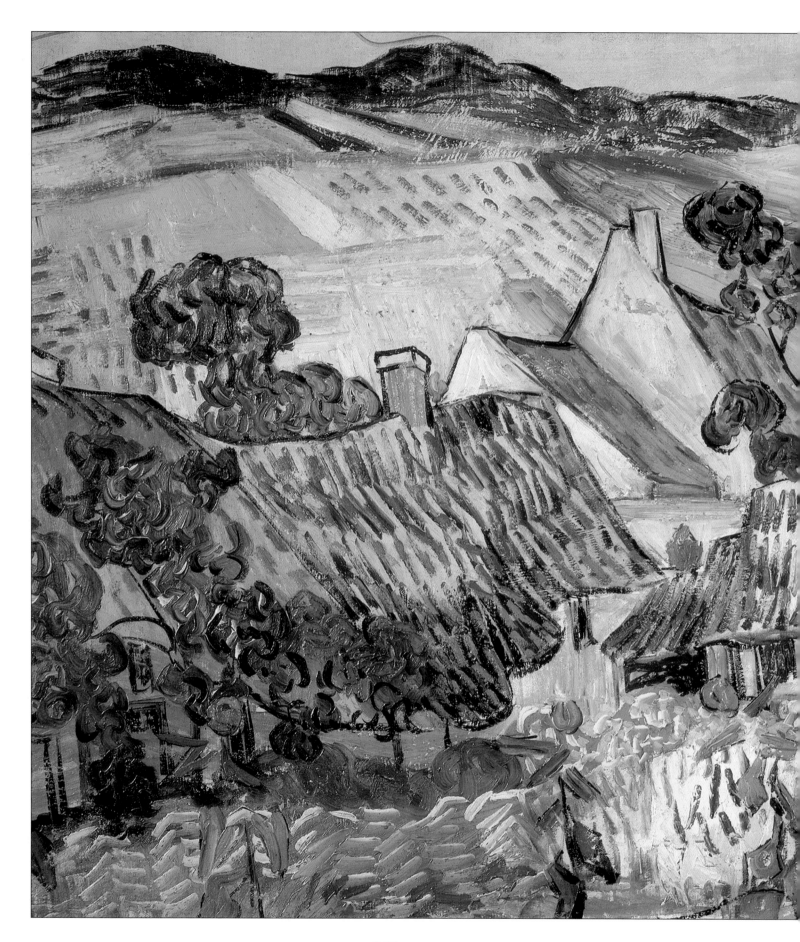

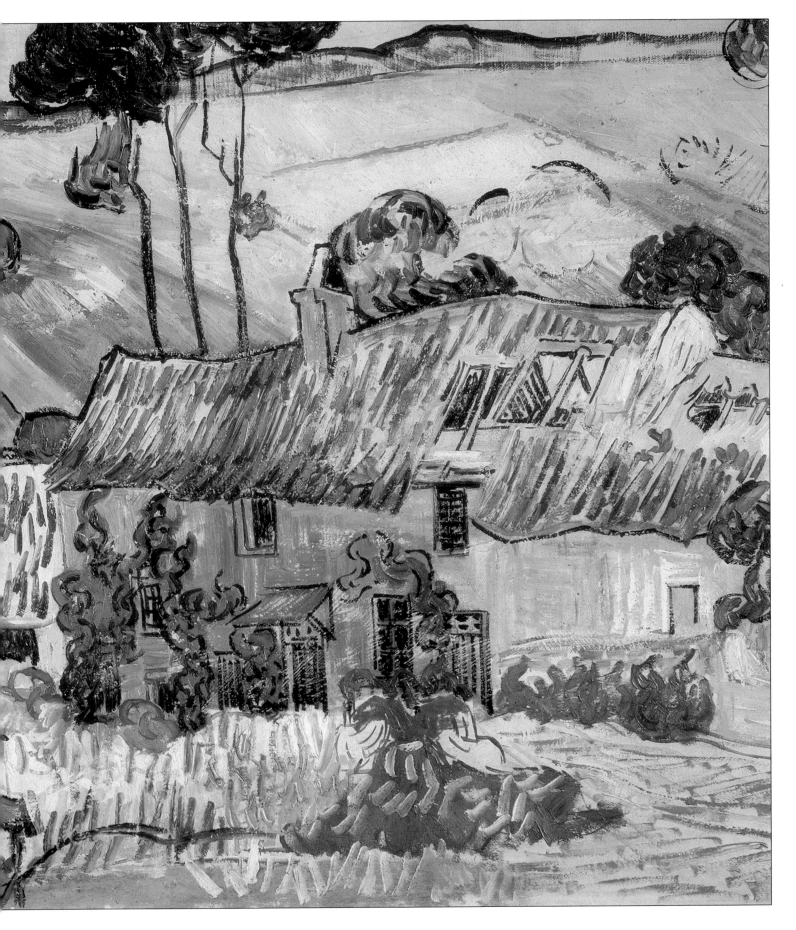

actual production of some canvases which,' as Vincent remarked in a doom-laden phrase, 'will retain their calm even in the catastrophe'. This was generous up to a point, but was worded in a way which suggested that Theo's actual profession, as 'a simple dealer in Corots', was of no great consequence. Vincent had once urged his brother to follow his example and become an artist; now, perhaps with that idea still in mind, he urged Theo to make a choice. This famous passage begins with hauntingly expressed phrases that have often been used to summarize Vincent's life in terms of tragic fulfilment: 'Well, my own work, I am risking my life for it and my reason has half-foundered because of it – that's all right.' However, the sentence continues 'but you are not among the dealers in men as far as I know, and you can still choose your side, I think, acting with humanity, but *que veux tu?*'

Cloudy though it was, the message cannot have been a comfortable one to read immediately after Vincent's death, and its contents may well have influenced Theo's subsequent behaviour. In view of his relationship with Vincent and his role as part-creator of the paintings, the story would in any case be incomplete without some further account of him. Following Vincent's death he tried to assure the safety of any paintings held by relatives, and attempted, without success, to perpetuate his brother's name by organizing a memorial exhibition. Emile Bernard finally put together a small show in 1892, but by that time Theo was already dead. Suffering from a kidney infection which seems to have triggered a mental breakdown, he began to behave erratically, throwing up his job and sending Gauguin a cable promising to finance his departure for the tropics: both, perhaps, were attempts to carry out Vincent's wishes. At first violent and then apathetic, he failed to benefit from treatment in French clinics, and Jo took him back to Holland. His condition worsened rapidly and he died in an asylum at Utrecht on 25 January, 1891. He was buried there, but later Jo had his remains transferred to Auvers, where the brothers now lie side by side.

Jo van Gogh became the guardian of the largest collection of Vincent's paintings and she laboured nobly to establish and then to spread his reputation. By the early years of the twentieth century, avid collectors were hunting down the canvases he had given away to often unappreciative sitters such as Dr Rey, and a new generation of artists was acknowledging his influence. By the 1920s he was world-famous and the publication of his letters had revealed new facets of his mind and art, giving him a place in

ABOVE:
Wheatfield with Crows 1890
VAN GOGH MUSEUM (VINCENT VAN GOGH FOUNDATION), AMSTERDAM

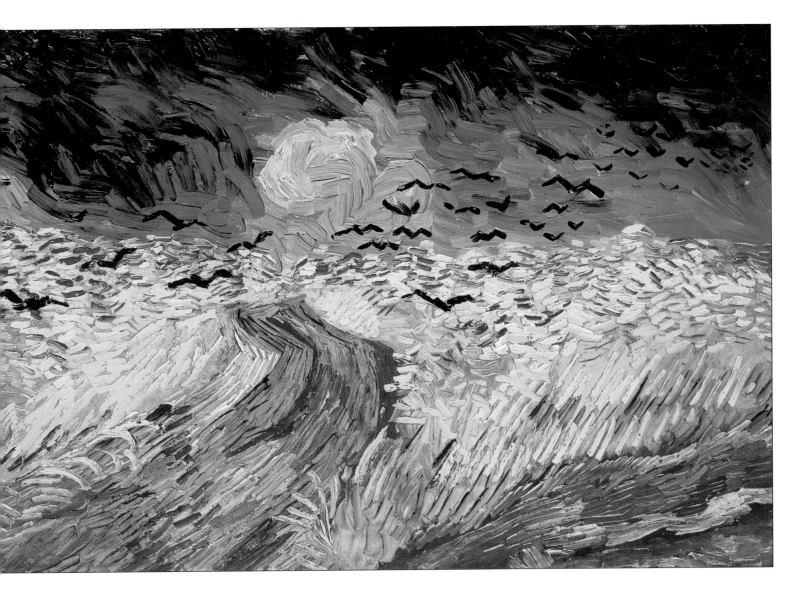

history as a personality as well as a painter of genius. As a result, in the 1950s and 1960s he became a modern icon, celebrated – and romanticized – in a movie and a pop song. Since then, there has been something of a reaction against the idea of Van Gogh as the artist-martyr or visionary genius, but his greatness remains unchallenged. Evidently each generation will remake him in its own image, as it remakes all the great men and women whose influence endures.

Index of illustrations

Acknowledgements

The publisher would like to thank the following for their kind permission
to reproduce the paintings in this book

Bridgeman Art Library, London/Rijksmuseum Vincent van Gogh, Amsterdam – 8-9, 28-9, 46-7, 57, 63, 64-5, 67, 77, 95: /**Rijksmuseum Kröller-Müller, Otterlo** – 11, 51, 68, 128-9, 131,206-7, 211: /**Museum Boymans-van Beuningen, Rotterdam** – 145: /**Musée d'Orsay, Paris** – 53, 232-3: /**Giraudon, Paris/Musée d'Orsay, Paris** – 73, 74, 104-5, 115, 117, 140, 175, 180, 184-5, 190, 223, 225, 226, 228-9: /**Musée des Beaux-Arts, Lille** – 243: /**Giraudon, Paris/Art Institute of Chicago** – 49: /**Armand Hammer Museum of Art, Los Angeles** – 16, 106-7, 188: /**National Gallery of Art, Washington, DC** – 99, 201: /**Detroit Institute of Arts** – 59: /**Phillips Collection, Washington, DC** – 118-9, 197: /**Norton Simon Museum of Art, Pasadena** – 124, 195: /**Metropolitan Museum of Art, New York** – 135, 172: /**Museum of Fine Arts, Boston** – 100: /**Fogg Art Museum, Harvard University, Cambridge** – 110: /**J Paul Getty Museum, Malibu, California** – 164-5: /**Kunsthaus, Zurich** – 26, 39, 240-1: /**Städtische Kunsthalle, Mannheim** – 40-1: /**Neue Pinakothek, Munich** – 92, 244-5: /**Museum Folkwang, Essen** – 101, 142: /**Oskar Reinhart Collection, Winterthur** – 160-1: /**Kunsthalle, Bremen** – 166: /**Bühle Collection, Zurich** – 218-9: /**Pushkin Museum, Moscow** – 85, 86-7, 132-3, 151, 187, 212-3: /**Hermitage, St Petersburg** – 138-9, 141, 163, 214-5: /**National Gallery of Scotland, Edinburgh** – 25, 78-9, 198-9: /**Glasgow Art Gallery and Museum** – 36, 50: /**National Gallery of Wales, Cardiff** – 239, 246-7: /**National Gallery, London** – 93, 178-9, 209: /**Tate Gallery, London** – 147, 250-1: /**Barber Institute, Birmingham** – 31: /**Courtauld Institute Galleries, London** – 154, 156-7: /**Kunstmuseum Solothurn, Switzerland** – 177: /**Galleria Nazionale d'Arte Moderna, Rome** – 204: /**Israel Museum, Jerusalem** – 88-9: /**Narodni Gallery, Prague** – 169: /**Private Collection** – 18-19, 32, 42-3, 60, 97, 120-1, 123, 126-7, 153, 183,191, 202-3, 220, 235, 236

Rijksmuseum Kröller-Müller Stichting, Otterlo – 6-7, 12-13, 80, 82-3, 114

Stedelijk Museum, Amsterdam – 14-15, 108-9

Rijksmuseum Vincent van Gogh, Amsterdam – 20-1, 22-3, 35, 54, 71, 148, 252-3

Yale University Art Gallery, New Haven, bequest of Stephen Carlton Clark, B.A. 1903 – 112-3

Museum of Modern Art, New York – 170-1